THE COMPLETE GUIDE TO
PRINTS AND
PRINTMAKING
TECHNIQUES AND MATERIALS

THE COMPLETE GUIDE TO
PRINTS AND PRINTMAKING
TECHNIQUES AND MATERIALS

Edited by
John Dawson

PHAIDON

Consultant Editor
John Dawson

Contributing Editors
Stanley Jones
Reginald Legro
Derek Milner
Irit Rogoff
Rosemary Simmons
Robert Smyth
Lou Weelan

A QUILL BOOK

Published by Phaidon Press Limited
Littlegate House
St Ebbe's Street
Oxford

First published 1981
© Copyright 1981 Quill Publishing Limited

ISBN 0 7148 2184 5

This book was designed and produced by
Quill Publishing Ltd.
32 Kingly Court, London W1

Art director James Marks
Production director Nigel Osborne
Editorial director Jeremy Harwood
Senior editor Liz Wilhide
Editors Anne Charlish, Julian Mannering, Judy Martin
Design Paul Cooper
Illustrators Ray Brown, Paul Cooper, David Weeks
Photographers Michael Fear, Richard Grey, Paul Sawyer, Jon Wyand
Picture Research Linda Proud

Filmset in Great Britain by Text Filmsetters Ltd., Orpington, Kent
Colour origination by Hong Kong Graphic Arts, Hong Kong
Printed in Hong Kong by Leefung-Asco Printers Ltd.

Quill would like to extend special thanks to Chris Betambeau at Advance Graphics, Glynn Boyd-Harte, Kathleen Caddick, The Contemporary Arts Society, L. Cornelisson and Son, Curwen Studio, Faulkner Fine Papers, Archie French, David Gentleman, Jonathan Heale, Hunter Penrose and Littlejohn, Laurie Hoff- man at Editions Alecto, Sue Jameson, Jeremy King, Keith MacKenzie, Marler, Megara Screenprinting, Garrick Palmer, St. Bride's Printing Library, Sericol Group Ltd., Sielle and Cuthbert, Nikos Stangos at Thames and Hudson Ltd., Ian Stephenson, S. Tyzacks and Sons, John Wagstaff and his department at the Victoria and Albert Museum, Carol Walker at Christie's Contemporary Art, Derek Wroughton at Dryad Press, Ann Usborne; and to the staff of the Department of Prints and Drawings at the British Museum and the staff of the Print Room at the Victoria and Albert Museum.

CONTENTS

Introduction

The print is unique among artistic media. The wide range of materials and diversity of techniques associated with printmaking make it a particularly flexible and resourceful medium, offering the artist many varied possibilities for experiment and expression. This flexibility accommodates both the serious artist and the beginner – satisfying results can be achieved quite quickly, using the simplest techniques. No matter how complicated the process, all printing involves two surfaces: one bearing the image and the other upon which the image is impressed. The image-bearing surface can be made in a wide variety of materials, such as clay, wood, stone, metal or fabric; at times several materials can be used together for the composite creation of a single printed image. The most basic prints, such as those made by early man in caves or by young children, are made by dipping hands in ink and then applying them to a surface. At the other end of the spectrum, the modern print is a product of constantly evolving mechanical processes, a result of a technological inventiveness which has stimulated the artist's imagination and developed his skill as a printmaker.

A utilitarian approach to printmaking (the simple desire to reproduce an image) persisted well into the fifteenth century. At that point, the invention of the printing press introduced hitherto unknown elements into the concept of printmaking. The ability to produce prints of reliable quality in large quantities and the consequent emergence of an individual and independent print aesthetic were the two most exciting and widely explored of these developments. In particular, the new aesthetic brought in tonal and textural qualities particular to printmaking, explored by such artists as Rembrandt.

The print eventually progressed from a mode of repeating images and illustrating narrative to the most popular method of reproducing phenomena. Today it is a medium of pure artistic expression. The factors involved in this development in communication and expression include the invention of the printing press, the rise of the popular illustrated journal, the invention of photography and the advent of the poster as a form of abbreviated mass visual communication. The industrial revolution and the ever-increasing social mobility towards the end of the nineteenth century stimulated the search for knowledge and brought culture and art to many more people. The print became the most popular medium for the acquisition of factual knowledge and cultural images in an easily accessible form. This combination of rapidly advancing mechanical and technological innovation on the production side and a growing demand in the market, is at the core of the energetic evolution of printmaking. Today, the print serves a dual purpose; it is both a major mode of artistic expression and the principal form of commercial illustration.

The four main types of printing In relief printing, the surface which creates the printed impression is raised in relief and the rest of the block is cut away. In the intaglio processes, the image is incised on a metal plate. In planographic printing, the image and the undrawn area are on the same level – the process is based on the antipathy of grease and water. In screen process printing, ink is pushed through a mesh or screen. The design is applied to the screen by a masking stencil or by painting out areas with a liquid that sets as a resist.

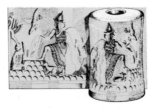

Cylinder seals from Sumer (*c.* 1400–1200 B.C.) are some of the earliest known forms of relief printing. They were rolled across documents.

Relief Printing

Relief printing is an overall term used for several processes which share the same fundamental principle: the surface which creates the printed impression is raised in relief while the rest of the block around it is cut away. The raised design is inked and the impression is transferred to paper by applying pressure to the entire block.

The earliest known form of relief printing can be found in the seals used by Assyrian and Mesopotamian cultures. Such seals stamped into clay, and the later Greek and Roman versions carved into precious stones, were used for the duplication of a symbol of authority. They combined simplicity of execution with an instantly recognizable visual message in much the same way as do rubber stamps used today by official bodies.

Other early forms of relief printing originated in the Far East. Hand-printed textile designs from wooden relief blocks found in China from the ninth century were brought to Europe in the thirteenth century. Similarly, the earliest dated print in China is a Buddhist illustration (A.D. 828), while there is no evidence of woodblock printing in Europe before 1400. The reason for this time lag is due to relief printing's dependence on an efficient process of manufacturing paper which was not properly established in Europe before the middle of the fourteenth century.

During the fifteenth century, woodblock relief printing was limited to the production of playing cards, calendars and religious images of crude execution. Exceptions were the series of Pilgrim Prints sold in the holy sites and sometimes gathered into block books. An unusual feature of these books was that words were sometimes added to the images on the same block of wood and printed simultaneously. All of these prints were executed in a technique known as woodcut – a fairly soft wooden block being used to allow the printer to achieve lines of subtlety and delicacy.

To make a woodcut, the artist draws a design directly onto the wood and the cutter cleans away all the surrounding areas. Where a greater textural variety is required, areas of crosshatchings (patches of short diagonally crossed lines) are added to the contour lines providing greater shading and depth to the image. The ink or colour, which must be thick so that it remains on the raised areas, is applied by a dapper or a roller and the printing is done by hand or in a press through application of light and even pressure.

The invention of the printing press by Johannes Gutenberg in Nürnberg *circa* 1450 was monumentally important for the development of printmaking. The production of a book which had previously taken scribes and illuminators months of toil could now be finished in a few days. Furthermore, Gutenberg's press allowed mass production. The moulded letters set up in the appropriate formes could be reproduced, so that once the text of a book was set up many copies

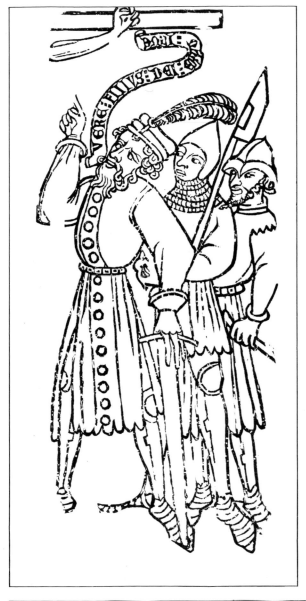

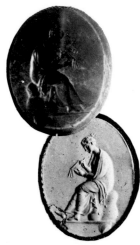

Gem stone seal and impression (*c.* 350–250 B.C.): portrait head on Sicilian jasper representing Philetairos. These seals were used by the Greeks and Romans to duplicate symbols of authority.

Left This contemporary impression showing a centurion and two soldiers was taken from the oldest existing woodblock (*c.* 1370), one of three depicting the Crucifixion. **Below** A double page from the *Ars Moriendi* block book (14th century, The Netherlands). Words and images were carved into the same block of wood and printed together.

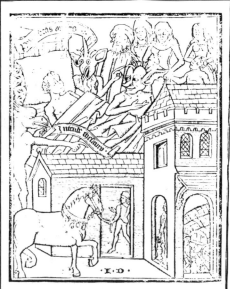

could be printed. Gutenberg's invention coincided with a period of significant developments in philosophy and the natural sciences and a renewed intellectual curiosity. The demand for books disseminating and illustrating information and ideas resulted in texts embellished by woodcuts, since these could be printed at the same time and by the same method in the press. A good example of these types of books is the *Weltchronik* of 1493, a textbook of geographical information with illustrations by the Nürnberg mastercutter Michael Wolgemut.

At this stage, the woodcut was still a means of illustration bound to a text and without an independent entity as an art form. It was Wolgemut's pupil, Albrecht Dürer (1471-1528), who revolutionized the concept of the woodcut in the dozen years that saw the publication of his great series of designs, *The Apocalypse* (1499), *The Great Passion* and *The Life of the Virgin* (both 1511). Dürer combined all the great achievements of the Renaissance in his work, striving for excellence in draughtsmanship, incorporating acute observation of nature with the lessons of three-dimensional perspective and thus elevating the woodcut to an expressive intellectual and artistic form. He was also able to use the medium's limitations of colour and tone and its austere line to enhance dramatic content and give a quality of suppressed intensity and authority. By this time, artists no longer did their own carving, a role which had passed on to trained cutters. Here too Dürer was revolutionary, training his cutters to reproduce drawings in perfect facsimiles of the originals, establishing the final departure from the medieval tradition, separating the artist who is preoccupied with the spirit from the craftsman who is in charge of execution.

The achievements of Dürer's work were continued by his contemporaries in northern Europe, Hans Baldung Grien (1484-1545) and Lucas Cranach (1472-1553). The technical virtuosity and vigour achieved by Dürer in both woodcuts and copper engravings created aesthetic standards which were to dominate printmaking for over a century. The work of Hans Holbein (1497-1543) in the generation following Dürer serves to illustrate that no attempt was made to improve on these standards, merely to enlarge the range of expression. Holbein's great work in woodcut, *The Dance of Death* (1528-1538), emphasizes symbols, drama and humour—a move away from pure realism. The post-Reformation desire for individualism, self-determination and knowledge are well expressed in the characterization of Holbein's figures.

While the woodcut was flourishing in Germany during the sixteenth century, partly due to the influence of the realism and use of perspective achieved in Italian painting, its progress in Italy was far less vigorous. In Florence and Venice, the two great centres of Renaissance art, the woodcut

remained essentially decorative, with repetitive geometric patterns and ornamental border frames. By the middle of the sixteenth century the woodcut was beginning to decline all over Europe. It was soon superseded by copper plate engraving as the usual method of illustration. For centuries following, the woodcut was a poor relation of intaglio printing, used only for ballads, broadsheets and for cheap reproductions of copper engravings by such artists as William Hogarth (1679-1764).

Towards the end of the nineteenth century a great revival occurred. Paul Gauguin (1848-1903), Edvard Munch (1863-1944) and the early German Expressionists ('Die Brücke' 1905-1912) found the woodcut a welcome relief from an increasingly industrialized and automated world. For Gauguin, the rough textural quality of the wood block's grain reflected the simplicity and directness inherent in primitive art. For Munch, it provided a natural means to express his view of the human condition and, for the German Expressionists, woodcut printing was part of a revival of the medieval tradition in Germany.

Parallel to the development of the woodcut, several minor traditions of relief printing were also being utilized, mainly for topographical and decorative purposes.

Wood engraving is very similar to woodcutting except that lines are engraved into the wood rather than the wood being cut away to expose the lines. For this process a much harder wood is used, so that very fine lines can be produced for minute detail.

Metal cut and relief etching were used alongside wood engraving, mostly for such decorative elements as border patterns, the highly ornate initial letters of printed texts and title pages. The technique is similar to wood cutting but the metal plate has a far greater durability and the precise edge of the raised images in metal give the effect of austere heraldic decoration. In the mid-fifteenth century a variant was introduced to metal cut relief in which the engraved plate was punched with dots inside the contour lines defining the image, thus making the final effect highly textured. Around 1500 many versions of *The Book of Hours* were printed by this method in France. William Blake (1757-1827) combined metal cut and relief etching in his series of illuminated books (*The Book of Job* 1825).

Intaglio Processes

Intaglio prints involve making incisions on a metal plate of copper, steel or zinc. The entire plate is inked and then wiped clean so that the ink is left only within the engraved lines and the printing is done under great pressure so that the paper comes into contact with the inked grooves. This pressure produces the plate mark and the raised ridges of the printed lines, both common features of most intaglio prints. Engraving,

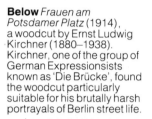

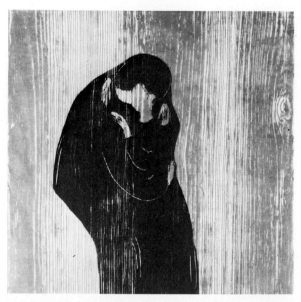

Right *The Kiss* (1902), colour woodcut on Japanese paper by Edvard Munch (1863–1944). Towards the end of the 19th century, artists such as Munch revived the woodcut, attracted by the rough and primitive texture of the wood block.

Below *Frauen am Potsdamer Platz* (1914), a woodcut by Ernst Ludwig Kirchner (1880–1938). Kirchner, one of the group of German Expressionsists known as 'Die Brücke', found the woodcut particularly suitable for his brutally harsh portrayals of Berlin street life.

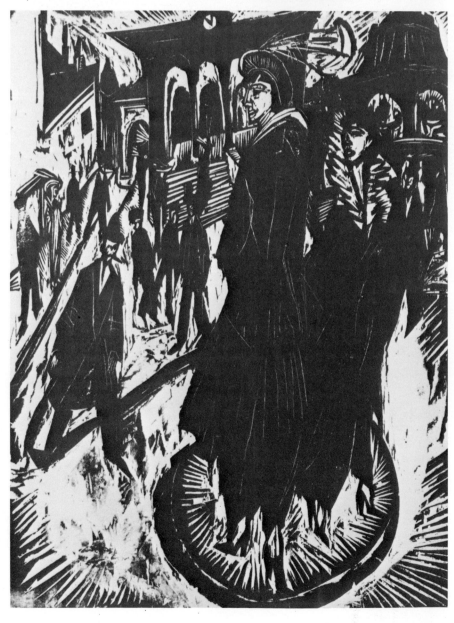

RELIEF PRINTING

	800	1000	1200	1400	1500

Woodcut
- c. 1450 Gutenberg invents the printing press
- Relief printing of textiles from wooden blocks in China.
- 1493 First great illustrated book, *Weltchronik*, illustrated by Michael Wolgemut
- 1276 Earliest established papermill in Europe – Fabriano, Italy
- 1538 Holbein's *Dance of Death*
- Earliest woodblock textile printing in Europe
- 1482 Earliest colour woodcut by Erhard Ratdolt
- 1511 Dürer's *Life of the Virgin*
- AD 828 Earliest dated relief print *Diamond Sutra*, China
- 1510 Earliest woodcuts with chiaroscuro effect (by Lucas Cranach)

INTAGLIO PRINTING

Engraving
- 1548 Commercial distribution of prints begins in Antwerp
- c. 1430 Earliest engraving, Germany
- c. 1470 Pollaiuolo's *Battle of the Naked Men*
- 1572 First catalogue of prints by Lafréry available on demand
- Height of development

Etching
- Parmigianino (1503-1540) first 'painter-etcher'
- Use of etching in armour decoration
- 1513 Earliest etching by Urs Graf
- Fontainbleu school of etching (1515-1547)

Drypoint
- 1480 Earliest drypoint print by Master of the Housebook

Metalcut and Relief Etching
- 1500 France – *The Book of Hours*

	800	1000	1200	1400	1500

etching, drypoint, mezzotint and aquatint are the major variants of this technique. The different ways in which the plates can be inked and wiped clean mean that there can be considerable differences between one print and the next and there is also a freedom to experiment with values of tone and atmosphere. The choice of paper also became important since its function of drawing out the ink meant that texture and absorbency could radically change the quality of the print.

Engraving, like relief printing, can be traced back to those early civilizations which had discovered how to make and use metal. The practice of engraving ornamental lines onto metal was employed by goldsmiths, armourers and object makers to break up a surface, using reflections to create a rich glitter. The engraving of metal plates for printing began in Germany in the middle of the fifteenth century and reached its height in the work of Albrecht Dürer and his Dutch con-

Above The chart which begins here and continues on the following pages shows the chronological development of printmaking.

temporary, Lucas van Leyden (1494-1533). Their work illustrates very well the profound difference between woodcuts and engravings, particularly in view of the rich and concurrent employment of both traditions in northern Europe. Whereas the woodcut is rooted in abstraction, abbreviation and a certain linear rigidity, the engraving is a concrete image approached from an analytical point of view. The severe linearity of the woodcut can be explained as an expression of the medieval mentality. Simple, recognizable images represented the body of mutual public knowledge; the grain of the wood dictated the form. In post-Reformation Europe, however, more people were literate and no longer needed instantly recognizable symbols. An analytical approach manifested itself in a change from abbreviated abstraction to realism. Engraving allowed a much greater freedom for interpretation and self-expression.

Renaissance Italy was less dominated by the

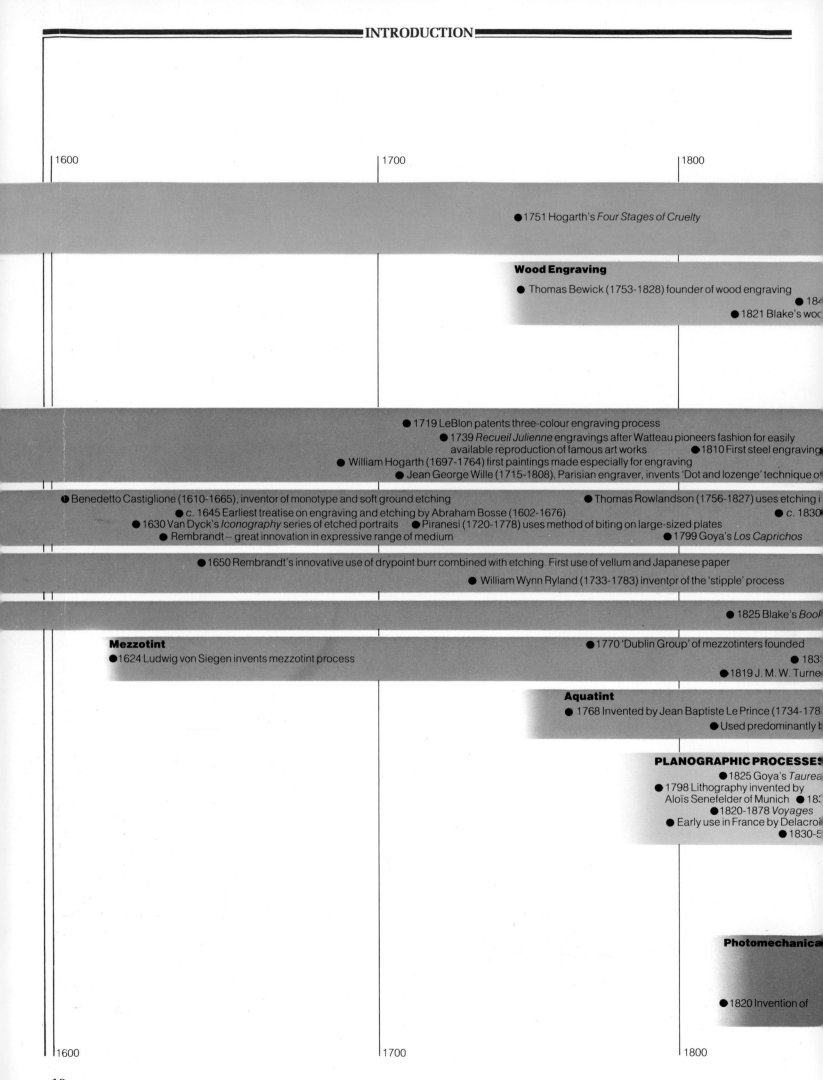

| 1600 | 1700 | 1800 |

● 1751 Hogarth's *Four Stages of Cruelty*

Wood Engraving
● Thomas Bewick (1753-1828) founder of wood engraving
● 184
● 1821 Blake's woo

● 1719 LeBlon patents three-colour engraving process
● 1739 *Recueil Julienne* engravings after Watteau pioneers fashion for easily
available reproduction of famous art works ● 1810 First steel engraving
● William Hogarth (1697-1764) first paintings made especially for engraving
● Jean George Wille (1715-1808), Parisian engraver, invents 'Dot and lozenge' technique o

● Benedetto Castiglione (1610-1665), inventor of monotype and soft ground etching ● Thomas Rowlandson (1756-1827) uses etching i
● c. 1645 Earliest treatise on engraving and etching by Abraham Bosse (1602-1676) ● c. 1830
● 1630 Van Dyck's *Iconography* series of etched portraits ● Piranesi (1720-1778) uses method of biting on large-sized plates
● Rembrandt — great innovation in expressive range of medium ● 1799 Goya's *Los Caprichos*

● 1650 Rembrandt's innovative use of drypoint burr combined with etching. First use of vellum and Japanese paper
● William Wynn Ryland (1733-1783) inventor of the 'stipple' process

● 1825 Blake's *Book*

Mezzotint
● 1770 'Dublin Group' of mezzotinters founded
● 1624 Ludwig von Siegen invents mezzotint process
● 183
● 1819 J. M. W. Turne

Aquatint
● 1768 Invented by Jean Baptiste Le Prince (1734-178
● Used predominantly b

PLANOGRAPHIC PROCESSES
● 1825 Goya's *Taurea*
● 1798 Lithography invented by
Aloïs Senefelder of Munich ● 183
● 1820-1878 *Voyages*
● Early use in France by Delacroi
● 1830-5

Photomechanica

● 1820 Invention of

| 1600 | 1700 | 1800 |

1900 1980

● 1905 Revival of woodcut by 'Die Brücke', founded by E. L. Kirchner

● 1857 Moxon's edition of Tennyson illustrated by the Pre-Raphaelites, the prototype of the illustrated book
● 1866 Doré's popular illustrations of the Bible
Menzel illustrated *Frederick the Great* ● 1890 Revolutionary edition of *Chaucer* combining illustration and book designs by Edward Burne-Jones and William Morris
engravings to Thornton's *The Pastorals of the Virgil*

Linocut ● 1965 Michael Rothenstein revolutionized tonal scope of linocut
● 1920 Earliest use by Claude Flight (1881-1955) and Futurists
● 1958 Picasso enlarged use of linocut through large series of prints

● 1875 Invention of steel-faced copper plates makes steel engraving obsolete

used widely in book illustration

engraving used for greater accuracy in reproducing paintings

contemporary satire ● 1880 Whistler founds Society of Painters and Etchers in London
Revival of etching in France, school of Barbizon
● 1862 'Société des Aquafortistes' founded in Paris, brings professional regulations to etching
●1930-37 Picasso's *Suite Vollard*

● Mary Cassat (1845-1926) instrumental in decreasing formality of subject matter
● Max Liebermann (1847-1935) promoted etching in Germany and founded annual Secession graphics exhibition

of *Job*

Constable publishes *Various subjects of Landscape*
publishes *Liber Studorium*

● Edgar Degas (1834-1917) innovative use of 'unelevated' subject matter
● 1930s Picasso made innovative use of mixed media in combinations
topographical watercolourists of etching, aquatint and drypoint

Lithography ● 1963 Jasper Johns (b. 1930) – makes lithographic
de Bordeaux ● 1890s Popular use of colour lithography in posters by Lautrec images of parts of his body
● 1900-1910 Innovation in lithography by Edvard Munch, E. L. Kirchner
T. S. Boy's *Picturesque Architecture* – early colour lithography ● 1953-62 Jean Dubuffet (b. 1901) begins to print actual objects
Pittoresques et Romantiques dans l'Ancienne France – series is highpoint of lithography in topographical – romantic landscape tradition
and Géricault ● George Bellows (1882-1925) first use of lithography in America
Daumier uses lithography in popular satire ● 1944-45 Picasso leads post-war boom in lithography

Screenprinting ● 1930 Process of attaching stencil to porous textile is developed by Vase Press, England
● 1880s First use of stencil attached to gauze mesh ● 1960s Use of photo screenprinting in artistic prints
● 1920s Industrial use of screenprinting ● Pop Art borrows industrial images for artistic prints
● 1916 First use of photo stencil ● 1940 Early use of serigraphy distinguishing hand printed
stencils from commercial screenprinting

Reproduction
● 1895 Commercial application of machine photogravure ● 1950s Early use of process in artistic prints
● 1868 First use of colotype in Germany ● 1915 Photoscreen printing patented
● 1870s First use of hand photogravure ● 1920s Early use of phototechnology in art – by Ernst and Heartfield
● 1880 Line block printing perfected for commercial use
photography ● 1890 Perfection of halftone screen for use in photomechanical reproduction processes
● 1855 Poitevin discovers sensitivity of light to bichromated gelatine resulting in photolithography

1900 1980

medieval idiom and, as a result, the tradition of engraving, rooted in realism from the start, developed a content and style independent of its northern neighbours. Antonio Pollaiuolo (1431-1498) and Andrea Mantegna (1431-1506) were the greatest exponents of early engraving in Italy with their use of broad sweeping lines and the portrayal of sensuous and tactile masses, up to that point explored only in painting.

Raimondi Marcantonio (1480-1527) was another Italian engraver who revolutionized the concept of engraving, not through creative skill, but rather through a development of the possibilities open to its use. After arriving in Rome in 1510, he began collaborating with Raphael (1483-1520), reproducing designs made by the painter especially for this purpose. Engraving gained in importance by association with an artist of Raphael's stature. The collaboration also began the movement of reproductive art, and perhaps most importantly enabled the rapid dissemination of stylistic innovation throughout Europe, a function which grew to dominate the art of engraving. The centre of engraving shifted from one European capital to the next, ending up in Paris in the eighteenth century with the publication of *Recueil Julienne* (1739), two volumes of engravings after the paintings of Antoine Watteau (1684-1721).

Concentrating on the extremely lucrative reproduction of works of art by famous painters and on small-scale book illustrations, engraving survived as a popular form of printing until the 1880s when the early photomechanical processes were perfected and it became almost totally obsolete. Photography had been invented in the 1820s and, by the end of the century, discoveries of the light sensitivity of bichromated gelatine (by Poitevin in 1855) and of the halftone screen, which breaks up the image into a mass of dots, meant that multiple photographic positives could be made and images mass-produced. In the wake of these discoveries came the rise of the popular illustrated journal such as the *Illustrated London News* and the *Illustrierte Zeitung* in Germany, which allowed the cheap and rapid spread of precise information, both printed and visual. In the twentieth century, these journals developed into photo-news magazines such as *Life*, and finally into filmed newsreels.

Another of the early intaglio printing methods was etching. In etching, the lines of the design are eaten away by acid rather than cut out of the metal plate with a tool. The plate is coated with a resist mixture which is resistant to acid and the artist draws the lines directly onto the plate, exposing the metal. The whole plate is then immersed in acid until the lines are sufficiently eroded. Finally, it is cleaned, inked and printed in the same way as an engraving. The process of direct and fluent drawing on the waxy surface instead of the laborious cutting away of lines from a metal plate

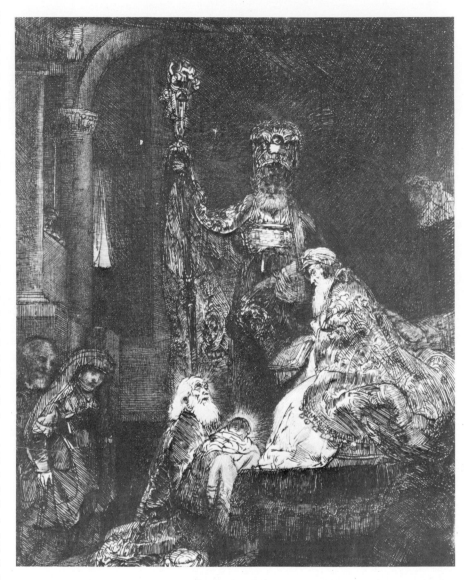

The Presentation in the Temple (c. 1654) by Rembrandt (1609–1669) is one of the many etchings (in this case, combined with drypoint) executed by the artist in his lifetime. These Biblical scenes enjoyed a wide appeal but also demonstrate Rembrandt's innovative approach and range of technique. His experiments with inking and preoccupation with tone lifted the medium to new heights of expression.

gives a far greater artistic freedom. The uneven bite of acid gives the line a barely noticeable furred edge, the most easily distinguishable characteristic of etching, and one which contributes a great vibrancy to the image.

Experiments with etching began in the sixteenth century. The earliest known etchings were made by Urs Graf (1485-1528) in 1513, but artists such as Lucas van Leyden used the method mainly as an easier way of achieving the effects of engraving. It was in the Low Countries that etching came into its own in the seventeenth century and its artistic possibilities were fully exploited. Hercules Segers (1589-1635), Van Dyck (1599-1641) and, above all, Rembrandt (1606-1669), pursued experiments in etching which pushed the medium to new heights of expression, in the same way that Dürer had done a century earlier with woodcut and engraving. Rembrandt used the full powers of his artistic genius in his experiments with etching, beginning with small genre scenes and culminating in majestic scenes from the Bible. By using different

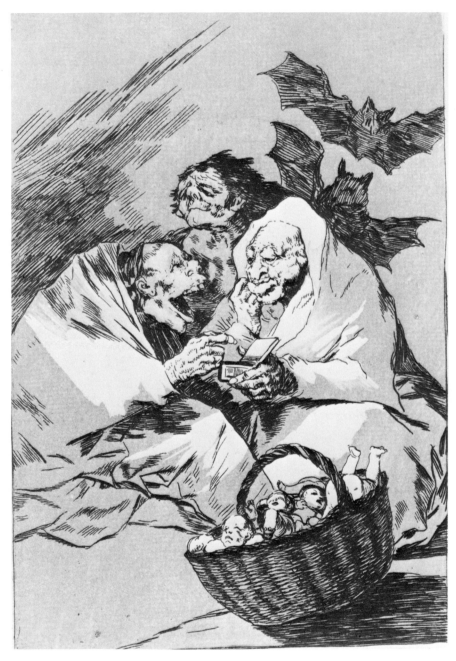

The etchings of Francisco Goya (1746–1828), Spain's greatest artist of that period, were technically influenced by Rembrandt but show an extension in terms of subject matter and expression. The illustration, *El sueño de la razon produce monstruos*, is one of the 82 etchings comprising *Los Caprichos* (Caprices), made during the period 1793–8 and published in 1799. These masterpieces of printmaking were satirical and macabre attacks on the Church and combined etching with aquatint.

inking techniques, tonal shading and drypoint, Rembrandt was able to produce a swift and spontaneous line married to concepts of great emotional power. Rembrandt's art was not only an expression of his individual genius but also echoed the liberalism and dignity of the emergent bourgeoisie unique to the Low Countries in the seventeenth century. It is no wonder that when Rembrandt's art was rediscovered in the late nineteenth century, it was closely followed by a great and renewed interest in etching.

During the eighteenth century the focal point of interest in etching moved to Italy and Spain. Piranesi (1720-1778), an Italian architect, etched enormous plates showing the declining glory of Rome, etchings exceptional for their combination of strict architectural detail and subjective melancholy. Francisco Goya (1746-1828), Spain's greatest artist of the period, worked in isolation due to the lack of etching tradition in that country and produced powerful dramatic effects instead of the abbreviated images traditional in other European cultures. The 82 plates making up Goya's masterpiece *Los Caprichos* (1799) reached a wide audience, exciting controversy with their savage social criticism and implied threat to the absolute authority of the Church. Goya had begun his work in etching under the influence of Giovanni Battista (Giambattista) Tiepolo (1696-1770) but manipulated the airy Baroque images into agonized visions of horror which retained only the freedom of rapid execution and visual mass found in the Italian artist's work.

Goya's experiments with aquatint, the stark modernity of his images and the critical nature of his work had a great influence on French artists of the late nineteenth century, stimulating a revival in etching at that time. Artists such as Edgar Degas (1834-1917), Edouard Manet (1832-1883) and others, experimented with the atmospheric qualities of etching and its ability to convey momentary sensations. Their art, however, was so rooted in the expression of light through colour that it was left to James McNeill Whistler (1834-1903), who brought etching from France to America, to so excel in it that he gained the reputation of being Rembrandt's disciple. Whistler pursued the Impressionist's search for fleeting sensations and moods, leaving films of ink on the plate to create a hazy shimmer over the etching.

In this century, the greatest practitioner of etching has been Pablo Picasso (1881-1973), whose great etched suites of prints with their rapid, sweeping lines and clarity of images, including bulls, nymphs and other satyric creatures, have become part of our visual vocabulary. Since the Second World War, several artists have kept up the tradition of etching, drawn to the medium by its spontaneity of line and ability to render solid mass. Foremost among these are the American Jim Dine (b. 1935) and the English artist David Hockney (b. 1937).

Other methods are included in the intaglio family. These are drypoint, mezzotint and aquatint.

In drypoint, the line is scratched directly into the copper plate with a sharp point. This creates a tiny metal ridge, known as a burr, which rises on both sides of the scratched line. In the process of inking, this burr receives ink, giving the line in the final print a smudged, furry quality. Drypoint has been used in combination with etching by Rembrandt and with engraving and etching by Picasso; this use of mixed media enhances the print's wealth of texture and expression.

Mezzotint is a process of reverse tonality working from dark to light. The copper plate is first worked over with a sharp rocker until its surface is pitted; if it is inked in this state it will print entirely black. The engraver then burnishes areas of the copper so that they will hold either less ink or none at all; when printed the design emerges out of the dark area. The method was invented in 1624 by a German soldier, Ludwig von Siegen, and was elevated to great artistic expression by the English artists J.M.W. Turner (1775-1851) and John Constable (1776-1837).

Aquatint is a printing process capable of producing an effect similar to watercolour wash. The plate is covered with an etching ground consisting of minute particles of resin. This ground is so porous that when the acid bites the plates it forms pools of liquid around each particle. According to how fine these particles are, the final print can

Right *Jane Avril with Snake* (1899) by Henri de Toulouse-Lautrec (1864–1901) is a colour lithograph which illustrates the use Lautrec made of lithography to create large areas of pure strong colour, direct and immediately understandable as part of a poster design.
Above opposite In *The Election Campaign (with Dark Messages)* from *A Rake's Progress (1961–3)*, David Hockney (b. 1937) combines etching with aquatint. Hockney is one of the post-war artists who have revived contemporary interest in etching.
Below opposite *Addled Art* (1973) by R. B. Kitaj (b. 1932) is an example of the use of mixed media (newsprint and photographs). The collage was photographically reproduced, using several screens, one for each colour.
Far right This 18th century Japanese colour woodcut was produced from 91 separate blocks. Japanese relief prints, exhibited in Europe for the first time in the late 19th century, had a great influence on French painters and graphic artists.
Below *Yellow* by Michael English is a screenprint with hand-finished details – a bold, realistic composition.

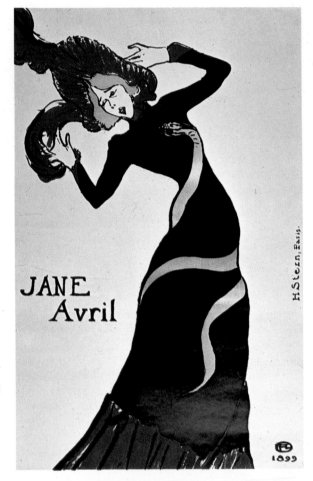

JANE Avril

H.Stern, Paris.

1899

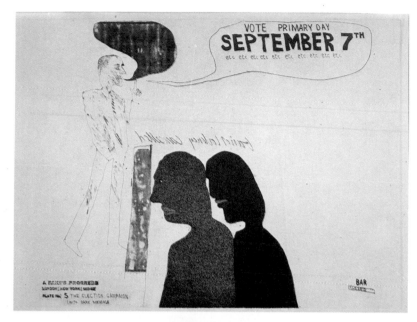

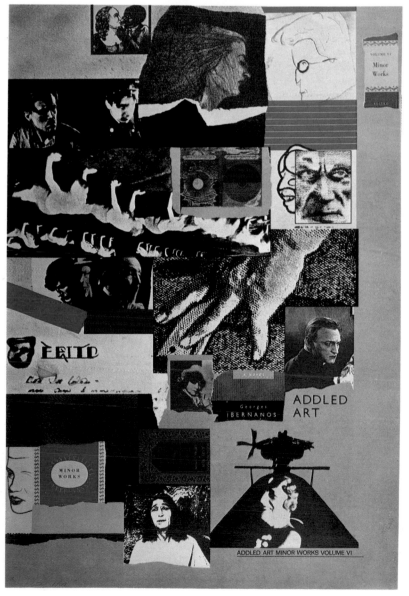

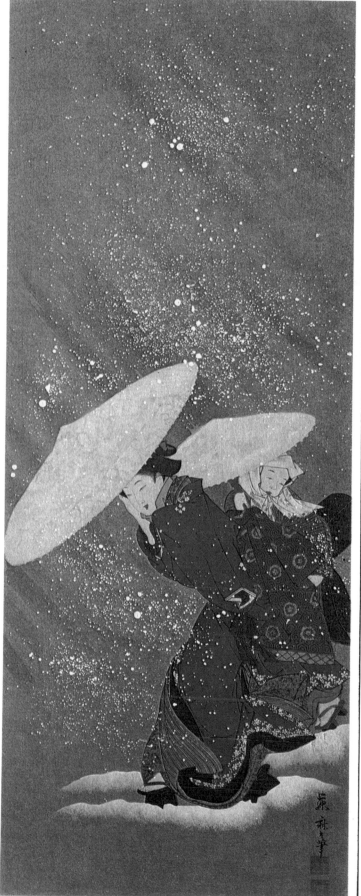

The Studio

Although a print can be a work of art, the actual process of printmaking is a craft, and one that encompasses a variety of techniques. The materials available to the printmaker, the size of the print he wishes to make, his experience in using tools, together with his design ideas – all of these factors will influence choice of technique. Making a print need not be complicated; a basic studio will allow you to practise a variety of simple methods such as making woodcuts, linoleum printing, stamp printing, and colour printing – printing with more than one colour and more than one block.

Setting Up a Print Workshop

Even in a small studio it is essential to match your equipment to the size and scope of the printed matter you intend to produce. This is an obvious point, perhaps, but one which is easily overlooked. Define the functions of the studio as closely as possible – are you going to prepare your drawings and working ideas prior to printmaking in the studio, or will you need additional working space there? The cost of setting up a studio need not be excessive – a modest but adequate space for one person can be established for less than £50 ($120).

Where the studio is located will obviously depend on how much room is available in your home and also on the type of work you propose to do. Ideally the latter consideration should be the governing factor. Try to avoid having to move your equipment and blocks from one corner to another as your skills develop and your ideas become more ambitious.

If you are taking up printmaking seriously, the studio should be set up in a separate room, not least for reasons of cleanliness. Equally importantly, when a room is designated 'the studio' it is easier for everyone to get used to the idea that it is a place for serious work and not just the spare room.

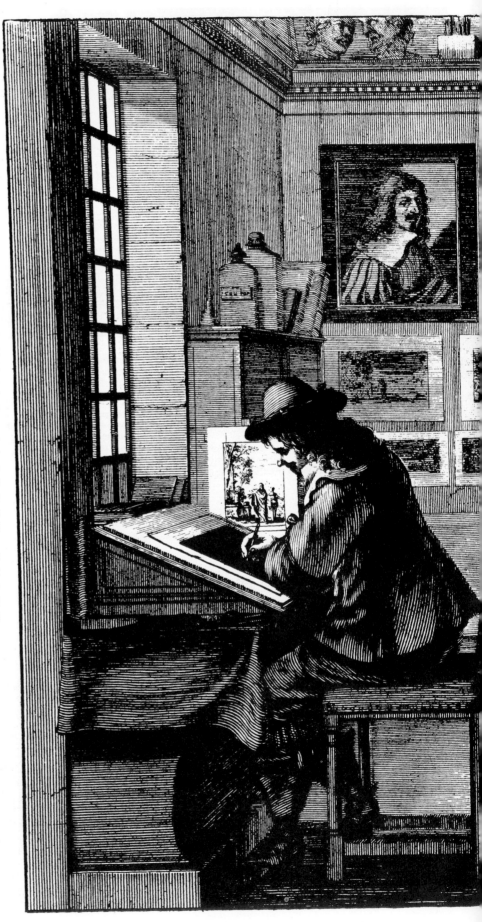

An engraver's studio in Paris during the 17th century, showing two engravers at work on copper plates with burins and nitric acid. Prospective clients view the work displayed in the background. During this period, many such studios flourished in the major capitals of Europe, specializing in the reproduction of works by famous artists and in book illustration.

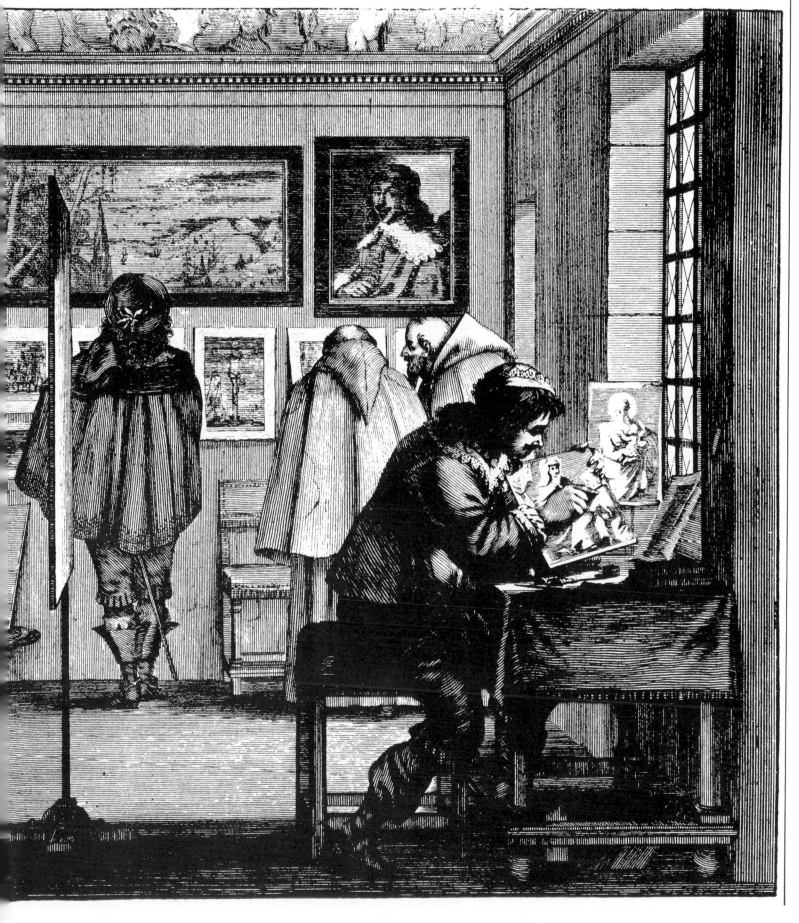

Lighting

Select a room with good natural lighting, preferably facing north, to give a good even viewing light for colours without glare. When this sort of choice is impossible and the room is in sunlight for much of the day, then it is worth applying a solar control film to the inside of the windows. This will produce a well balanced spread of light.

Adequate artificial lighting is also essential. Fluorescent tubes are probably best for overall illumination. For studios where colour rendering and colour matching are important, special fluorescent tubes which give an effect similar to daylight with some sunlight, are a good choice. When you hang fluorescent tubes from the ceiling or a wall-mounted fitting, bear in mind head height and the spread of light at the lowest possible hanging distance so that you gain the full benefit of the lighting. Additional lighting on drawing tables and working surfaces can be pro-

vided by a portable desk lamp with a tungsten spot bulb, either free-standing or, more suitably, mounted on the wall so that the lighting can be directed on to specific areas in the studio where extra local light is needed. A large range of reasonably priced studio lamps are available that can be fixed to walls or clipped to working surfaces. Be careful not to fit a greater wattage of bulb into your lamp than that recommended by the manufacturer.

The main source of artificial lighting should be installed with its length above and slightly in front of your working position in the studio, to avoid the handicap of trying to do fine cutting work in your own light. If the studio does have windows, you should work facing them or no more than at right angles to them (remembering in this instance that a right-handed person should have the light to his left and vice versa).

Desk lamps range from basic anglepoises to sophisticated varieties incorporating magnifying glasses. Anglepoises are available in different sizes. The two models shown here have solid bases, but others have clamps for fixing them to the side of the working surface. The magnifier lamp permits shadowless lighting of the viewing area and has a ring fluorescent tube. The fluorescent lamp has two tubes.

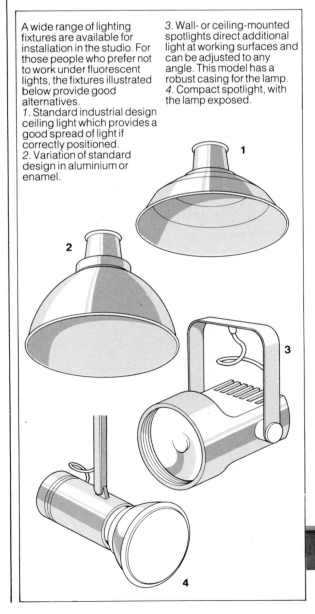

A wide range of lighting fixtures are available for installation in the studio. For those people who prefer not to work under fluorescent lights, the fixtures illustrated below provide good alternatives.
1. Standard industrial design ceiling light which provides a good spread of light if correctly positioned.
2. Variation of standard design in aluminium or enamel.
3. Wall- or ceiling-mounted spotlights direct additional light at working surfaces and can be adjusted to any angle. This model has a robust casing for the lamp.
4. Compact spotlight, with the lamp exposed.

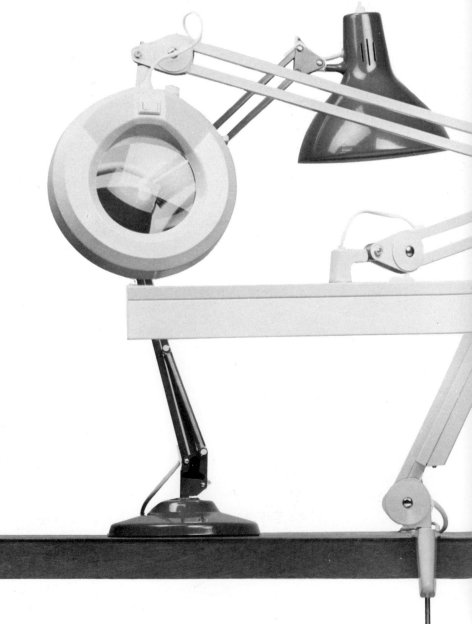

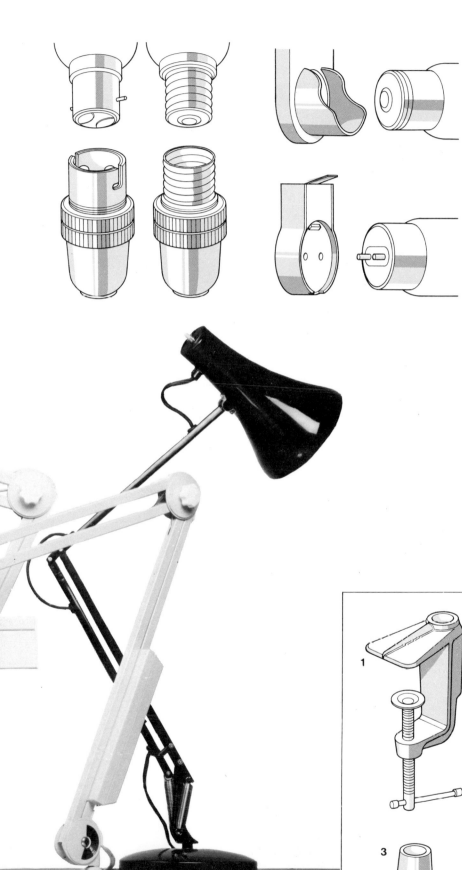

Right Different fixtures for fluorescent strip lighting (top to bottom): enamel trough with open end, enamel trough with closed end, bare lamp, moulded prismatic plastic enclosure, louvered plastic trough, moulded enclosure for indirect lighting.

Left *Lampholders* Some ordinary domestic bulbs have bayonet caps that are pushed into the lampholder and twisted. Spotlights usually have screw caps, tubular filament bulbs have plain caps and fit into spring holders, while fluorescent tubes have pin caps.

Below *Mounting brackets* Lamps can be attached to horizontal or vertical surfaces by a variety of brackets and clamps. Four types are illustrated below: a fixed clamp for level surfaces *(1)*, a wall bracket *(2)*, a bracket for horizontal surfaces *(3)* and an adaptor for use with a fixed clamp for mounting on a slanted surface *(4)*.

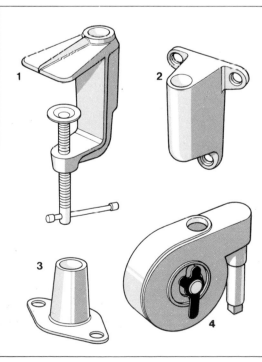

Layout and Planning

All the equipment in your studio should be arranged to provide an adequate working surface, with essential tools and equipment to hand. The best plan is to place basic working units in an L-shape. This design is suitable even for the smallest studio. Avoid blocking doorways or putting equipment in hallways or gangways – not only is it tiresome to walk around it, it is also dangerous.

At this stage it is a good idea to draw a scale plan of the room and make cut-out cardboard shapes of all the equipment and working surfaces you plan to buy so that you can work out a satisfactory layout for your immediate needs. This is an essential preliminary to installing additional electrical points, water and gas pipes, heating units or a telephone.

Basic Equipment

A working surface is the first consideration. A solid heavy table with a flat working top is ideal,

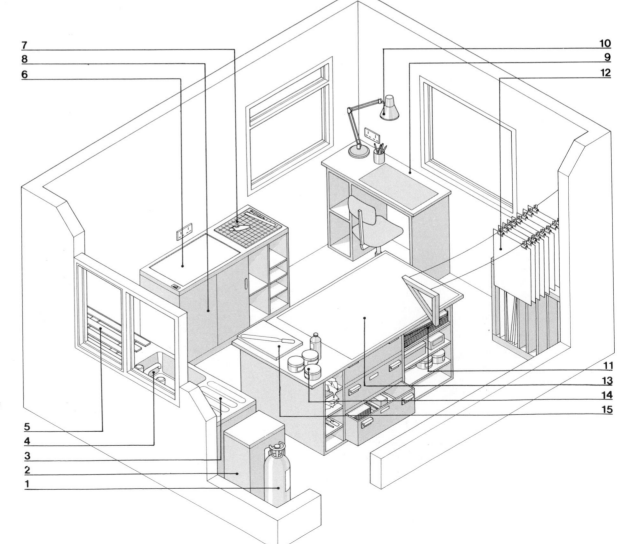

Basic studio layout for use without a mechanical press
1. Fire extinguisher.
2. Metal cabinet for storing inks and solvents.
3. Draining area.
4. Sink.
5. Wooden drying racks.
6. Light box for viewing.
7. Cutting mat.
8. Storage for materials.
9. Drawing table in front of north facing window.
10. Adjustable table lamp.
11. Paper storage.
12. Print drying rack.
13. Printing and working surface with protective covering and storage underneath for tools. Strip lighting should run directly overhead, slightly in front of the working position.
14. Inks and solvents.
15. Ink palette.

Below A fire extinguisher is a crucial piece of equipment in any studio. Many of the chemicals used are highly inflammable and so you should get advice from the fire brigade as to which type of extinguisher would be most suitable.

Above A printing table provides a firm working surface and should consist of three layers. A sheet of glass, which is smooth and easily cleaned, is laid on a rubber mat. Both are then placed on a firm base. A protruding base should be constructed to keep both the glass and rubber in position.

and the stronger it is, the better. Cover the working top with a good surface, either plastic self-adhesive sheeting, hardboard (masonite), zinc sheeting or Formica. These materials are all smooth and easy to keep clean. Newspaper is also adequate and, provided it is not too saturated with inflammable solutions such as oil-based inks and solvents, is relatively easy to dispose of after use, if you follow basic safety procedures.

Cleaning Cloths

Old pieces of *clean* clothing, cotton dusters, muslin cloth and paper towels can be used to clean the print table, ink palettes, inking rollers, squeegees and brushes. Store them in a tea chest or wooden packing case so they do not get dirty before they are needed.

Containers

All jars with screw lids, plastic seal-lids containers, yoghurt pots and clean used plastic food containers make suitable containers for storing liquids (not acids) or mixed printing inks.

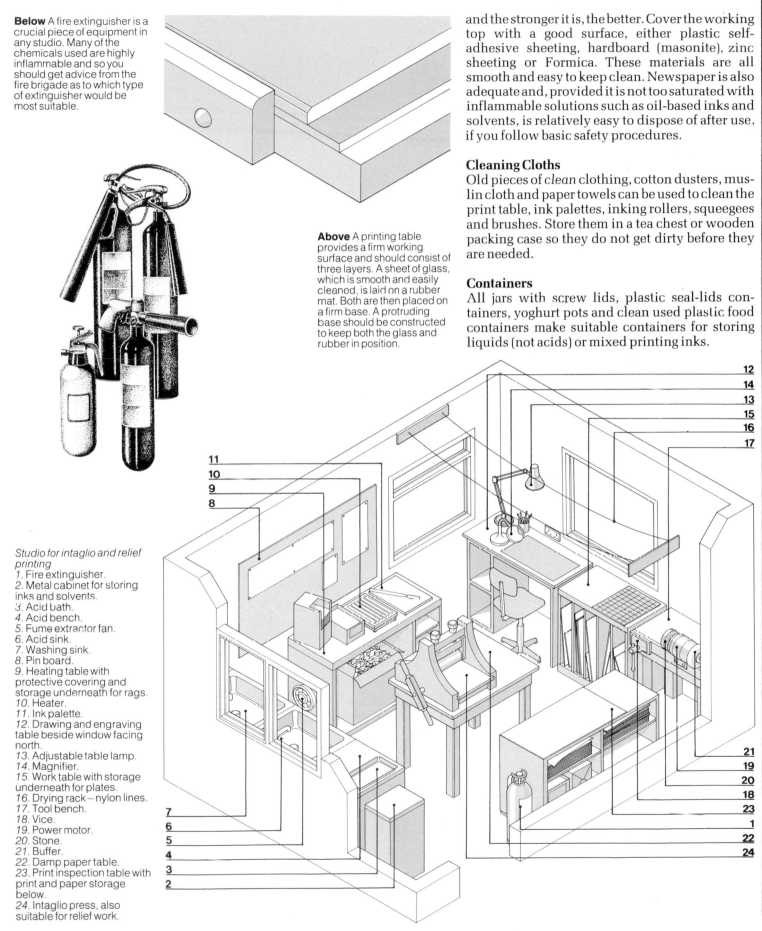

Studio for intaglio and relief printing
1. Fire extinguisher.
2. Metal cabinet for storing inks and solvents.
3. Acid bath.
4. Acid bench.
5. Fume extractor fan.
6. Acid sink.
7. Washing sink.
8. Pin board.
9. Heating table with protective covering and storage underneath for rags.
10. Heater.
11. Ink palette.
12. Drawing and engraving table beside window facing north.
13. Adjustable table lamp.
14. Magnifier.
15. Work table with storage underneath for plates.
16. Drying rack – nylon lines.
17. Tool bench.
18. Vice.
19. Power motor.
20. Stone.
21. Buffer.
22. Damp paper table.
23. Print inspection table with print and paper storage below.
24. Intaglio press, also suitable for relief work.

Storage

Begin by storing all your materials and tools in a workmanlike manner. Storage units such as wooden or cardboard boxes can be painted to give them a good appearance and improve their durability. Keep tools in boxes or drawers, or on wooden wall racks, so they do not become dirty or damaged when they are not being used. Printing inks must be stored away from heat and direct sunlight, and all solvents must be kept in a fireproof metal cabinet or container. A secondhand metal filing cabinet is ideal for this purpose and is a worthwhile investment for safety.

As your ideas progress and become more ambitious, your paper requirements will become more complex. Storing papers properly in a flat plan chest will become a necessity.

Palettes

The cheapest form of palette for mixing printing inks is a piece of strong white coated (smooth) cardboard. Alternatives are pieces of plain linoleum, non-ferrous metals such as zinc or copper, hardboard (masonite), plywood, laminated plastic or thick glass with ground edges.

The best palette is a sheet of ground glass about 25 x 35cm/10 x 14 inches, approximately 2.5cm/1 inch thick. Its surface is extremely smooth, allowing you to mix inks quickly and cleanly with a palette knife. If you cannot find a slab of heavy glass with a ground surface, it is relatively easy to put a ground tooth on the surface using carborundum stone. The tooth (finely scratched surface) holds the ink on the slab while you mix. If you are fortunate you may find an old lithographic stone (Kelheim limestone) with its surface still smooth and hard. This is a splendid mixing base for all printing inks; it is solid enough to allow you to mix heavy inks confident in the knowledge that the palette will not suddenly slip onto the floor. Established printing companies may still have some of these stones available.

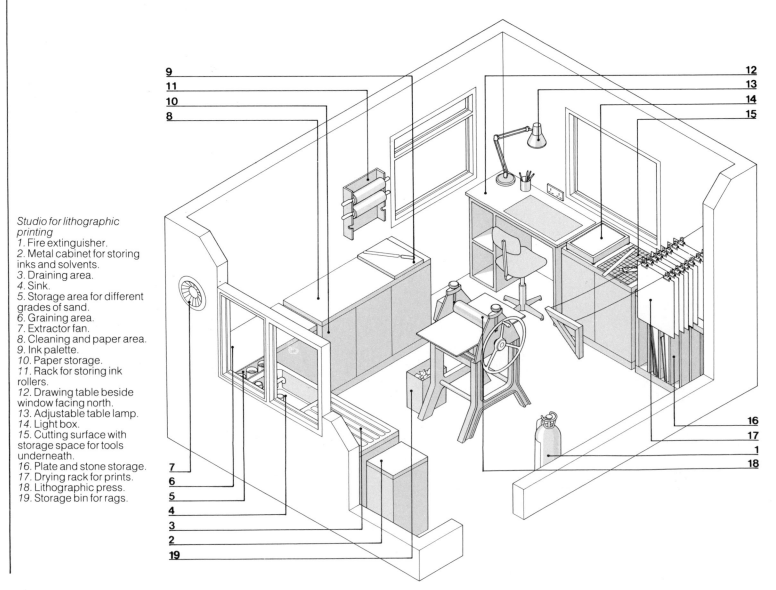

Studio for lithographic printing
1. Fire extinguisher.
2. Metal cabinet for storing inks and solvents.
3. Draining area.
4. Sink.
5. Storage area for different grades of sand.
6. Graining area.
7. Extractor fan.
8. Cleaning and paper area.
9. Ink palette.
10. Paper storage.
11. Rack for storing ink rollers.
12. Drawing table beside window facing north.
13. Adjustable table lamp.
14. Light box.
15. Cutting surface with storage space for tools underneath.
16. Plate and stone storage.
17. Drying rack for prints.
18. Lithographic press.
19. Storage bin for rags.

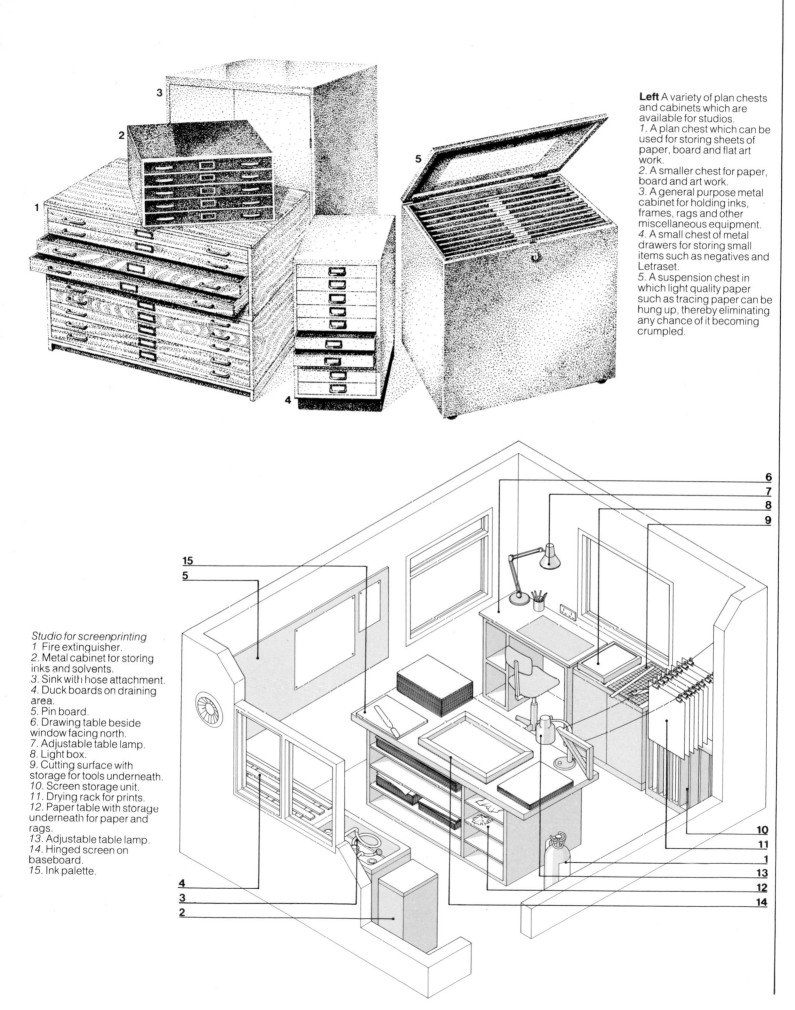

Left A variety of plan chests and cabinets which are available for studios.
1. A plan chest which can be used for storing sheets of paper, board and flat art work.
2. A smaller chest for paper, board and art work.
3. A general purpose metal cabinet for holding inks, frames, rags and other miscellaneous equipment.
4. A small chest of metal drawers for storing small items such as negatives and Letraset.
5. A suspension chest in which light quality paper such as tracing paper can be hung up, thereby eliminating any chance of it becoming crumpled.

Studio for screenprinting
1. Fire extinguisher.
2. Metal cabinet for storing inks and solvents.
3. Sink with hose attachment.
4. Duck boards on draining area.
5. Pin board.
6. Drawing table beside window facing north.
7. Adjustable table lamp.
8. Light box.
9. Cutting surface with storage for tools underneath.
10. Screen storage unit.
11. Drying rack for prints.
12. Paper table with storage underneath for paper and rags.
13. Adjustable table lamp.
14. Hinged screen on baseboard.
15. Ink palette.

Printing Rollers

A couple of rubber rollers to 'ink up' your prepared printing surfaces are essential; for silkscreen printing you will also need to buy a good quality rubber squeegee. These tools can be bought at any good art shop. The various widths of rollers you choose will depend on your printmaking ambitions. Initially, for general use, buy both a hard and a soft roller about 10cm/4 inches in size. For more ambitious and meticulous printmaking you might consider buying a roller made out of gelatine which spreads an even layer of ink on almost any surface and is especially suitable for inking type. Rollers must be cleaned thoroughly after each working session and should not be laid face down for long periods of time, otherwise one side will begin to flatten and the roller will no longer lay ink evenly. Rollers and squeegees are best stored away from excessive heat, in a drawer or cupboard, or hung under cover in a tool rack.

Burnishers

The simplest burnisher is the flat of your hand. Old smooth kitchen spoons, smooth rounded pebbles or pieces of polished wood or metal are ideal for burnishing the reverse side of a sheet of paper as you apply an even pressure across the surface. Eventually you will need to buy steel or agate burnishers for such specialist functions as repolishing corrections or lightening surfaces in the plate, as in aquatint.

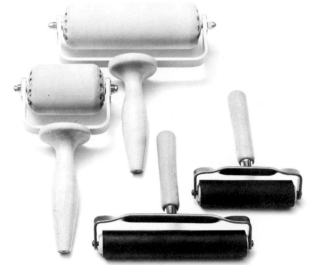

Above Rollers for inking up. The two on the left are made of calf skin and are known as nap rollers. They are used in lithography for inking up the stones or plates. The two general purpose rollers on the right are made of a rubber composition. **Below** A range of studio knives. Scalpels (1, 2, 3); rotating head cutter (4); screen stencil knives (5, 6, 7, 8); snap off knives (9, 10, 11, 12); multi-purpose craft knife (13); heavy duty craft knife (14).

Above Burnishers are made in all shapes and sizes. Those with fine points are used for detailing while those with rounded edges are used for flattening.

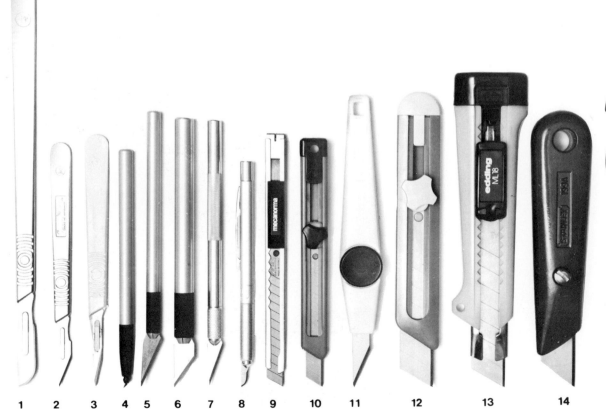

1 2 3 4 5 6 7 8 9 10 11 12 13 14

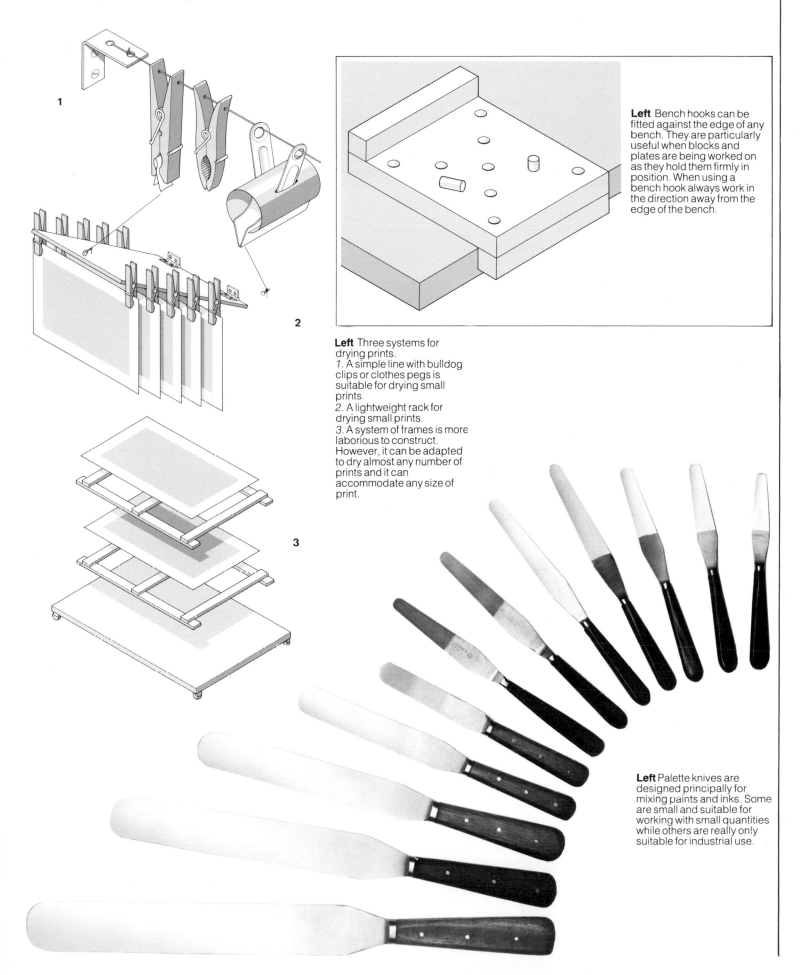

Left Bench hooks can be fitted against the edge of any bench. They are particularly useful when blocks and plates are being worked on as they hold them firmly in position. When using a bench hook always work in the direction away from the edge of the bench.

Left Three systems for drying prints.
1. A simple line with bulldog clips or clothes pegs is suitable for drying small prints.
2. A lightweight rack for drying small prints.
3. A system of frames is more laborious to construct. However, it can be adapted to dry almost any number of prints and it can accommodate any size of print.

Left Palette knives are designed principally for mixing paints and inks. Some are small and suitable for working with small quantities while others are really only suitable for industrial use.

A Handmade Printing Press

A basic yet surprisingly satisfactory press can be made by using a sheet of heavy gauge plywood (approximately 19mm/¾ inch thick) and a sheet of foam rubber of the same size (approximately 12mm/½ inch thick) backed onto another sheet of plywood. To operate this floor press you feed in your inked plate and a sheet of paper, then stand on the press to transfer the printed image. The press size will depend on the size of image you want to make.

If you look in secondhand furniture and junk shops you should be able to find a few household clothes mangles or wringers which can be successfully converted into simple types of hand-operated presses for planographic or relief printing. Only use those wringers that employ two sets of rubber rollers. Set up the spaces evenly between each roller and after some experimentation and care you will be able to produce worthwhile results.

For future projects you will want to look at the range of printing presses available for different processes, but these are expensive and heavy items of equipment.

Right The platen press *(1)* is the simplest letterpress machine. The forme is held vertically and inked by rollers when the platen opens. When the platen is closed it presses the paper against the inked surface. The rotary press *(2)* can print single prints at a high speed. In the flat bed cylinder press *(3)* the type forme lies on a flat bed and travels under the inking rollers. A rotating pressure cylinder presses the paper against the type. In a web offset press *(4)* the ink is offset from the plate to a rubber blanket to the paper.

Above *Printing with a wringer* An old-fashioned clothes wringer can be adapted to serve as a printing press for intaglio plates. A sheet of metal between the rollers forms the bed of the press. Place plate and paper on the metal bed and cover with blankets as on the full size press. Wind the handle to pass the plate between the rollers.

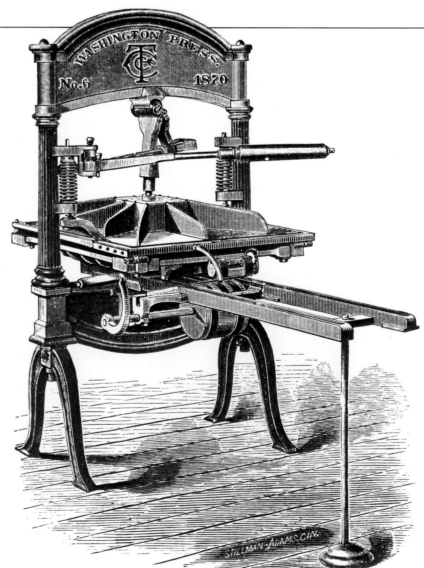

2

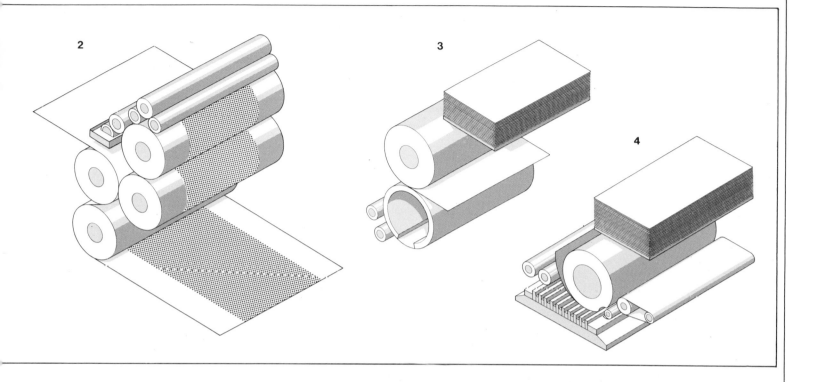

3

4

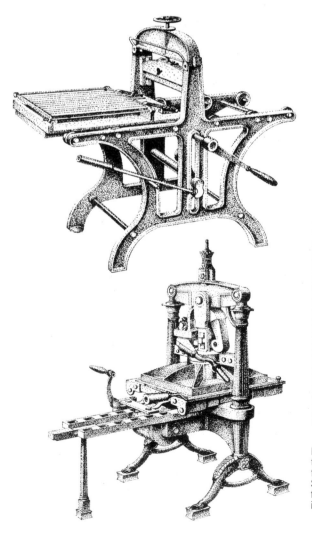

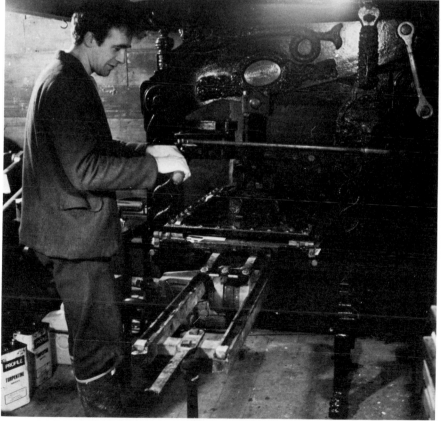

Left Old-fashioned presses: the 'Washington' hand press for relief printing, the 'New Style' lithographic press and the Albion, a relief press invented about 1823.

Above A Columbian relief press in operation.

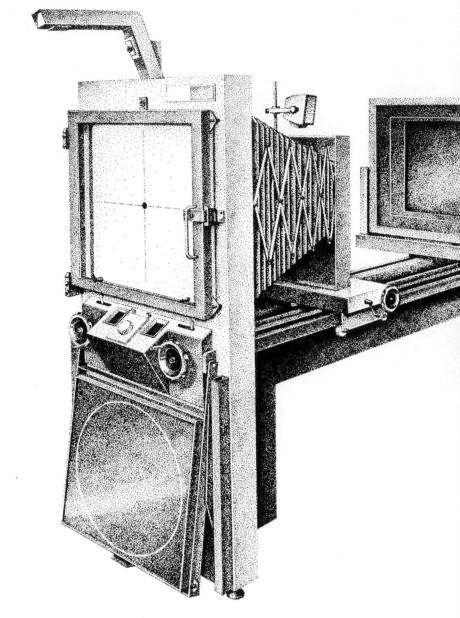

Right The process camera consists of a copy holder, a lens and a film carrier. There are both vertical and horizontal versions and the latter can accommodate larger originals and film sizes. The camera illustrated here is a horizontal one. Their large size is partly a result of their need to be stable and free from vibration so as to give good register.

The Process Camera

A process camera is a specialized type of camera for copying flat art work or converting tonal variations into a series of dots which can then be printed. The main features of the camera are the copy holder, a lens, and a film carrier. The final image which is produced depends on the type of filter or screen as well as the sort of film which is used.

For the printmaker a process camera is necessary for making halftone negatives or positives for plate or block-making. These can be used for making photo stencils or doing photo etches. Because printing ink is of a uniform density it is not possible to create intermediate tones. As a result, any originals which have gradations of tone, such as a photograph, must be broken down into a series of dots which merge to create an optical illusion of continuous tone. The breakdown into dots is done at the camera stage by placing a screen in front of the film. A conventional halftone screen consists of two sheets of plate glass on which parallel lines are etched and filled in with black pigment. The sheets are sealed together so that the rulings intersect at right angles thereby forming an overall lattice pattern of opaque lines enclosing square windows.

During photography, the image projected by the lens passes through the tiny windows of the screen to produce the series of dots required on the film. These vary in size according to the degree of light reflected from the original. Since highlights on the original project plenty of light, the resulting negative will be predominantly opaque in these parts, with the eventual printing surface peeping through the small transparent dots. On the other hand, the reflections coming from deep shadows will be very weak showing up on the photographic negative as a comparatively large transparent area relieved by small, opaque non-printing areas. On photographic positives, the black and white will be reversed.

This simple principle applies proportionately to all intermediate tones. Thus, an illusion of grey in a finished print is the result of the arrangement of jet black dots of different sizes at the same distance from each other, reckoning from their centre.

A process camera is an expensive and bulky piece of equipment and considerable know-how is needed for its operation. It is not something which an amateur printmaker will own so that halftone negatives and positives will have to be made for the printmaker by a professional.

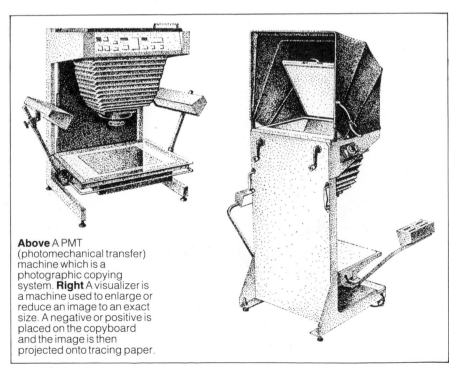

Above A PMT (photomechanical transfer) machine which is a photographic copying system. **Right** A visualizer is a machine used to enlarge or reduce an image to an exact size. A negative or positive is placed on the copyboard and the image is then projected onto tracing paper.

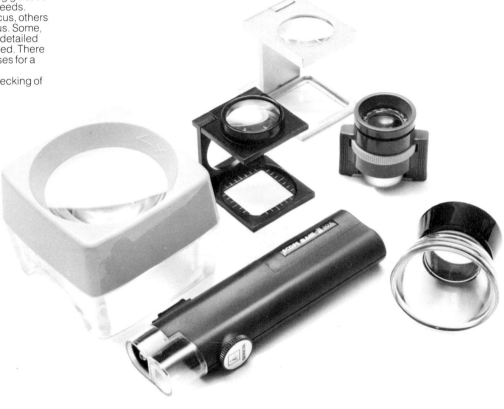

Below There are different types of magnifying glasses to meet different needs. Some are fixed focus, others have variable focus. Some, designed for very detailed work, are illuminated. There are a number of uses for a magnifying glass, particularly the checking of registration.

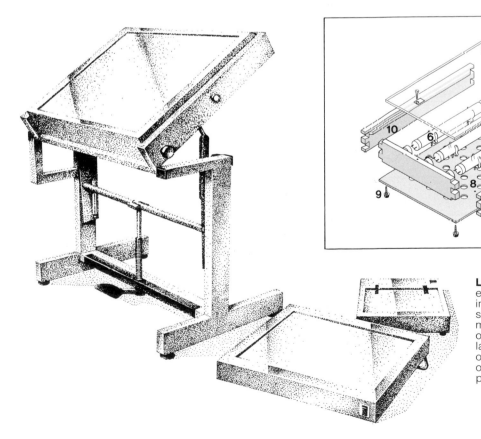

Left Construction of a lightbox.
1. Retaining screw and metal plate.
2. Frosted perspex.
3. Starter motor.
4. Daylight fluorescent tubes.
5. Dovetailed wooden sides.
6. Clips to hold tubes.
7. Switch.
8. Ventilation holes in wooden base.
9. Rubber feet
10. Fillet to support perspex.

Left Lightboxes are useful, especially if you are intending to cut photo stencils. If you do not want to make your own you can buy one. They vary in size, the larger ones being mounted on their own stands. Smaller ones are designed to be placed on a table or bench.

Inks

Ink in its simplest form is a coloured pigment or dye mixed in a fluid which is known as the vehicle. This forms a homogeneous mixture that can be applied to the substrate from a pen, character or printing plate to leave a coloured impression. The blending and selection of the vehicle and pigment is a complicated operation as some pigments disperse easily in the pigment to give even, homogeneous mixtures, while others require long milling times in rolling mills to produce good dispersions. The wide range of properties, both of pigments and vehicles and their varied interactions makes the manufacture of ink for printing a specialist operation not really suited to the amateur. The principal materials used in ink manufacture are pigments and dyes, vehicles and varnish, antioxidants and driers.

Pigments and Dyestuffs

Pigments are insoluble coloured materials. Some of them are found naturally, such as sepia which comes from the cuttle fish. Others are manufactured commercially. The actual hue and brightness of a pigment depends upon the amount of light which it absorbs and which it reflects. In addition, the colour of the ink laid down on the paper is a function of its colour strength, the shape and size of the pigment particle and the degree of dispersion of the pigment in the vehicle. Pigments which are used for printing should be resistant to water, acids, alkalis, and organic solvents. Dyes are coloured compounds which have solubility in the vehicle or the solvent which is used to make the ink. They have a high purity of colour and give transparency to the ink. Sometimes they are used to tone inks as in the case of the blacks. This toning results in blacks acquiring certain tones such as blue-black, green-black or slate-black.

Pigments come in a wide range of vivid hues. To convert them into ink they must be mixed with some type of vehicle. The vehicle is the liquid component of the ink and determines how the ink flows and its drying properties. It also binds the pigment to the substrate.

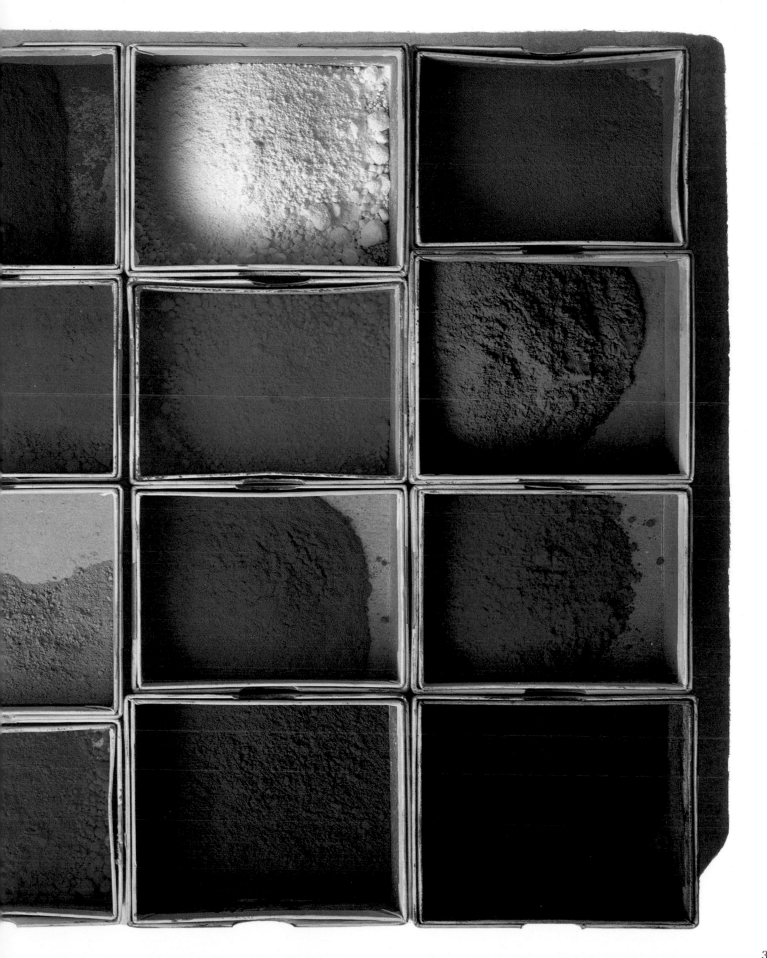

Vehicles and Varnish

The ink vehicle is the liquid component of the ink in which the pigment or dye is dispersed. It therefore determines the manner in which the ink flows as well as its drying properties. It is also the adhesive component which binds the pigment or dye to the surface of the substrate.

For quality printing the ink must dry hard, to prevent smudging. The importance of this can be seen in the use of non-drying mineral oil as the vehicle in the ink used to print newsprint or other absorbent materials. Even after several days the oil does not dry and the print can be smudged. Chemically treated natural oils and resins are used and set sufficiently hard to prevent smudging and offsetting. The majority of these vehicles are based on chemically modified rosins. The terms resin and rosin are, incidentally, commonly misunderstood. Resin is an organic chemical, solid or semi-solid material which can be used as an ink vehicle. Rosin, on the other hand, is one particular resin, being the product remaining after the turpentine has been removed from the gum rosin which is found in certain pine trees. Glycol derived vehicles are used for certain speciality water set inks. The glycol in the water causes the dissolved resin to set with the ink pigment.

Varnish, from the ink manufacturer's point of view, can have two specific meanings. It can be a vehicle which carries pigment and when it is used for this purpose it is simply an ink vehicle. Alternatively, it can be a clear resin applied over an entire area or surface in order to protect it from damage. Though clear varnish is applied as a protection it is used mainly as a means of increasing the aesthetic value of the image by making it stand out by its gloss appearance. The natural varnishes, based on shellac, are described according to their degree of transparency and lack of colour. Synthetic polymeric materials are also available. Polyurethene is one such varnish and is a near colourless material which gives a hard, relatively impervious layer. When varnishing images, only the clearest and lowest coloured varnish should be selected.

Antioxidants, Driers and Plasticizers

Antioxidants are added to inks in order to stabilize them and stop them hardening in their containers. Driers are blended into inks to increase the speed of drying of the ink. Plasticizers are chemicals which control the thinness and thickness of inks.

Ink Drying Mechanisms

For quality printing, using relief and planographic techniques, the ink dries and sets mainly by oxidation of the vehicle, though there is a slight penetration of the vehicle into the paper. The vehicle reacts chemically to produce larger molecules which eventually form a skin and set solid to give a hard film. With gravure inks the pigment and resin are dispersed by solvent and the principal method of drying is due to the evaporation of the solvent, leaving behind the pigment and traces of resins to body the ink. The solvents are normally inflammable hydrocarbons. For the intaglio process based on engraving, the ink has a butter-like consistency and the resins which act as the binder are dissolved in a solvent which has a high boiling point so that the initial stages of drying are by evaporation. After a longer period the resin in the ink sets.

Types of ink

Relief Inks

The quality of relief inks varies widely. One type is newsprint ink which uses a non-drying oil as the ink vehicle. It therefore takes a long time to dry and even after a few days it can be smudged. Another type is jobbing ink which is used for printing such things as hand bills, programmes and invitations on platen presses. A further type is a quick setting ink which produces a hard film on the paper surface and does not penetrate it. The

Varnishes are used to protect the surface of the substrate and to give the image a glossy appearance. Natural varnishes are based on shellac; synthetic polymeric materials such as polyurethane are also used. Only the clearest varnishes should be employed. Resin can be used as an ink vehicle and comes in solid or semi-solid form.

effects produced thus range from a dull print to a high finish appearance. All these inks are viscous but nevertheless have the property of flowing and can be worked out by rollers.

Lithographic Inks

The ink film deposited on the substrate from the lithographic printing plate is thin in comparison to inks used for, say, relief or screenprinting. This ink must have, therefore, a high tinctorial value or colour strength. It is very viscous but must be able to be rolled out. The formulation of the vehicle can be altered to produce a matt or gloss finish.

Gravure (Commercial) Inks

Gravure ink is light and mobile compared with the thick, viscous consistency of both relief and lithographic inks. The ink is a combination of a pigment and a solvent, frequently xylol, in which is dissolved a binder. The binder, after the solvent has evaporated, must retain the pigment and set into a hard, non-tacky material on the substrate. Binders vary from modified natural resins to synthetic binders based on vinyl polymers, or lacquers such as nitrocellulose. The choice of

binder is influenced by the substrate so that these inks are designed individually for specific substrates. One characteristic of all of them is that they contain no hard particles which would damage the gravure ink cells.

Engraving Quality Inks (Intaglio)

These are thick, greasy inks somewhat similar in composition to lithographic inks. In place of the mobile solvent xylol, however, they use a solvent with a high boiling point, hence the drying time is somewhat slower. The ink appears on the paper as a thick film and is raised up from the surface.

Screen Inks

Screen inks are soft and are pressed through a screen with a squeegee. The ink needs to be of such a consistency that it can flow easily.

Process Inks

These are standard inks suitably formulated for the three printing processes to enable illustrations to be produced in colour by the halftone reproduction process. The colours are standardized: yellow, magenta, cyan and black.

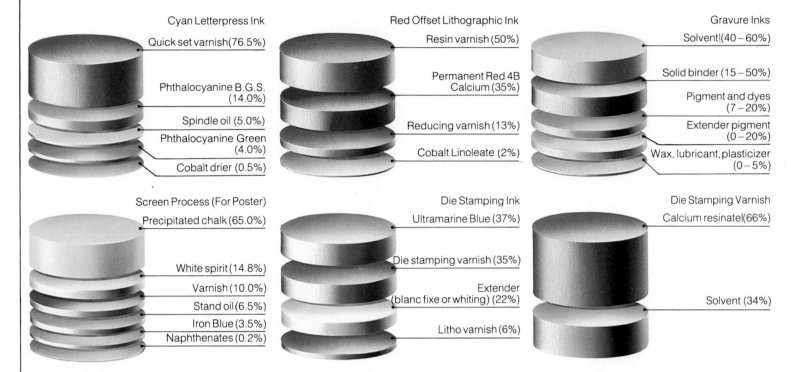

Cyan Letterpress Ink
Quick set varnish(76.5%)
Phthalocyanine B.G.S. (14.0%)
Spindle oil (5.0%)
Phthalocyanine Green (4.0%)
Cobalt drier (0.5%)

Red Offset Lithographic Ink
Resin varnish (50%)
Permanent Red 4B Calcium (35%)
Reducing varnish (13%)
Cobalt Linoleate (2%)

Gravure Inks
Solvent (40–60%)
Solid binder (15–50%)
Pigment and dyes (7–20%)
Extender pigment (0–20%)
Wax, lubricant, plasticizer (0–5%)

Screen Process (For Poster)
Precipitated chalk (65.0%)
White spirit (14.8%)
Varnish (10.0%)
Stand oil (6.5%)
Iron Blue (3.5%)
Naphthenates (0.2%)

Die Stamping Ink
Ultramarine Blue (37%)
Die stamping varnish (35%)
Extender (blanc fixe or whiting) (22%)
Litho varnish (6%)

Die Stamping Varnish
Calcium resinate (66%)
Solvent (34%)

High Gloss Inks

These are formulated so that the vehicle and varnish will remain on the surface of the paper during drying. As a result, the ink has a brighter colour and gloss. The effect is that the ink appears to stand out from the paper in comparison with an ordinary matt finished ink – hence their use in advertising, where strong visual impact is important. These inks are only suitable for coated and art papers.

Quick Setting Inks

These inks are designed primarily for letterpress and dry offset printing. They set by a combination of coagulation and absorption. They are used for high speed printing.

Metallic Inks

In these inks the pigment is replaced by fine metal powders thereby producing a very high lustre and brilliance to the printed surface. Aluminium, bronze and copper metal powders are used normally. Bronze powder is used to imitate gold. The tarnishing of metallic inks is a possibility, especially if the metal is copper-based and is exposed to a polluted atmosphere. Likewise, care is required in formulating these inks so that the chemicals used do not react with the powdered metal.

Watercolour Inks

The main artistic use of these inks is in the production of watercolour paintings and in the printing of wallpapers. They are formulated so that they can be printed from relief plates or rubber or polyvinyl rollers. They give clean, bright matt colours. The formulation is based on mixtures of

Above Typical ink formulations with ingredients shown in percentages.
Right There are many drawing inks available. Rotring inks are suitable for technical pens and come in a variety of colours. Other drawing inks can be used with brushes or mapping pens.

gum arabic and dextrins in glycols along with the pigment. The finished prints are sensitive to moisture. Watercolours can be used to make vegetable prints or for transparent effects when you are working with wood blocks.

Inks for Beginning Printing

Water-based printing inks are the best inks to buy when you start printing. Obtainable at any good art suppliers, they usually come in tubes and are easy to manage. They can be used straight from the tube or can be diluted with a little clean cold water to obtain a better working consistency. Squeeze out just the amount you need, and make sure that your palette is clean. These inks have many advantages, and it should not be imagined that they are just for beginners. They are non-toxic, come in a range of good colours and wash off rollers, palette, palette knives and working surfaces easily with cold water. Working clothes can also be cleaned with soap and water. Water-based inks should not be used on paper that is printed damp or used to print fabrics – they will run during printing.

Storage

You should store inks in sealed tins away from the excesses of heat or cold in a well ventilated store. If you have partially used tins of relief and lithographic inks, the ink should be levelled off using a palette knife and covered with greaseproof paper before the lid of the container is tightly closed. This will ensure that no skin forms. Water-based inks should not be allowed to freeze. Solvent-based gravure inks should be stored away from sources of ignition and kept in well ventilated areas.

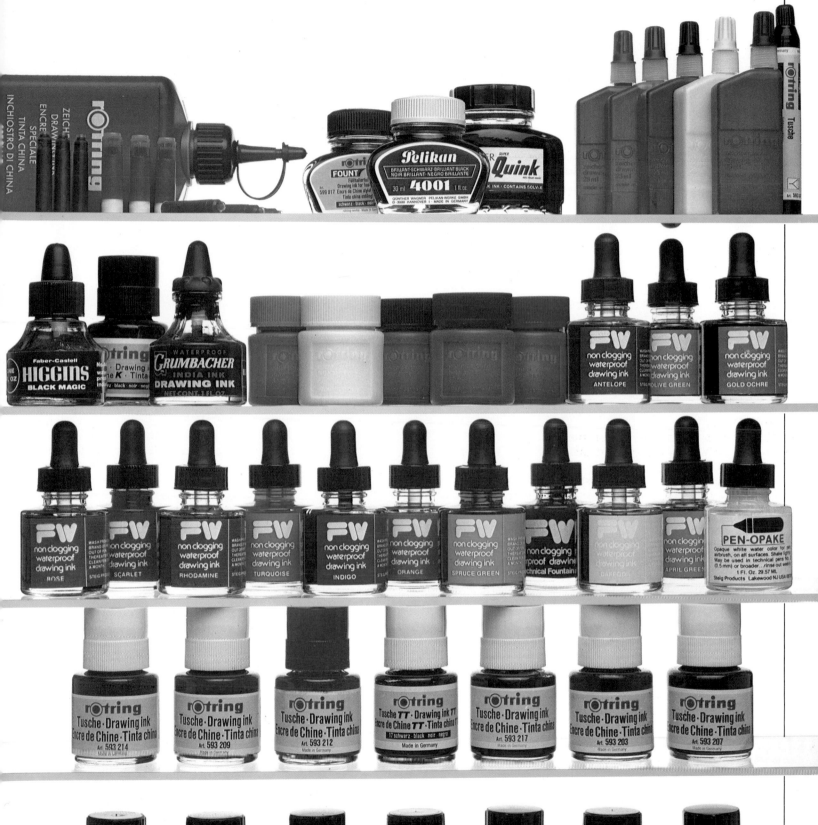

Safety

In normal operating conditions there is little hazard from fumes when using the common relief, lithographic or engraving inks. The solvents in the ink vehicles are high boiling point materials and produce small quantities of fumes which do not reach hazardous levels.

For the solvent-based gravure inks the situation is different. The solvent forms a high proportion of the ink formulation so it can give rise to fumes and care is required to ensure that there are no sources of ignition. Some of the hydrocarbons such as toluene and xylol used in gravure ink are toxic and the working area should be well ventilated and the concentration of the fumes should not exceed the T.L.V. (Threshold Limit Value) for the chemicals. This is a health measurement and is the concentration of the chemical which a person can stand when in contact with the chemical over a working week without detriment to health. It is expressed for gases in parts per million of air. Local authorities and the fire authorities may have local byelaws as to the use and storage of solvents found in gravure inks, and these should be complied with since they can affect insurance of the premises. The disposal of materials, including both solid and liquid waste, is important and may likewise be covered by regulations and byelaws. Solvent waste, whether from inks or machinery cleaning, should be collected for disposal by the council or a private contractor. Solvents should be stored in steel drums.

Papers and Other Printing Surfaces

A wide selection of papers is useful for beginning to experiment with prints. One of the cheapest and most suitable forms of paper to begin with is duplicating paper. It comes packed in boxes, is easy to handle and store, and can be bought already trimmed in various sizes and colours of stock. Newsprint (newspapers), magazines, wrapping papers, tissue papers, pads of cartridge paper, typography paper, tracing paper and layout paper all produce good prints. Pads of paper are relatively inexpensive, come in a range of sizes and paper weights (thickness) and again they are easy to keep clean and store. Inexpensive medium-weight rice paper takes a print beautifully. Usually made in Japan, it is available at most art suppliers.

More expensive papers, especially handmade printing papers, are also available at art suppliers, but until you become more experienced and skilful, the cheaper ranges will be more than adequate.

For other printing surfaces try using thin plywood, hardboard, canvas, hessian, white linen, cellophane, white card, laminated plastics, and even white surfaced corrugated board. Ex-

Above 1777 woodcut illustrating the various stages in hand papermaking.

perimenting with unusual surfaces will often produce surprising and pleasant results, but avoid using papers with a smooth, hard, shiny finish. This type of surface will repel both water-based and oil-based inks, and under pressure the inked block or plate may skid, giving a blurred image.

Paper-Ink Relationship

An understanding of how paper influences the accuracy and appearance of the final print is essential for successful printmaking. Art work is produced on any substrate by many forms of colouring; painting and printing are two examples. Each has its own distinctive characteristic and appearance which can be altered to some extent by the substrate.

In printing, the colouring matter is a coloured pigment mixed with a transparent oil or synthetic resin together with chemicals to aid drying and control viscosity. When applying the ink to the paper there are some general rules to be taken into account. A rough white paper will make a weaker, duller print with less apparent detail than a smooth white sheet. It is impossible to recreate the great brilliance of transmitted light even with transparent inks due to the double filtering of the light as it passes to the paper surface and is then reflected back through the ink. Coated papers are the best for this situation. The use of tinted paper for a particular job will influence the ink colour, and any halftone will alter colour too. Paper is frequently criticized for poor print results, but in many cases it is the choice of the wrong paper for a particular job that causes the trouble. If the paper quality is correct for the work in hand and inks have been selected accordingly, then the problems should be much reduced.

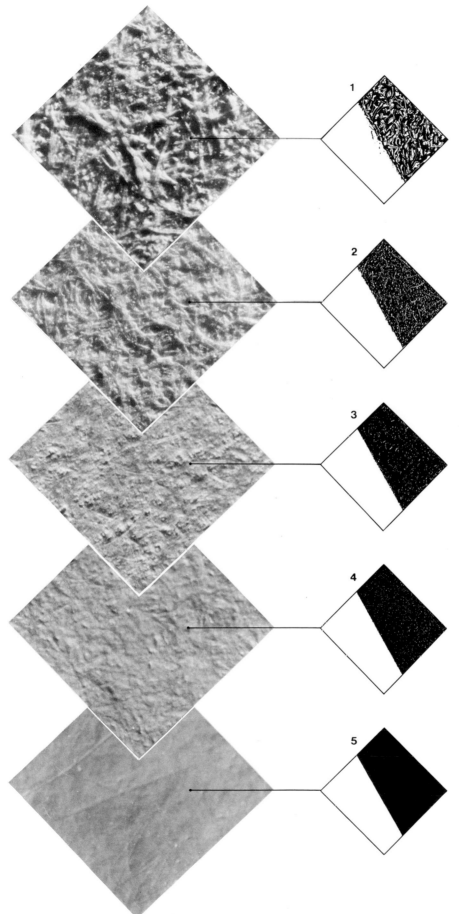

Paper Manufacture

The raw material of papermaking is derived from cellular plant matter. All plants in theory can be processed to give fibres but taking economic and technical considerations into account, very few are commercial propositions. The process of preparing the fibres for papermaking from plant sources is known as pulping, and it can be either a chemical or mechanical process or a combination of both.

These pulps are the raw materials for the papermaker to convert into paper. This he does by treating the fibres by mechanical processes to alter their length, their physical state, fibrillation and their water content. This stage is referred to as stock preparation. At this point, chemicals are frequently added, such as dyestuffs and mineral loadings, which alter the opacity and smoothness of the sheet, and chemicals which control water penetration, known as sizing agents. This slurry of fibre and chemicals is then passed forward to a drainage device: the mould in hand papermaking or the wire – a moving woven belt of metal or plastic wire woven into a sieve – for machine-made papers. It is at this stage that the fibres intermesh and begin to arrange themselves into a mat of paper, which is subsequently pressed and dried.

The final operations to produce the finished sheet of paper are carried out in the finishing end of the mill. Here, special effects can be produced, such as the putting of gloss on the paper by calendering which is a manner of friction glazing.

It is clear that due to the variations of fibre, and the different means of processing at the pulp making, stock preparation and papermaking stages a vast number of qualities can be achieved.

Handmade Papermaking

Only cellulose fibres can be used to make traditional paper and these are found either as textile wastes or in plants. In industry the plant materials are boiled with chemicals to free the cellulose

Left Surface microphotographs of different types of paper. The smaller diagrams show the effects of the texture of the paper on the ink when printing takes place.
1. Newsprint.
2. Cartridge paper.
3. Super calendered uncoated paper.
4. Art paper.
5. Cast coated paper.

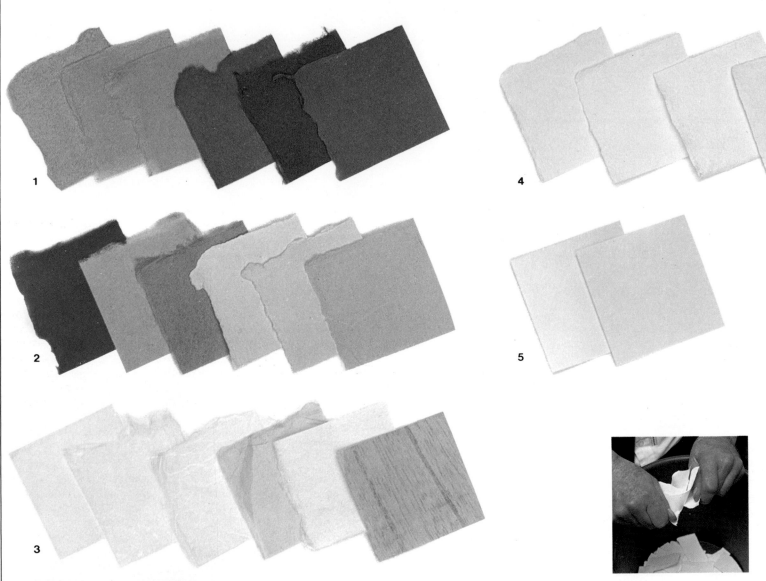

1

2

3

4

5

Papermaking 1. Scrap and waste paper can be used to form the pulp for hand papermaking. Shred the paper and soak it overnight, just covered with water. Note the weight of paper and water used.

Above The main types of moulds for hand papermaking are wove *(left)* and laid pattern *(right)*. The characteristic of laid pattern paper is the parallel lines in the mesh which indent the paper.

fibre and these are then bleached. The chemicals are strong and are very corrosive in the concentrations used to process the plant matter. Pure cotton or linen textile waste is difficult to come by for it must not contain any synthetic matter such as nylon or rayon. The simplest procedure is to buy small quantities of commercial bleached wood pulp or cotton linter as the source of the fibre. If scrap rag textile is used as the pulp, then it must be cut into small pieces and boiled in a stainless steel vessel for about five or six hours with 5% sodium carbonate solution to clean the fibre and begin to break down the cloth into threads, before the stock preparation stage. Adequate washing to remove the alkali is also required. For safety, protective goggles and gloves are advised at this stage.

Stock Preparation
The boiled rag will not have completely broken up into threads, and even if it has, then these must be cut down to a size appropriate to papermaking, about 3mm/¼ inch long. This can best be done by using a sink disposal unit mounted in a frame

7. Turn the paper out of the mould on to a piece of felt. Hold the mould at one end of the felt, drop it down flat to release the paper and pull it quickly up from the felt at the other end.

so that the cellulose material is fed into the feed mechanism and churned around the system until it is broken down to the correct size.

In theory, household liquidizers will do, but the majority are grossly underpowered for this work and the electric motor soon burns out. The more powerful commercial liquidizers do work, but even then it will take a long time to break down the threads.

Pulp

The pulp is then mixed with water and turned into stock. The final concentration of the stock should be in the range of 1% – 2%, i.e., one to two parts fibre to 98 – 99 parts water. The pulp is milled for at least five minutes or more to work the fibre so that it will produce a stronger sheet, the longer the milling the stronger the sheet and the more even its texture. The milling is best done in a heavy commercial liquidizer.

Sheet Forming

A suitably sized vat to accommodate the forming mould is required and this is filled with a mixture of the milled fibre and water at a consistency of 0.5 parts fibre and 99.5 parts water. This consistency can be varied slightly by personal experimenta-

tion as this factor influences sheet thickness as well as the texture of the final sheet. Generally speaking the more dilute the stock, the more even will be the sheet.

After gentle agitation of the fibre and water the mould is dipped vertically into this vat, then turned through 90° before raising it through the liquid and fibre firmly and gently so that it breaks the surface. A slight twist and shake at this stage helps the fibre to orientate itself and encourages drainage. After drainage of the water from the mould the sheet is turned out of the mould and is couched onto a bed of woollen felts. Couching is the pressing of the damp sheet onto the felt to transfer it to the felt. A stack of felt, paper, felt is built up before being placed into a hand press to squeeze out more water. The felt is removed, the sheet gently lifted off the felt and hung over a line or laid down on clean white blottings to dry.

When dry, the sheet can be sized by immersion in a gelatine solution or the gelatine solution can be brushed over both sides. The sheet is then dried though great care is required at this stage to ensure that the gelatine treated sheets do not come into contact with materials which could form an adhesive bond between paper surface and the drying support.

Left The range of papers which can be used for printing is enormous. A small sample is illustrated here. All of them are handmade and deckle-edged.
1, 2. A range of coloured papers.
3. Papers incorporating decorative grain.
4. White papers variously textured.
5. Papers with shiny surfaces. They are usually coated with china clay.

2. Put the soaked paper into a liquidizer and add a measured amount of water – enough to ensure that the machine will work smoothly. Liquidize the paper until it forms a pulpy mass.

3. Pour out the pulp into a plastic bucket or other suitable storage vessel.

4. Measure out a quantity of pulp and pour it into a large vat of water. The proportion of fibre to water in the vat should be ½ :99½ so it is important to have noted weight at each stage of the process.

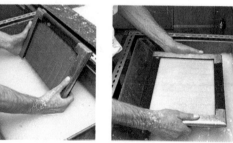

5. Stir up the water in the vat to distribute the pulp. Plunge the paper mould into the vat and immerse it completely in the pulp solution.

6. Bring the mould out of the vat in a horizontal position so that the water drains away leaving an even layer of pulp in the mould. The process of filling the mould should be done in one smooth, quick action.

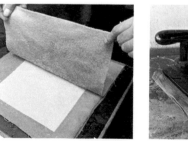

8. Lay another sheet of damp felt over the paper. Repeat the process if more than one sheet is being prepared.

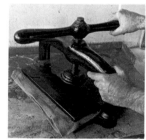

9. Put the felt sheets containing the paper into a press and apply heavy, even pressure to squeeze out the surplus water.

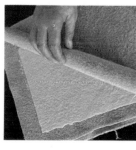

10. Take out the felts and roll back the top layer to expose the sheet of paper.

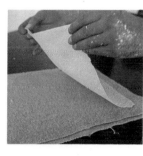

11. To lift the paper hold it by the top corners and peel it gently away from the felt. The paper is still damp but quite strong at this stage.

12. Lay out the paper completely flat on a sheet of blotting paper and let it dry naturally. It can alternatively be dried in a small photographic print drier. Finally, brush a coat of size over the paper.

Relief – Coarse Line Etching and Text

Quality	Size (mm)	gm^{-2}	Furnish	Characteristics	Remarks
Handmade	570 x 785 570 x 790 510 x 640 510 x 760 590 x 710 510 x 710 560 x 780	72-610	Rag Rag and chemical wood pulp	Smooth. Hard surface, no grain.	Three finishes: ROUGH – 'Mould finish'. NOT – Intermediate between rough and H.P. HOT PRESSED (H.P.) – Tough, strong papers with no grain. Often tub-sized with gelatine. Finest texture of all papers. These papers are all expensive.
Mould Papers	560 x 760 572 x 775 various derivatives of crown imperial 650 x 1000	50-410	Rag Rag and chemical wood pulp Chemical wood pulp	Hard surface, grain.	Finished in three finishes similar to handmade. These papers are machine-made and have grain. They are expensive.
Featherweights	Derivatives of SRA1 RA1	60-70	Mechanical wood pulp	Has compressibility, rough surface, off-white cream colour.	Not permanent, discolours and becomes brittle. Inexpensive.
MF Wood-Free	Derivatives of SRA1 RA1	70-105	Chemical wood pulp	MF finish. Most are multi-purpose papers suitable for all types of printing.	Usually medium sized. Whites are tinted. Inexpensive.
S.C. Wood-free Printings	Derivatives of SRA1 RA1	70-105	Chemical wood pulp	Slightly less absorbent to ink than MF finish. Lower gloss than imitation art and art paper. Even formation.	Usually medium sized. Inexpensive.
Antique Laid	Derivatives of SRA1 RA1	85-115	Esparto and chemical wood pulp Chemical wood pulp	Best qualities have compressibility. Good ink absorbency. This is good paper for a wood block printing, and comes in various textures. Bulky and opaque.	Tinted or white. Laid water mark. Best qualities have a rough surface and are soft. Chemical wood pulps give a more rigid paper and surface. They are relatively expensive.
Antique Wove	Derivatives of SRA1 RA1	85-115	Esparto and chemical wood pulp Chemical wood pulp	As for Antique Laid.	Tinted, white, no watermark, slightly smoother surface to laid quality. They are relatively expensive.

Relief – Fine Line Work

Quality	Size (mm)	gm^{-2}	Furnish	Characteristics	Remarks
Art Paper	Derivatives of SRA1 RA1	95-170	Chemical wood pulp	White, smooth, calendered surface. Ink absorbency controlled. Calendering can affect this property. Good surface strength. Clean surface.	Clay adhesive surface calendered to give a high gloss surface. Can be found in an embossed finish, eg. linen finish. Ideal for halftone reproduction. Relatively expensive when compared with uncoated papers.
Matt Coated Art	Derivatives of SRA1 RA1	115-135	Chemical wood pulp	Coated surface but not calendered, hence matt finish.	Due to lack of calendering some qualities have a weak surface and the printing ink will smudge easily, and dry slowly. Relatively expensive when compared to uncoated.
Cast Coated	Derivatives of SRA1 RA1	70-210	Chemical wood pulp	Soft glass-like absorbent surface.	Glass-like finish, easily scratched, and requires special inks. White, tinted, metallic finishes. Expensive.

Handmade, Mouldmade, M.F. Wood-free Printing *See coarse line etching*

Intaglio – Engraving

Quality	Size (mm)	gm^{-2}	Furnish	Characteristics	Remarks
Handmade	570 x 785 560 x 790 510 x 640 395 x 520 510 x 710 450 x 590 510 x 760	72-610	Principally rag Some mixed rag and chemical wood pulp	No grain direction. Frequently tub-sized with gelatine.	Three finishes: ROUGH, NOT, HOT PRESSED (smooth). For engraving, paper should not be too hard-sized. Laid watermark paper also available. Expensive.
Mouldmade	Similar to above. Derivatives of Double Crown and Imperial sizes.	50-410	Rag Rag and chemical wood pulp	These papers have grain.	These are machine-made papers of high quality, and similar to the handmade. Laid watermark available. Slightly less expensive than handmade.
M.F. Wood-free Printings	Derivatives of SRA1 RA1	70-105	Chemical wood pulp	Standard printing papers. Usually MF finish.	Must not be hard-sized for engraving. Inexpensive.

Lithographic Papers

Quality	Size (mm)	gm^{-2}	Furnish	Characteristics	Remarks
Art Paper	Subdivision of RA0 SRA0	105-135	Chemical wood pulp	Coated with mineral and adhesive then super-calendered.	Especially suitable for halftone reproduction. Dimensionally stable quality required. Relatively expensive.

Lithographic Papers/cont.

Quality	Size (mm)	gm^{-2}	Furnish	Characteristics	Remarks
Cartridges	Subdivision of RA0 RA1 SRA1 and of A sizes	95-170	Chemical wood pulp	Papers with measure of dimensional stability, and good surface strength. One of the commonest papers used for lithographic printing. Frequently starch surface sized.	Wide range of finishes: rough, drawing offset, coated. Twin-wire smooth on both sides. Can be white or tinted. At low grammages paper is similar to a wood-free printing. Coated cartridge has a very thin layer of pigment bound to surface. Reasonably expensive to inexpensive depending on quality.
M.F. Wood-free White Printings Multipurpose Printings	Subdivision of RA0 RA1 SRA0 SRA1	70-105	Chemical wood pulp	Similar in characteristics to cartridge.	Wide variety of shades of white and some are tinted. Dimensionally stable quality needed. Inexpensive.
Handmade	See Relief and Intaglio				
Cast Coated	See Relief				

Kraft Papers

Quality	Size (mm)	gm^{-2}	Furnish	Characteristics	Remarks
M.F. Pure Kraft		80-150	Chemical wood pulp	Strong wrapping paper.	Can be used for marbling. Can also exist as a bleached quality. Reasonably expensive.
M.G. Kraft		80-150	Chemical wood pulp	Strong wrapping paper.	Glazed on one side, frequently a ribbed pattern also, quality is then M.G. ribbed kraft. Reasonably expensive.
M.G. Imitation Kraft M.G. Ribbed Imitation Kraft		80-150	Chemical wood pulp plus waste paper and/or mechanical pulp	Weaker than pure kraft, dyed to a brown colour. M.G. quality normally found, glazed and also frequently ribbed on one side.	Normal wrapping paper. Inexpensive.
Union Kraft		135-165	Chemical wood pulp	This is a bitumen laminate.	Waterproof wrapper. Reasonably expensive.
Polyethylene Coated Kraft		120-165		Polyethylene laminate on one side.	Waterproof wrapper, cleaner looking than Union Kraft. Expensive.

Paper Storage

The influence of temperature, humidity and light on paper is crucial. Changes in the moisture content of the paper due to absorption and de-absorption can cause problems of curl, cockle, wavy edges and tight edges in a stack of paper, purely as a result of the uneven stretching and contraction of the fibres within the sheets. These changes inevitably cause strains to build up in the paper. When this happens, there will be feeding problems in the press and the paper will not register correctly to the printing surface or plate. This is a serious problem in the case of multi-colour printing.

A wavy edge is produced when moisture from the air surrounding the paper condenses on its surface; a tight edge is the result of moisture evaporating from the edge of the paper. These two conditions will give rise to difficulties in printing geometric shapes. Overdry paper could cause feeding problems.

To avoid these problems, paper must be stored in such a way that temperature and humidity variations are kept to a minimum. The paper should be stored in its original wrapping, away from sources of heat such as radiators, and away from draughts from windows and doorways. If at all possible, the paper should be allowed to stand, or hung in the studio several hours before use, to condition it to the room's atmosphere.

Choice of Paper

The choice of papers for the different printing processes is summarized in the table. All the papers itemized in the tables can be used for screenprinting; slight ink modifications may be required to suit the absorbency of the paper.

Speciality papers include embossed boards and Japanese papers. Embossed boards, patterned in a variety of textures, can cause problems in printing because of the design indentation. Japanese papers come in a wide range, from almost transparent in quality to thick and bulky varieties. Many are purely decorative and contain dried material. Most are made from long fibres, frequently paper mulberry, gampi, mitsumata and bamboo.

General Printing Procedures

For most printing projects the general procedures are very much the same.

First, cover the working surface with a thick layer of newspapers. Later these papers can be rolled up and disposed of when the printmaking session is over. The ink mixing palette should be spotlessly clean and positioned close to the edge of the work surface so that you can roll out the ink easily. Printing inks and solvents should also be close at hand, together with spatulas or palette

Industrial papermaking
Paper is mainly composed of cellulose fibre, obtained from wood, rag or old paper (or a combination of these). The type of paper is determined by the nature of the fibre used.
1. Softwoods, such as pine, spruce and fir have a long fibre, which gives strength to the finished paper. They are grown extensively in Scandinavia.
Timber can be pulped chemically or mechanically. Chemical pulping produces higher quality paper but is less economical. Mechanical pulping is used for less permanent papers, such as those used for newspapers.
2. Before delivery to the mill or factory, the pulp is washed, screened for impurities, bleached and

then beaten to release a gelatinous substance which bonds the fibres together.
3. At the mill, fillers, sizing and dyes are added to the bales of fibre. China clay is the most common additive. It serves as a filler, improves the colour and opacity of the paper and is also used as a surface sizing for high gloss papers.
4. The pulp is broken down in the pulper where it is mixed with water to form a slurry called 'furnish', which has a certain percentage volume of fibre and water. The furnish is then broken down by more chemical and mechanical treatment.
5. The furnish is pumped to the 'wet end' of the system where it is diluted further and then moved to the flow

1

2

4

7

5

6

8

3

10

head or head-box.

6. The flow head feeds the furnish onto an endless, moving wire, which conveys it through a series of presses where most of the water is squeezed out.

7. It next moves to the drying section where it is dried by passing over hollow metal cylinders filled with steam.

8. The heat cylinders are mounted on a frame and surrounded with felts so the paper can move smoothly. The surface of the paper is then smoothed and finished under heavy chilled iron rollers, a process known as calendering. The more calenders or 'nips' the paper runs through, the higher the final gloss.

9. The finished paper is reeled up on bobbins.

When the roll reaches the required size, it is removed without interrupting the continuous web production process.

It can take less than two minutes for the pulp to pass from the flow head until the point where it emerges as finished paper. The end product is a continuous sheet known as a web. It can be used in reel form for web-fed printing or cut into sheets for a sheet-fed press.

10. High quality paper is often treated with fluorescing agents to increase whiteness. Exposure to an ultraviolet lamp checks how much fluorescence is present.

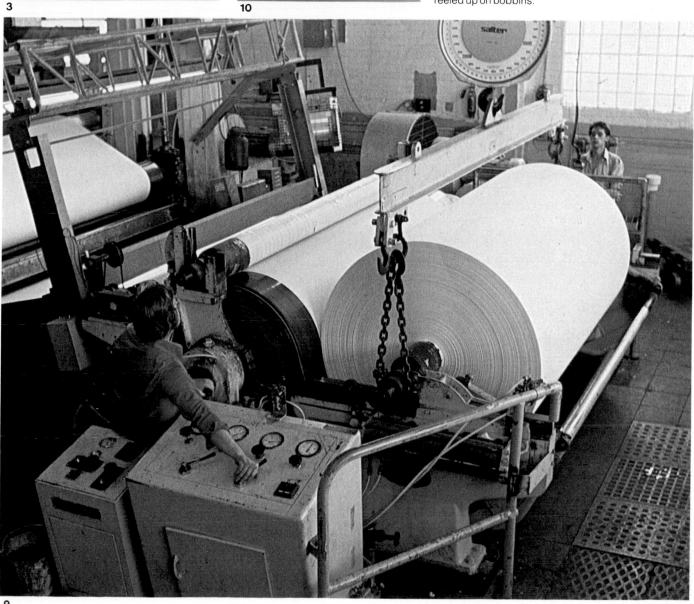

9

thirds

12mo

24mo

6to

folio (Fo)

octavo (8vo)

quarto (4to)

16mo

32mo

knives, and clean ink rags.

The printing table or press bed should be free from dust and covered with a fresh layer of newspaper. Carefully lay out and position the paper or fabric you intend to print on this bed of paper. It might be necessary to pin the paper or fabric down so that it does not move.

Use a palette knife to scoop out a small amount of printing ink from its container and place this in a top corner of the palette. If you want to lighten the colour of the ink, use white ink; to make a colour darker, add black, brown or deep blue ink. Dip the roller lightly into the printing ink and roll it backwards and forwards on part of the palette until the roller is evenly and completely covered. Now roll the inked-up roller lightly over the whole surface of the block or 'found' object you are going to print.

Lift the inked object and place it face down in the position you want the print to be on the paper or fabric. Press down as hard as you can. If the printing bed is on the floor (like the handmade press described previously), walk all over it. If you are working on a table surface, lean heavily on the block or even pummel it with a rubber mallet — making sure that the block does not slip.

When you think that you have applied enough pressure to make a clear print, lift the block straight up from the printing surface to avoid smudging. You will now be able to see the result of your printing.

Another method of working from a relief surface, such as a wooden block or lino cut, a method which allows you to control exactly where the weight of printing should be, involves placing the

1

2

Above Printing from a 'found' object.
1. A sheet of paper is laid on a plywood block. On top of this is laid a 'found' object which has been inked up. Then the printing stock, a blanket and another piece of plywood is laid on top.
2. Pressure is applied by burnishing with some hard object such as a spoon or a pebble.

block face up. Put the paper on top of the block and then, using your kitchen spoon as a burnisher, rub the paper gently all over until the image begins to come through. Rub fairly heavily over those areas that you want to be dark and strong, and lightly over those that should be lighter. Finally, peel the paper carefully away from the surface.

No matter which method of printing you use, the printing block, printing plate or silkscreen must be inked each time it is printed. Start experimenting by using a series of progressively lighter or graded prints from corner to corner, and move your blocks around to form patterns.

Print Drying Alternatives
1. Lay them out on clean paper in cupboards or shelves.
2. Pin the prints, using mapping pins, on to wooden battens running across the wall of your studio.
3. Pin the prints on a large sheet of soft board and stand it against a wall, or fasten it to the wall. (This is a good way of viewing a progression of colour prints.)
4. Peg the prints, using clothes pegs or bulldog clips to a simple wooden clothes dryer, with smooth flat slats.
5. Stretch nylon lines across the studio, without interfering with your working areas, and peg out the prints like washing. Pegs should be drilled with a small hole and threaded on the line so that they stay in place. If you have the space, two parallel nylon lines stretched from one side of the studio to the other, with threaded pegs, make an ideal print dryer.

<table>
</table>

British – untrimmed	ins	
Crown	15	x 20
Double Crown	20	x 30
Quad crown	30	x 40
Demy	17½	x 22½
Small Demy	15½	x 20
Double demy	22½	x 35
Quad demy	35	x 45
Foolscap	13½	x 17
Small foolscap	13¼	x 16½
Double foolscap	17	x 27
Quad foolscap	27	x 34
Imperial	22	x 30
Medium	18	x 23
Double medium	23	x 36
Post	15¼	x 19
Large Post	16½	x 21
Double large post	21	x 33
Royal	20	x 25
Double royal	25	x 40

American – untrimmed	ins	
Writings	16	x 21
Basic size – writings	17	x 22
Writings	17	x 28
Writings	18	x 23
Writings	18	x 46
Writings	19	x 24
Basic size – covers	20	x 26
Covers	23	x 35
Printings	24	x 36
Basic size – offset, book	25	x 38
Covers	26	x 40
Printings	28	x 42
Printings	30½	x 41
Printings	32	x 44
Printings	33	x 44
Printings	35	x 45
Printings	36	x 48
Printings	38	x 50
Printings	38	x 52
Printings	41	x 54
Printings	44	x 64

ISO A series – trimmed

	mm	ins
A0	841 x 1189	33.1 x 46.8
A1	594 x 841	23.4 x 33.1
A2	420 x 594	16.5 x 23.4
A3	297 x 420	11.7 x 16.5
A4	210 x 297	8.3 x 11.7
A5	148 x 210	5.8 x 8.3
A6	105 x 148	4.1 x 5.8
A7	74 x 105	2.9 x 4.1
A8	52 x 74	2.1 x 2.9
A9	37 x 52	1.5 x 2.1
A10	26 x 37	1 x 1.5
RA0	860 x 1120	34.4 x 44.8
RA1	610 x 860	24.4 x 34.4
RA2	430 x 610	17.2 x 24.4

German and Swiss – untrimmed

	mm
Véreinsdruck 1	500 x 760
Vereinsdruck 2	550 x 840
Vereinsdruck 3	640 x 940
Vereinsdruck 4	700 x 1000
Normal A1	610 x 860

Mixing ink 1. Scoop out small amounts of ink with a palette knife and place them at the top corner of the palette. (White ink will lighten the colour; black, brown or deep blue will darken it.)

2. Make sure the inks are thoroughly mixed so that the colour is even when you begin to print.

3. Spread the ink across the palette with the palette knife.

4. Lightly dip the roller in the ink and roll it backwards and forwards until it is completely covered. The roller is now ready for inking up the block or object you intend to print.

Relief Printing

A relief print is an image produced by transfer from a raised, inked surface to a sheet of paper or some other surface and it derives its name from the Italian word *rilievare* which means to raise. The plates are designed so that the white parts of the image are cut away leaving the positive design as a raised area which can then be covered with ink and transferred to paper. Relief prints can be taken from natural objects which have distinct textured surfaces such as wood, bark or leaves. Alternatively, they can be taken from surfaces which have been cut into or raised, and these include such varied techniques as woodcuts, wood engravings, linocuts, metal cuts and relief etchings.

The history of relief printing is really a series of histories of all the different techniques, evolved at quite separate times and fulfilling distinct needs. The woodcut is by far the oldest of all of them and it is thought to have been used as long ago as the fifth century in the Middle and Far East, principally for the decoration of fabrics. Woodcuts began to be used generally in Europe at the beginning of the fifteenth century and their appearance coincided with the widespread adoption of manufactured paper. Their importance was considerable because they offered a means of reproduction which was both quicker and cheaper than that of the hand-coloured drawing and they were used mainly for the production of devotional prints as well as more unholy items like book illustrations and playing cards. Many of these

The principles of relief printing A raised surface on a plate is inked with a roller before the printing stock is laid down on it. The stock and the plate are then pressed either by hand burnishing or with a mechanical press. The stock which will have received the image can then be peeled off.

Opposite *Blind Spaniard* (1958) by John Sewell. The key block has been printed in brown. Some details, such as the walking stick, are printed in black. Red and orange tints have also been incorporated and the brown key line has been deliberately suffused with the orange tint.

early woodcuts were merely linear and were designed to be coloured in by hand, the printed lines acting as boundaries between colours.

These primitive but nonetheless charming woodcuts gave way later in the century to more complete works by a number of artists in Germany, Italy and The Netherlands, all countries where the paper industry flourished. Hans Holbein (1497–1543) and Albrecht Dürer (1471–1528) in Germany, Lucas van Leyden (1494–1533) in The Netherlands, and Titian (c. 1487–1576) in Italy are prominent examples. Holbein, who worked as a designer for printers in Basel, produced some of his best work in this medium and his series of 51 plates, *The Dance of Death*, has a strong visual impact as well as considerable narrative power, despite the simple images so natural to the woodcut medium. The real delight of the woodcut was that it enabled images to be reproduced cheaply and easily. All the artist had to do was to draw his image onto the block and then hand it on to a skilled craftsman who would reproduce it faithfully. Woodcuts did, in effect, offer the first means of printing.

Because of the practical limitations imposed by the cutting of wood with a knife, and other factors, mainly associated with inferior inking and printing methods in use in the sixteenth century, the woodcut finally gave way to the more sophisticated techniques of intaglio.

In the nineteenth century, however, painters looked at the woodcuts, not merely as a means of

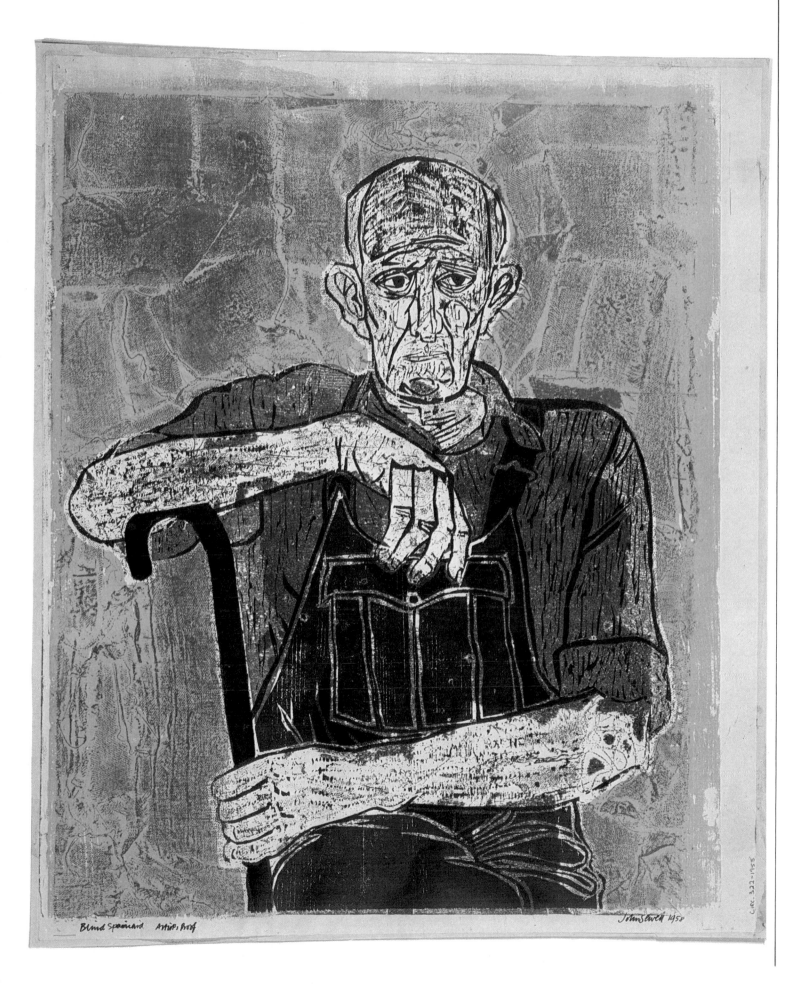

Blind Spaniard Artist, Proof John Stewart 1958

reproduction, but as a means of expression quite as valid in their own right as their paintings. Paul Gauguin (1848–1903) and Edvard Munch (1862–1944) were particularly involved in the revival of the woodcut. Unlike their predecessors they did not hand the working of the woodcut over to a craftsman and printer, but did all the work themselves, experimenting at every stage of the process. Gauguin altered and exploited the texture on the surface of the block and he lowered some areas fractionally so that they would pick up less ink and therefore transfer less to the printing paper. He varied the quality and quantity of his inks as well as the paper which he used and by these techniques produced highly inventive and individual prints. In the twentieth century, this experimental outlook was continued by a number of painters, notably Ernst Ludwig Kirchner (1880–1938) and Franz Marc (1880–1919).

The process of wood engraving derived from the woodcut block and differs from it in that the engraver cuts into the end grain rather than into the side grain and uses a burin instead of the woodcutter's knife and gouge, thereby obtaining a finer line and a better articulation of detail. The beginnings of wood engraving are by no means clear. It is unlikely, because of the skill required to manipulate an engraver's burin, that the process made its appearance earlier than did metal engraving and its past is made even more obscure because, in practice, the difference between a woodcut and a wood engraving is not always apparent. Often the two techniques were combined. It was for this reason that the French minimized the problems of identification by simply referring to both as *gravure sur bois* (engraving in wood).

At the end of the eighteenth century the technique of wood engraving was developed to such a pitch of sophistication that it became the chief method of making relief prints during the following century. The person who was mainly responsible for the development of the wood engraving was Thomas Bewick (1755–1828). He was a trained metal engraver and succeeded in establishing a school of wood engraving in Newcastle-on-Tyne. Through the subtle use of crosshatching he managed to achieve a wide range of tones and he developed other techniques which involved the lowering of specific areas of the block resulting in solid grey tones being printed alongside blacker ones.

By the 1840s the technique of wood engraving had developed into a highly skilled and flourishing profession both in England and on the Continent. It became a highly specialized art. Artists such as Sir John Tenniel (1820–1914), Charles Keene (1823–91), and Gustave Doré (1832–83) did drawings on wood blocks which were then sent to a wood engraver who prepared them for printing. It always remained a strictly reproductive medium, used mainly in book illus-

tration, and not an experimental one.

The Victorian weeklies like *Punch* and the *Illustrated London News* as well as books of all descriptions incorporated wood engravings. By the 1880s, however, photomechanical engraving techniques had superseded the production of wood engraved blocks for commercial printing. The techniques, however, did not die out altogether. In the 1920s there was a revival of wood engraving, especially as a means of illustrating books. Eric Gill (1882–1940), for instance, produced many prints and illustrations in books published by the Golden Cockerel Press.

The appearance of linoleum as a substitute for wood occurred around the beginning of the twentieth century. Two early exponents of the material were Henri Matisse (1869–1954) and Pablo Picasso (1888–1973). The latter used the method to produce a number of colour prints, notably the *Bust of a Woman after Cranach* (1959). Michael Rothenstein (b. 1908) has also made a considerable reputation as an exponent of the linocut and he introduced techniques during the 1960s for creating tonal effects.

Although there is plenty of evidence of engraving on copper plate going back as far as the fifteenth century most of it was black line engraving for making intaglio prints. There are, however, a number of examples of relief metal cuts. In Croxall's publication of *Aesop's Fables* of 1772 there are 196 oval-shaped illustrations cut in relief by a metal engraver thought to have been a certain Elisha Kirkall (1682–1742), a Sheffield man who worked in London as an engraver. José

Below *Mahana Atua* (*c.* 1894) by Paul Gauguin (1848–1903). This print is one of an edition of a hundred which was printed by Pola Gauguin, the son of the artist, in 1921. The texture of the wood grain has not been disguised but exploited in a manner which helps define the forms.

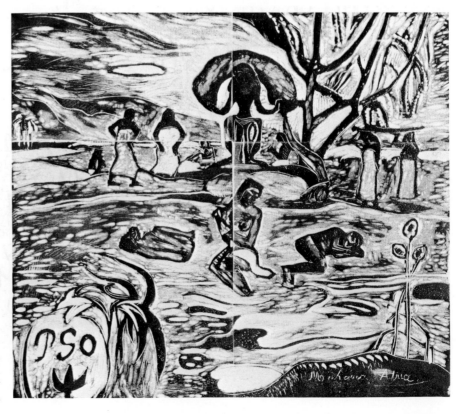

Left *Self Portrait* (1927) by Eric Gill (1882–1940). Gill, who was an adept master of the woodcut, dismissed the use of complex tonalities in favour of simple lines. The power of his illustrations was achieved through the boldness of the lines and forms and the style which he evolved was particularly suited to the medium.

Below *Primavera* (1890) by Timothy Cole (1852–1931). The composition is after Botticelli. The print was taken from a wood engraved block. Such intricacy, as can be seen in the floral designs, can only be achieved by engraving on an end-grain block.

Guadalupe Posada (1852–1913), a Mexican engraver, used relief engraving to produce satirical caricatures printed in Mexico City at the turn of the century.

Relief etching does not have quite so long a history. William Blake (1737–1827) is considered to have been the first person to use the method, one which involves etching away the non-printing areas of a copper or zinc plate to leave the required image areas standing in relief. These illustrations he combined with text. Notable examples include *The Book of Job* (1825) and *Songs of Innocence and Experience* (1789–94).

Relief etching has special attractions, particularly for the beginner. The linocut and the woodcut are reasonably easy to cut and the nature of the materials encourage simple designs. The technique must also attract those who like the striking, predominantly black image, while the woodcut itself has become particularly popular because of the textured surface of the wood which can be exploited in many varied and imaginative ways.

Below *Pilate Washing His Hands* (16th century, Italy). The intricate detail which might be expected in a metal engraving, is missing. Considerable effect has been achieved by the use of strong chiaroscuro.

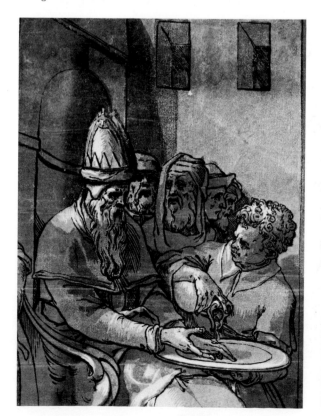

Linocut

In common with the woodcut, wood engraving and metal cut, the areas of the design which are not to print are lowered down by cutting away with hand tools. It is important to realize that the nature of linoleum, and this applies to the wood-cut as well, limits the amount of detail which can be incorporated into the design and so the medium is ideally suited to simple images. These limitations, however, can be of some value to the beginner. Linoleum is cheaper to use than either wood or metal and the design can be easily re-paired by cutting a replacement piece which can be glued back into the cut block. Because of the softness of the material it is easy to push the tools.

Begin by sketching out the design either direct-ly on to the surface of the lino or draw it onto tracing paper which can then be turned over so that the design is traced in reverse onto the sur-face. Paint in with white the areas which you are going to cut away and paint in black those areas which are to be left. This will give you a good idea of what the final print will look like. Bear in mind though, that you can make alterations to your design as you proceed with the cutting. It is im-portant that this guideline image should not be too elaborate, otherwise the design may appear too fussy when it is printed.

Above On the left is a piece of linoleum which has been cut and inked up. Those areas which are black are where linoleum has been removed while the areas which are brown are the relief surfaces which print. On the right is a print taken from the linocut.

When you are cutting the lino you need to be able to control the tools properly and this is made easier if the bench or table top is set at a comfort-able height and preferably at a slight angle to the body. During cutting you should rotate and move the block to facilitate the movement of the cutting tool as it is pushed through the material. A V tool and knife are used mainly to produce different thicknesses of line and for actually cutting around the contours of the shapes. Open areas are cut away to the base by using a gouge. Providing that the lino has a good thickness (something in the order of 6mm (¼ inch) it is quite easy to gouge out without damaging the canvas backing.

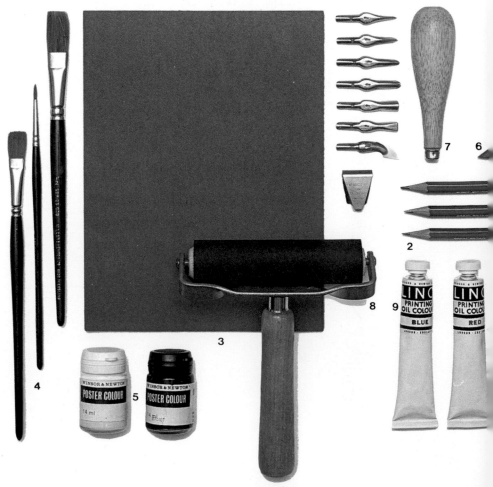

Drawing on lino 1. Degrease the surface of the block by wiping it with methylated spirits on a clean rag. Paint over the surface with a thin layer of white poster paint.

2. Place a sheet of carbon paper on the block and position the traced image over the top. Reverse the image so that it will later print the right way round. Draw over the tracing with a sharp pencil.

3. Anchor the tracing paper with adhesive tape at each corner. Peel back one corner to check that the drawing is clearly transferred to the block.

4. When the tracing is complete reinforce the design by painting over the carbon lines with Indian ink on a fine brush. You may prefer to draw freehand with the brush from the start, directly on the block.

Cutting lino 1. Use a small V tool to outline shapes and make fine cuts in the lino.

2. After cutting intricate shapes with the V tool use a gouge to clear broad areas.

3. To cut a broad line with straight edges first cut down the outline with a knife and then chip away small pieces of lino with a fine gouge, working towards the knife cut.

4. Cut fine, even lines with the V tool to 'draw' outlines or create areas of hatched tone and linear pattern.

5. When clearing large areas with a gouge, the cuts must be quite deep or the cut-away shape may pick up ink from the roller. Ease the tool from side to side if it sticks as it is pushed through the block.

6. Make areas of pattern and texture by chipping out small irregular shapes either with a gouge or V tool. The nature of the pattern depends upon the size and type of tool used.

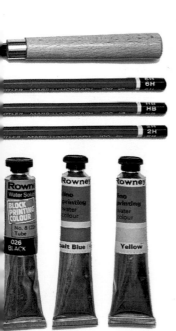

Left The list of equipment needed for doing a linocut is short. Tracing and carbon paper and pencils *(1, 2)* are used for transferring designs to the linoleum *(3)* Brushes and paints *(4, 5)* are for clarifying the design on the lino. A knife *(6)* and gouges *(7)* are needed for cutting the linoleum, while a roller and inks *(8, 9)* are used for printing. **Right** *Audley End* (1973) by Edward Bawden. (b. 1903). This linocut print was made using five blocks and five colours, one for each block.

Woodcut

Woodcuts are made on pieces of wood which have been cut from a tree so that the grain runs along the surface and these cuts are referred to as plankwoods or side grain. Almost any wood can be adapted for this purpose though sycamore, lime, pear, cherry and boxwood are the most popular. The last, which is very tough, is usually reserved for wood engraving. Secondhand furniture and demolition timber are also sources of material. If you are going to use recently cut wood you must make sure that it is properly seasoned and has been allowed a period of time in which to dry out and lose all its resin. Really any wood which has dried out and which is not warped is suitable for the beginner. Indeed, cheap offcuts are ideal for the beginner, for they allow him to experiment and take risks with the knowledge that he is not wasting expensive materials. It is not easy to produce a finished composition the first time that you tackle a woodcut so some time spent acquiring the basic skills involved in cutting a relief image will not be wasted.

The first job for you to do is to plane and sand the surface. How much you do will depend on the smoothness that you require. If you want to produce a finely textured print you will have to start with a piece of wood which is finely grained, but, on the other hand, you might be quite happy to incorporate highly textured grain in your print. If you want a very fine surface you will find that power tools help, especially if the surface is badly pitted or scarred.

The design can be drawn on directly, either with a brush and drawing ink, or by cutting the outlines directly with the knife. Alternatively, a drawing can be made on tracing paper and then transferred to the wood. If you are working with darkly stained wood you should do the transfer using a chalk paper or white carbon paper so the drawing will show up clearly.

A simple woodcut can be cut in the same way as a linocut, the lines which define the shapes being cut with a knife. After this you should employ the gouge chisel and the mallet, used together, to remove the non-printing areas so that the design is left in relief. When you are cutting you will find that the use of a bench hook, suitably modified with a system of holes and pegs, will enable the tools to be used safely. Generally speaking, you should avoid cutting large areas at a time and concentrate on taking out the wood little by little. Also avoid allowing the gouge to bite downwards deeply into the wood as this generally leads to the wood being undercut and then splintering. Where possible, cut with, rather than against, the grain, and initially take shallow cuts so that mistakes can be more easily repaired. Finally, take proofs at regular intervals so that you can check on the progress of the cut block and adjust your design accordingly.

Preparing a wood block
1. Wrap a sheet of sandpaper round a small block of wood and rub over the printing block to smooth out the surface.

2. An electrically powered sander is useful for preparing a large block or if the wood surface is unusually rough and grainy.

3. To bring up the texture of the wood grain pass a wire brush lightly over the surface of the block, following the direction of the grain.

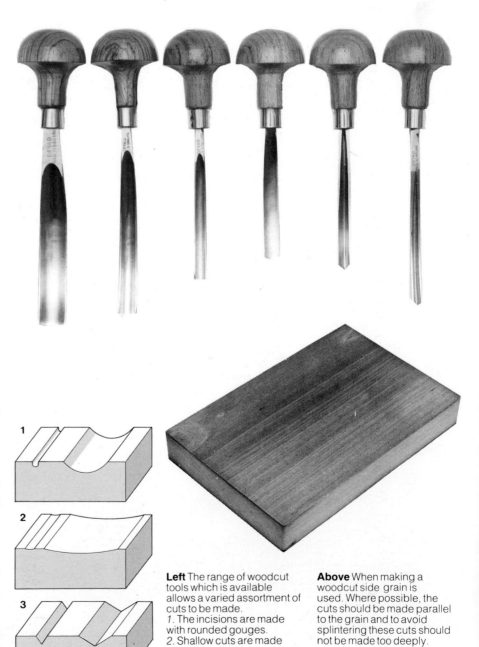

1

2

3

Left The range of woodcut tools which is available allows a varied assortment of cuts to be made.
1. The incisions are made with rounded gouges.
2. Shallow cuts are made with flat gouges.
3. Deep, sharp cuts are made with V tools.

Above When making a woodcut side grain is used. Where possible, the cuts should be made parallel to the grain and to avoid splintering these cuts should not be made too deeply.

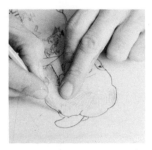

Cutting rough grained wood
The effect of printing a coarse wood grain can be estimated by lightly inking the block. Be careful if cutting across the grain as the wood may splinter.

2. Draw over the tracing with a sharp pencil. Lift one corner of the paper to check the progress of the drawing. Continue until the whole design is transferred to the block.

Cutting wood 1. Cut round outlines with a sharp knife. To remove a fine furrow of wood cut round the shape again with the knife blade at a slight angle to the first cut.

2. Remove large areas of waste wood with a gouge, working into the knife cuts to make a clean edge to each shape. Use a V tool to cut fine lines and small details.

Drawing on the wood block 1. A thin coat of white paint on the block will help to make the drawing show clearly. Place a tracing of the design wrong way up over a sheet of carbon paper on the wood surface.

Left Six woodcut tools. The four on the left are gouges and are used for clearing away large areas. The two tools on the right are used for cutting lines. **Right** Tools should be sharpened regularly on an oil-stone. Each side of a V tool should be sharpened while a knife is sharpened by pulling it across the surface. Gouges should be rocked from side to side.

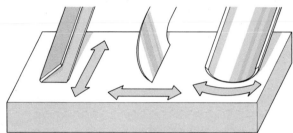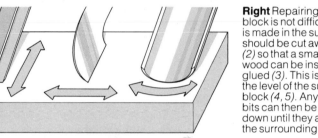

Right Repairing a wood block is not difficult. If a gash is made in the surface *(1)* it should be cut away evenly *(2)* so that a small piece of wood can be inserted and glued *(3)*. This is cut down to the level of the surface of the block *(4, 5)*. Any protruding bits can then be sanded down until they are flush with the surrounding areas *(6)*.

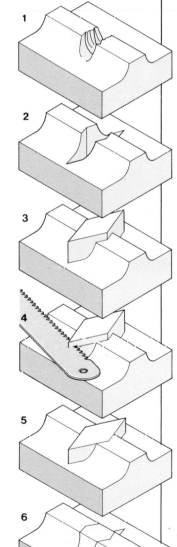

Above left *Christ at Emmaus* (1931) by Eric Gill (1882–1940). This illustration was made from a wood engraving and appeared in an edition of *The Four Gospels* published by the Golden Cockerel Press. The curved lines depicting the folds of the clothing and the sweep of the letter 'D' are carefully balanced with the straight, sharp lines which make up the rest of the composition.

Left *Pilot Boats* (1958) by Paul Shaub. In this colour woodcut the artist has used the texture of the wood grain to define the surface of the water.

 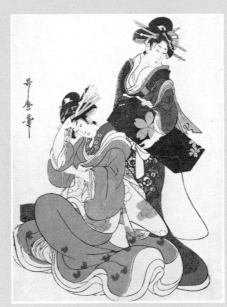

Two Geisha Girls (c. 1835), Utamaro II. Illustrated here are eight stages in the printing of a colour wood block. In all, sixteen printings were necessary to produce the final print **(opposite).** Four blocks combined more than one colour while the other twelve blocks were used for one colour only. A large number of blocks were needed because Japanese inks failed to mix satisfactorily. Each area in the design which needed a different colour required a separate block. The first block was the key block which printed the black outline. Each subsequent block introduced a new colour into the composition.

The detail **(above)** shows the printing of the grey which constituted the ninth stage in the development of the print. Careful registration was vital to ensure that the colour blocks related accurately to the key block.

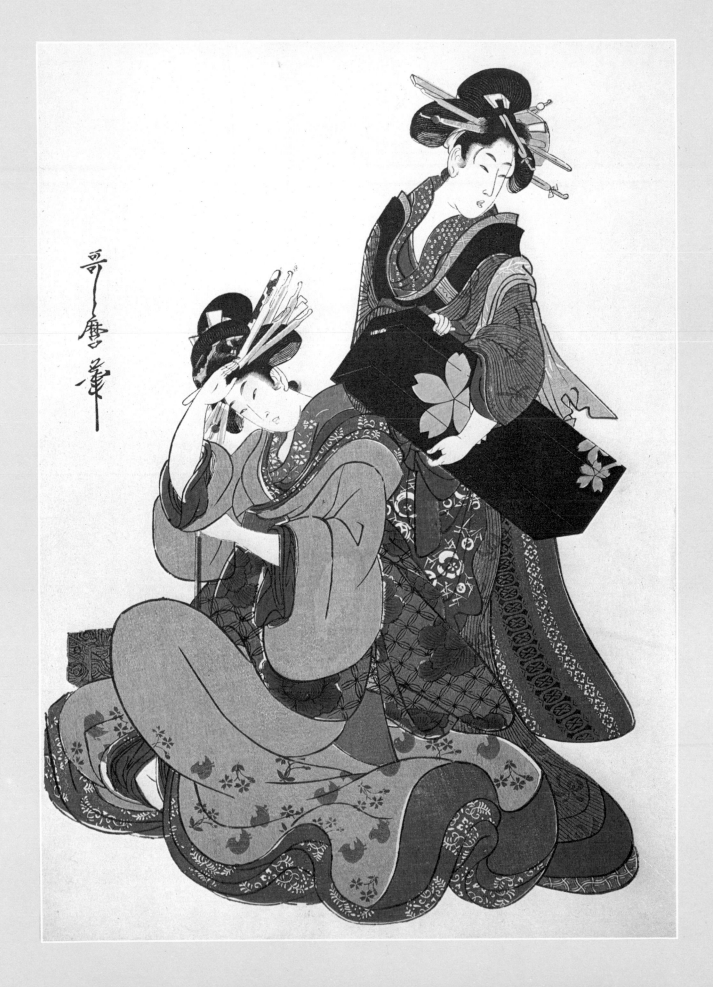

Some of the stages in the cutting and printing of a wood block. Before cutting the surface of the wood block it must be smoothed down with sandpaper and a cabinetmaker's scraper *(1)*. The design is traced down onto the block and then the artist works directly onto the block with a pencil, roughing in the basic tones *(2)*. When cutting the design the tools should be held as flat as possible to the surface of the block *(3)*. The linear details are cut using a knife and V tools *(4)*. The broad areas of waste wood are cleared with gouges *(5)*. At various stages during the cutting the artist will want to take a pull in order to see how the design is progressing *(see opposite page)*. Firstly, the block is inked up *(6)*. The paper is then placed onto the block *(7)* prior to it being put through the printing press. After some proofs have been taken trimming and refining must be carried out *(8)*. The block is finished and ready to be printed *(9)*.

1

2

8

3△ 5▽

4

6

7

1

Right *(1)* The first proof will be light as the ink will not have built up on the surface of the block. It will, however, help the artist to see whether any further cutting is required. *(2)* After the second proof some of the shapes may require further adjustment still. *(3)* The image is now satisfactory and the block must be cleaned with turpentine to remove the ink. An edition can now be run from the block.

2

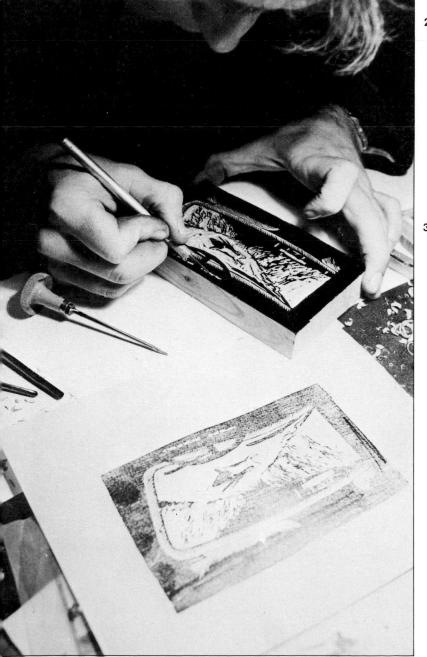

3

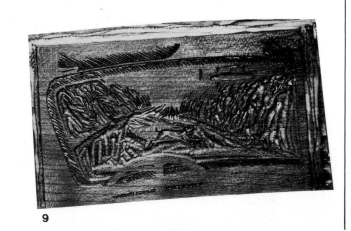

9

Wood Engraving

The wood engraving is a variation of the woodcut. The main difference is that in wood engraving the wood is cut across the grain rather than plankwise, along the grain. For the artist it means that he can work freely with his tools in any direction. Furthermore, because the wood is harder when cut in this way, he can use the more intricate tools of the engraver and is not merely reliant on the knife and the gouge. On most wood engravings, therefore, the image is defined by fine white lines against a black or coloured background.

The wood which is used for this process needs to be hard and close-grained and boxwood is by far the most suitable. There are other hardwoods, notably holly and hornbeam, which can be used as substitutes, though they will not give the degree of fineness and unity of end grain structure that allows the engraver to achieve the intricate detail and crisp cut shapes that exemplify this method of printmaking. Though boxwood is ideal it is very expensive for it is not easily obtainable and the seasoning and preparation procedures are lengthy. When you begin engraving you might use manmade substitutes which are of a similar density but much cheaper. Good examples are Lucite and Perspex.

The tools which you will need are finer than those used for doing a woodcut and resemble more closely the tools used by the intaglio engraver. There are three basic types of tool and it would be advisable when you are beginning, to invest in no more than two from each category. Tint tools are used for engraving lines of even width, spitsticks are used for engraving lines of variable width while scaupers are used for clearing out the spaces around the image. If you are feeling extravagant you might acquire a multiple tool which can be used for cutting parallel lines.

To prepare the wood for engraving, one surface is planed smooth before it is brought up to a highly polished state by the application of glass paper. It is worth pointing out the beginner will probably

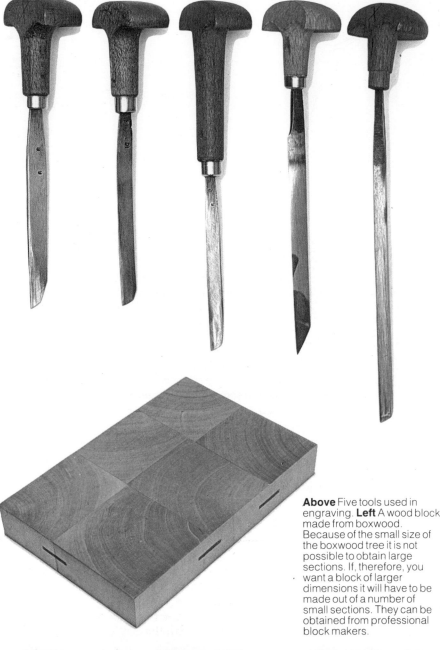

Above Five tools used in engraving. **Left** A wood block made from boxwood. Because of the small size of the boxwood tree it is not possible to obtain large sections. If, therefore, you want a block of larger dimensions it will have to be made out of a number of small sections. They can be obtained from professional block makers.

Wood engraving 1. Hold an engraving tool with the handle resting in the palm of the hand and grip the blade between finger and thumb. Steady it with the other fingers keeping them tucked back into the palm of the hand.

2. Rest the block on a sandbag while cutting so that it will rotate freely. End grain blocks are quite small and the cutting tools must be carefully controlled. Cut curves by turning the block, not the tool.

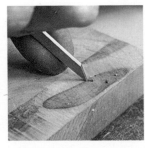

3. To start a cut with a square scauper hold the tool at an angle to the block and push the blade into the wood.

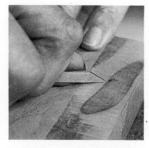

4. Once the cut has started lower the tool and push it smoothly through the wood, working at a shallow angle to the block. Steady the block with your free hand keeping fingers away from the path of the tool.

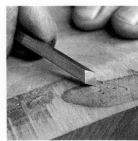

5. Cut or trim fine, straight lines with a lozenge-shaped tool, similar to the burin used in metal engraving. Do not dig too deeply into the block or the tool may stick in the wood.

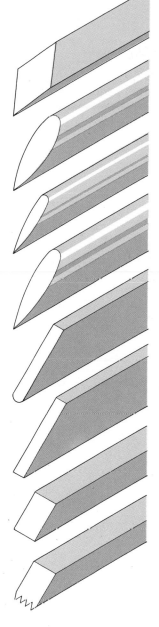

Left The blade sections of wood engraving tools. From top to bottom: a gravure or lozenge, a spitstick, two tint tools, a round scauper, a square scauper a chisel and a multi-tint tool. **Right** *British Birds* (1797) by Thomas Bewick (1753–1828). The delicacy of the detailing in this print reflects Bewick's training as a metal engraver. That a wood engraving should have been used in a natural history book is testimony to its ability to print fine detail.

find this is a very time consuming task and that in the end his finished article will in no way match the quality of the ones supplied by professional block makers.

In order to draw your design on the block you can apply a thin coat of white flake mixed with a small amount of water. A minute amount of finely ground grit (brickdust) could be added to give a fine tooth to the drawing surface of the wood. A medium hard pencil can be used to draw out the design. Alternatively, you can simply use a fine sable brush and drawing ink. If you do not want your image reversed then you must draw it on tracing paper and then transfer it on to the block.

The technique of engraving requires the development of quite controlled cutting, certainly more than is needed for the woodcut, so to begin with you would be well advised to confine yourself to unambitious designs. When using one of the tools previously mentioned, hold the handle in the palm of the hand and use the thumb to keep control of the point. When you are pushing the tool forward into the material make sure that the angle of entry is not too steep or else the point will jam and stop cutting. Equally, if the angle is too shallow, the point will tend to slip across the surface of the wood. The block is best held on a sandbag with the free hand so that it can be easily turned to assist with the cutting of the curves. Do

not attempt to cut a long straight line with one cut; it is better to do a series of short cuts which then connect up to make the total length of the line required.

Keeping all the tools honed sharp on an oilstone is most important because a blunt tool can quite easily slip and the consequences of this can be dire. Tools can be sharpened by a professional for a small charge, though during the course of engraving a little gentle rubbing of the straight back edges of the gravers will keep them in good condition while a slipstone can be used to remove the slight burr which will collect on the tools.

A common fault with beginners is to over cut. It is not easy to replace wood after it has been cut away so it is sensible to work slowly and take proofs as you proceed so that you can see how your image is progressing. There are a number of approaches to wood engraving which the novice will discover as he develops more skill and expertise. Basically, the technique involves cutting white lines onto a black background. Slowly you will break up the solid background by cutting the surface into a series of fine or wide lines, or areas of crosshatching. You might produce tonality by applying dots of varying density. Alternatively, you might want to cut the block so that lines appear in relief with everything else cut away, the print then resembling a pen and ink drawing.

6. Use spitsticks to 'draw' on the block. These are available in several different thicknesses and may be used to make a variety of linear qualities in the design.

Proofing a wood engraving 1. Ink up the block in black and lay a sheet of paper over it. Rub over the paper with a smooth, rounded object, such as the wood handle of the engraving tool.

2. If the block is quite small it can be proofed by burnishing with the fingers but a light image is obtained as the pressure is not so heavy and even.

Vignetting If an area of the block appears too solid and hard-edged, make a series of small parallel cuts across the edge of the shape with a small spitstick to break up the outline.

Metal Cut

Though linocuts, woodcuts and wood engravings are the major techniques associated with relief printmaking there are a multitude of other surfaces which can be worked on in order to produce a relief print. Common amongst these is the metal plate. Copper or zinc are usually used though some relief engravers have found that a soft metal like a lead compound is suitable. It is much easier to cut and the finished proof bears resemblance to the wood engraving. Its main disadvantage, however, is that it is expensive and because it is soft it will not stand up to a long print run. The method of engraving is similar to that applied to the intaglio process, the difference being that in the intaglio technique the engraved lines are printed whereas in the relief method the surfaces which remain are printed.

For this technique you will need some metal plate. If you are beginning you should perhaps use one of the cheaper metals, like brass or zinc, or even plastic. The engraving tools are basically the same as you would use for intaglio engraving. In comparison with other relief printing methods the metal cut, because of the hardness of the plate, is laborious and requires considerable skill and practice.

As you practise you will discover the wide variation of line which can be produced. Solids can be defined by crosshatching, or by dots jabbed into the metal. If you want to produce curved lines you should turn the plate rather than the graver. This is best done by placing the plate on a sandbag and then turning and twisting it in the direction

you want the line to follow. When engraving these lines you will find that fine spirals of metal are left on the surface of the plate. These can be removed with a scraper.

You should allow yourself to develop your own style and technique and not be impatient while doing so. Engraving in metal is not easy but the results, if you persevere, can be striking.

Relief Etching

Etching is another intaglio process which can be adapted to relief printing. Etching involves the erosion of unprotected areas of a metal plate by immersion in acid. Those areas which are left intact after the etch will later come out in the print while those areas which were corroded by the acid appear as the non-printing areas. The process is usually used to define areas rather than lines.

Left *Calavera Huertista* (1913) by Jose Guadalupe Posada (1852-1913), Mexican satirical graphic artist. Posada used metal cut (in this case on type metal) in the same way other artists have used the woodcut – to convey popular images in a direct manner.

Left *Orpheus Taming the Animals* (c. 1630). A plate made by etching. It was never intended for printing as the edges are unbevelled and the signature is not reversed. It was probably intended as a panel for a box or casket. **Right** *St. Francis* (15th century, Germany). This metal cut was done using a technique known as the *manière criblée*, by which areas were punched with a series of dots. In this print, as was the usual practice, the technique was combined with line engraving.

The list of equipment is not as extensive as that needed for engraving. No tools are needed for cutting the metal as that laborious task is done by the acid. You will only need your plate, usually zinc, stop-out varnish, a sable brush, nitric acid and a tray for immersing the plate in acid.

The first priority is to clean the zinc plate thoroughly, removing grease and fingerprints. If this is not done properly the stop-out varnish will not adhere to the plate and the acid may corrode areas of the plate that you wanted left intact. Next, polish the plate with a mixture of chalk and water made up into a paste. Then, after washing the plate with water, it should be passed through a weak solution of nitric acid (five parts nitric acid to 95 parts water). Finally, wipe the surface with a piece of clean rag or cotton wool and then dry with some blotting paper and a hot air blower.

The plate will now be ready to receive your design. Using a fine sable brush, charged with stop-out varnish, paint the design directly onto the prepared metal plate. Bear in mind that the image must be reversed right to left if any lettering is to appear in the print. It is also important that the back of the plate is protected by painting out with the varnish though you can buy plates which already have a resist backing.

Once you have drawn your design with the stop-out varnish only the etching remains to be done. This can be carried out in a stainless steel or plastic polythene tray of a size large enough to accommodate the largest plate which you intend to etch. Place it near a window or, even better, out of doors, where the toxic fumes of nitric oxide can escape. Ideally, some form of fume extraction hood should enclose the dish whilst etching is carried out. The etching solution can now be made up ready for use in the tray. A suitable solution is made up of one part nitric acid and ten parts water. The water should be poured into the tray first and the acid added gently to it. Take a graduated glass or stainless steel measure and pour in the nitric acid carefully until the required amount is reached.

The etching action of the nitric acid solution produces bubbles of hydrogen gas over the surface of the zinc plate. The plate must be lifted up by one edge so that all the acid solution drains off the surface and back into the dish taking the bubbles with it. A hook for lifting the edge can be made out of a piece of bent metal which has been heavily lacquered with bitumen paint or polyurethene varnish. If attention is not given to this factor uneven etching will take place.

There is one important point which you must take into account when preparing your design. If you want to print a line you should prepare the surface of the plate so that the acid eats away two parallel grooves leaving a thin shoulder of metal which will print as a line. There is, inevitably, a tendency for the acid to attack the sides of these shoulders and if the action goes too far the image

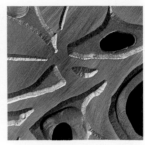

Relief etching 1. Paint the design directly on the plate with stop-out varnish and a fine paintbrush.

2. Pour a 10% solution of acid into a suitable flat-bottomed dish. Immerse the plate in the acid and brush away bubbles as they form during the biting.

3. Rinse the plate in running water and clean off stop-out varnish with turpentine. The plate is deeply etched leaving the design as clean areas of raised metal.

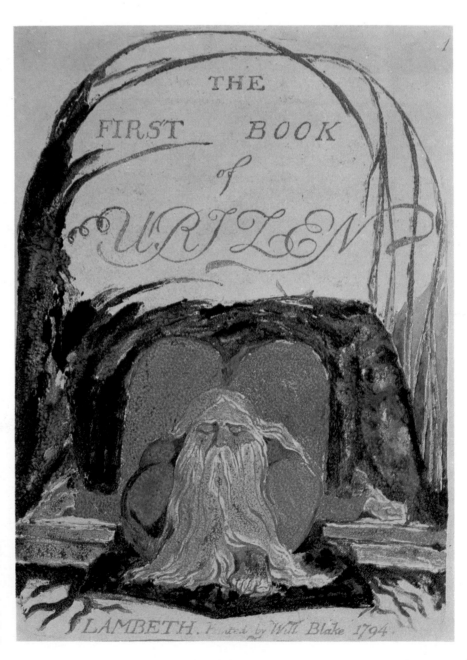

Right *Midsummer Night*
(1919) by William Giles
(1872–1940). This print, a
relief etching, was made
using six plates. The most
striking quality of the print is
the subtle, mottled effect,
created over the whole
surface. This was achieved
by inking up the metal plates
with watercolours instead of
the usual oil-based inks.

Left *The First Book of Urizen*
(1794) by William Blake
(1747–1827). This relief
etching was made for the title
page of the book which was
one of Blake's series of
Prophetic Books.

support will be eaten away and the shoulder will collapse. One way of avoiding this is to immerse the plate into the acid for only a very short time thereby limiting the depth of the etch. However, if you do this, be careful when you are inking up because the areas which have been etched will only be shallow and liable to pick up ink which will then appear in the print.

Photo Etching

Photo etching, like relief etching, has the advantage of requiring no cutting skill. The acid does all the hard work. In simple terms, a photo etching is done by exposing a metal plate, prepared with photo resist coating, to a light source which is passed through a transparent sheet on which an image has been created in negative; the part of the image which is not going to print being opaque. The photo resist hardens where it is exposed to the light but in those areas where it has not been exposed it remains soft and can later be washed away. The plate is then ready to be etched in the normal way.

There are a number of ways of preparing an image, though the easiest one is to simply draw your design with photo-opaque ink on to a transparent plastic sheet. Paint out those areas which you do not wish to print so that they are not exposed to the light source. The resist will not harden and can be easily removed from the plate, so that when it is etched those areas will be corroded. If you want to increase or decrease an image to fit the dimensions of a particular plate, or transfer a tonal image, then you will have to make use of a process camera. This is not a machine suitable for amateurs or beginners, so you will probably have to enlist the assistance of a professional. If you make use of this machine you will receive your image, transposed on to a transparent sheet. You can order either a positive or negative and if you want tonal variations defined you will receive an image which is made up of numerous dots, like the images found in newspapers and magazines.

The next stage of the process is to expose the plate to light which has passed through your film. The photo resist, which is crucial to the whole process, can either be applied to the plate by yourself or you can use a plate which has had the resist applied by the manufacturer. You now place the negative on the plate. It must be in close contact in order to stop the light from spreading where it is not wanted and this is best achieved by placing a piece of heavy glass over the film. The next step is to expose the plate to light for the length of time needed for the resist to harden. The exposure time will vary according to the type of light which is used. A domestic suntan lamp, for instance, is relatively weak so that the exposure time will have to be quite lengthy. After the exposure the plate has to be washed to remove the

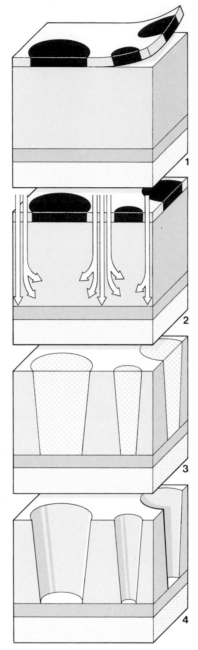

Above A method of making a relief plate by means of photo etching.
1. A negative is laid on a light sensitive polymer plate.
2. The plate is exposed to an ultraviolet light through the negative.
3. As a result the exposed portions are hardened.
4. Finally, the plate is sprayed with a dilute solution of sodium hydroxide which enables the unhardened areas to be washed away.

Photo etching 1. Prepare a high-key negative from the original design.

2. Lay the sensitized plate on the bed of the printing down frame. Position the positive on the plate with the right side down so that the emulsion on the plate is in contact with the emulsion on the negative.

Left *Trees Within Trees* (1976) by Mati Basis (b. 1923). This print is a two-colour image which was printed from one plate. The outer panels are black and dark blue, while the inner panels are black. The image was made from one photograph which was then repeated.

Above *Plastic and resin relief blocks* A professional photo-engraver or platemaker may prepare a relief block from one of the specially developed plastics or resins now available. Expert technical advice may be needed to avoid the problems encountered in relief etching.

3. Close the printing down frame and tip it into a vertical position. Expose the plate to ultraviolet light. If the light source is quite powerful this may take 3-4 minutes.

4. When the exposure is complete immerse the plate in dye developer. This is a colouring agent which forms the photo-resist image. The plate is now ready for etching.

Powderless etch machine 1. A quick modern method of etching the plate is in a powderless etch machine. This process must be done by a professional technician with full knowledge of the equipment.

2. The machine is fitted with a number of small jets which spray acid over the plate. The plate is locked into the lid of the machine which is then closed and the etching takes place.

3. The machine etches the plate far more quickly and evenly than the ordinary acid bath. The metal is deeply bitten away around the image.

Inking a block in graded tones 1. Mix white and coloured ink with a palette knife to make a light tone. Mix a second, darker tone.

2. Spread the inks side by side on a flat surface, drawing each colour away from the centre to form a broad band of ink.

3. Use a large roller which will cover the whole surface of the block. Roll out the ink, shifting the roller very slightly from side to side to blend the inks together in the centre.

4. When the roller is evenly coated with the blended inks pass it over the surface of the block, working in one direction only.

Taking a print in three colours 1. Draw the outline of the block in the centre of a sheet of printing paper. Mark one corner of the paper. This forms the registration sheet for printing.

3. Align one corner of the printing paper with the marked corner of the registration sheet. Lower the paper over the block so it fits exactly onto the registration sheet.

4. Run the block through the press to take the first print. Blot the wet print with a sheet of newsprint by running the two together through the press.

5. Put down the second block on the registration sheet, again inside the drawn outline. Place the print over the block, aligned as before from the marked corner of the registration sheet.

6. Run the print through the press and peel it back from the block. Blot the second colour with a clean sheet of newsprint.

7. Position the third block and repeat the printing process to lay the final colour.

unhardened resist. There will be left on the surface of the plate an area of hardened resist representing the positive image. After this only the etching remains to be done. This part of the process is exactly the same as for relief etching, described in the previous section.

Printing

The processes for relief printing are similar to those used in intaglio printing. Basically, the plate is inked up using a roller and then a print is taken, either by applying paper to the plate by hand or by using a press. But this printing is not as simple as it sounds. It requires great care and precision and a considerable amount of practice. Those who aspire to multicoloured printing will need a great deal of practice.

The equipment which is needed is not complex. First, you will need a sheet of glass or formica or a litho stone, for distributing ink evenly on to the roller. You will need a flexible broad blade knife for mixing and transferring inks to the ink slab and a push knife, similar to wallpaper

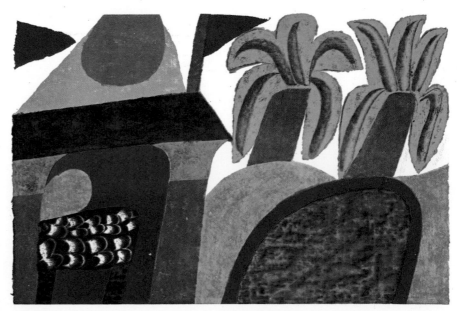

Above *Basholi* by Carol Summers (b. 1925). This striking print was taken from a wood block. It was printed on Japanese paper.

2. Place the registration sheet on the bed of the press and lay the first block inside the drawn outline.

8. Peel back the finished print and lay it out flat to dry naturally. Subtle effects of colour can be obtained in overprinting if the inks are made successively more transparent.

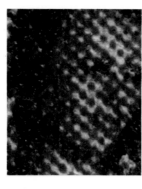

Above An image created by mechanical printing. It has been greatly magnified and gives a clear idea of how colour images are built up using series of dots of different colours and varying densities.

Right *Cat at Window* by Hiroshige (1797–1858). This print was made from a single printing, using a technique known as rainbow inking. Using this method the plate is inked up with all the separate colours so that only one printing is required.

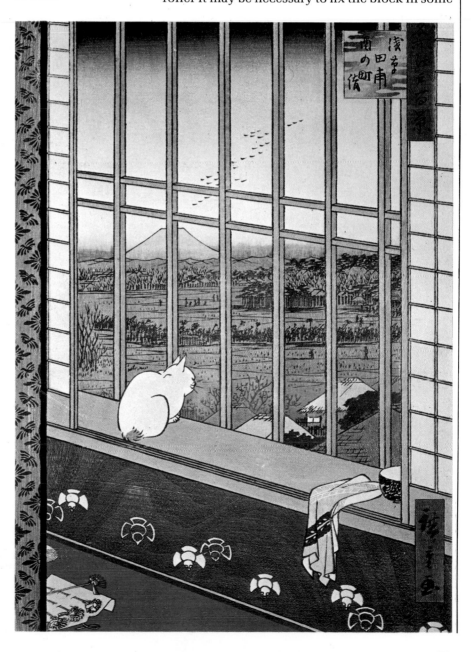

of initial procedures which are the same for both. Firstly, you must ink up the slab and the roller. Using a palette knife, spread a small strip of ink across the top end of the slab to act as a reservoir layer, and use this to charge the roller. Move the roller up and on to this reservoir strip and charge it with ink. Distribute the ink to the bottom half of the slab by rolling backwards and forwards in all directions until a thin layer of ink is left on the surface of the slab. The ink film which you have spread out should be free of pieces of ink skin and any other particles. Do not use too much pressure when charging the ink roller; a slight touch is all that is needed.

Before inking up the relief surface make sure that the block is clean by lightly brushing over the surface with a soft hair brush. If the block is smaller or larger than the length of the inking roller it may be necessary to fix the block in some

scraper, for removing unused ink from the slab. Tubes, rather than tins of letterpress printing ink are recommended because to begin with you will probably only use small quantities. If you buy tins there is more likelihood of skin forming on the surface of the ink once the tin has been opened. The last item of equipment you will need, and perhaps the most important piece, is the roller. Though they are more expensive than most, the polyurethene type will give you the best service. A roller which is hard will not deposit the ink evenly to all parts of the plate while a soft roller will tend to overfill the finer, close lines of the design causing a loss of definition and a tendency to make the lines too thick. The paper which you use will be determined principally by personal preference. For taking rough proofs you should use cheap paper like newsprint, though you might need stouter papers if you are printing by hand burnishing. The traditional papers used for woodcut printing are handmade Japanese papers but really any paper will do providing it has some absorbent qualities and is strong enough.

Whether you are going to take a print by hand-burnishing or by using a press there are a number

way in order to prevent movement. With a small sized roller it is a good idea to roll from the centre outwards and then to complete the roll-up by rolling from end to end. Recharge the roller with ink as required, though remember that the aim is to apply the ink evenly and lightly. Too much ink or pressure will lead to filling in of the finer lines in the image and possibly give rise to ink squash, a condition characteristic of letterpress printing where the ink is forced, under printing pressure, to escape outwards and over the edges of the image lines, giving a distinct heavy edging to the printed areas, with very little ink left to print at the centre of the image areas.

It is not necessary to have access to a relief press, or any other press for that matter, in order to take a print from your plate or block. Indeed, print-makers, particularly the Japanese printmakers, often prefer to use a hand system of printing since it gives a more individual result which looks less mechanical than a print taken from a press. The most popular hand method is to use some form of burnisher, specially shaped for the job. However, a simple wooden spoon or a large smooth pebble can be used to rub over the back of the paper.

It is most important to avoid movement of the paper whilst rubbing it down to the inked block for it will cause doubling or smudging and this can be a real problem if you are printing more than a single colour. The paper used for direct rubbing should be strong enough to stand up to this treatment though if you really do want to use thin paper, some kind of protection can be used, such as a thin card placed over it.

If you want to take a large number of prints from your relief block or plate some form of press will be required. To take twenty or more prints by hand is a laborious task, especially if they are to be multicoloured. There are, however, a number of other advantages which you might want to take into account. For instance, a press does produce an overall uniformity of inking, which once achieved can be maintained for the length of the run. There is less wastage of paper and this really is quite important if you are going to use the more expensive handmade papers. Finally, if you are going to print more than one colour you will find that the press provides more accurate registration.

Nevertheless, it does have its disadvantages. If a wood block is warped, for instance, it is not easy to secure an overall impression whereas a handprint can be more selective in the way the pressure is applied and any unevenness accounted for quite easily by the personal touch of the printer. There is also a tendency for the wood block to be damaged by the pressure applied by the press. If there are any signs of weakness then the block will deteriorate very quickly under the pressure.

If you do not have access to a press you should not be deterred from doing relief printing. A press can sometimes be a great bonus but there is no

 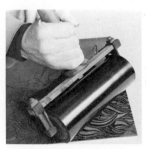

Proofing a block by hand
1. Using a palette knife spread a broad bank of ink on a clean flat surface. Roll it out evenly with a large inking roller.

2. Work over the surface of the block with the inked roller, laying an even coating of ink on the lino.

3. Place a sheet of paper over the block. Rub over it with a burnisher or smooth, rounded object such as a large stone or the back of a spoon. Apply heavy, even pressure over the whole surface.

doubt that you can work very successfully without one and enjoy a greater chance to experiment.

Multi-Block Colour Printing
To produce a quantity of multicoloured prints which have a high degree of colour consistency, it is necessary to print in coloured inks from separate relief plates or blocks. These are rolled up in the same way as described for making single colour prints. One of the main problems when printing multicolour images is to secure registration of the coloured images with the key plate. The key plate is usually the black printer block and, as the name implies, it carries the outline image which, when printed in register with the other colours, locks or fits the complete picture together. It is the method which is still used to print books and magazines, and is referred to as the four colour process.

A separate block is produced and used to print each separate colour and it requires some thought at the design stage if the printed result is to be

Below When the cylinder press is rotated the paper is lowered down onto the block so that an image is taken.

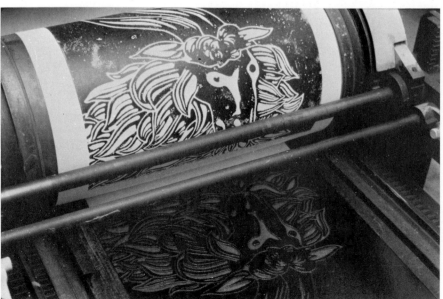

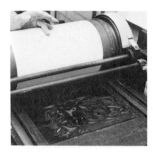

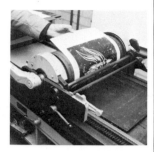

4. Peel back the paper from one corner to check the proof. It may take time to build up the full strength of ink on the block but the proof enables you to see the progress of the image.

Printing on a cylinder proofing press 1. Roll up the block with ink to lay an even coating of colour on the relief areas.

2. Fit a sheet of paper into the clamps on the cylinder of the press. The clamps are fixed or released by the operation of a foot pedal.

3. Place the block on the bed of the press and smooth back the paper over the cylinder. Wind the cylinder across the block holding down the free end of the paper.

4. The movement of the cylinder presses the paper down over the block to print the image. When the print is taken release the paper clamp and peel off the proof.

successful. The key block is the block on which an outline is created for the coloured areas. It can be another colour other than black; it is simply a matter of taste. It should, however, be a dominant colour in order to hide any overlapping of the other colours. For example, a yellow key would not hide the overlap of a blue coloured area. Instead a slight green appearance would develop where the two colours overprinted. The different coloured blocks are then prepared by either taking tracings off the original drawing or by offsetting a printed image from the key block onto a prepared plate or uncut block. To help in positioning or registering the key image onto the next plate or wood block, a registration frame can be made. The correct location of both block and paper can then be assured and the printed images should then fit each other perfectly after the initial setting for the printing has been carried out. After the required number of plates or blocks have been prepared the print run can commence.

Single-Block Colour Printing
Because of the difficulties encountered in the registration process of the multi-block method, the single-block method is recommended for the beginner. The method involves the removal of the relief image at each stage of printing a colour, until finally only the last colour print image is left remaining on the block. This method is sometimes called the waste method. It does impose a restriction on production for the colours have to be printed in an order which cannot later be reversed. You cannot go back to the first colour once you have proceeded to the next.

The other restriction is related to the number of colours which can be used. Normally it should not exceed more than three of four as too many layers of ink can cause problems of a thick build up whilst printing. The basic procedure begins by making a working drawing in several colours and in separated shapes; you then make and print the first block in the first colour. Having taken

enough prints of the first cut, plus a few extras for overs, cut the next colour on the same block and overprint this in the second colour on to the first colour printing. Repeat this process until all the colours have been printed. Because you will be laying colours on top of each other it is important that you should anticipate how the colours will mix before you actually go ahead with the printing. Colours can be made opaque by adding white but even then they will tend to mix and you should test them out before proceeding with your print run.

The White Line Method
This method is similar to the wood block in that only one block is used. On the other hand no colours are actually printed. It relies on the image being clearly defined by an outline so that each separate area can then be individually coloured in by hand, a brush being used to apply the colours. It is a method which can create rich and varied effects, similar to stained glass windows. Its main advantage over the printed image is that it is more controllable.

Below Using an Albion relief press. The block and paper are covered with the blanket and pushed under the platen. A lever pulls the platen down to exert pressure on the block and print the image.

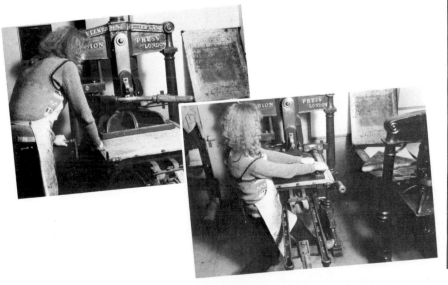

Intaglio Printing

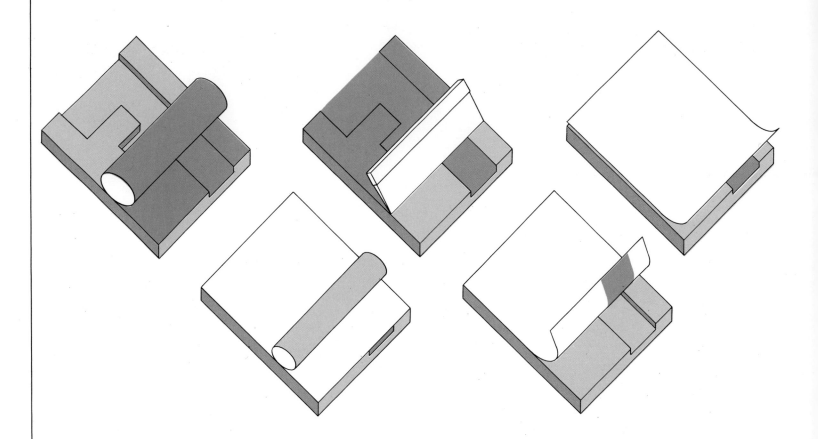

Intaglio printing, which derives its name from the Italian word *itaglione*, meaning to engrave or cut, covers a number of techniques, all of which involve the incision of designs into metal plates. Ink is later rubbed in so that an image can be transferred onto paper.

Engraving of designs began long before printing. Prehistoric man scratched decorations onto stone and bones, while the Etruscans began engraving on metal as long ago as 400 B.C., decorating bronze articles by hammering with small chisels and cutting out grooves in the metal.

It was the goldsmiths and metalworkers, the decorators of plates, chalices, shields and other items, who developed the tools and techniques which were used by the early engravers of the fifteenth century. The beginnings of intaglio printing can be traced back to the work of the European metalworkers who employed a technique known as *niello* engraving. In this method a black compound of sulphur was melted into the grooves of the engraved decoration so that the whole design stood out more clearly against the metal.

The idea that an image might be taken from an engraved metal was first conceived of in the fifteenth century. An early engraver who made prints was the Master E.S., so-called after the initials on his plates. These appear on some 18 engravings dated between the years 1461 and 1467. Martin Shongauer (c.1440-1491) might

The principles of intaglio printing The principles of intaglio printing are the same whether applied to industrial printing or printmaking. Ink is applied to the plate and rubbed into the grooves. All the surfaces in relief are then cleaned of all traces of ink. In the industrial process this is done by means of a scraper **(above)** while printmakers clean off the ink with a piece of tarlatan or scrim. Printing paper is then placed on the plate before both are run through a press. A powerful press is essential because the paper has to be forced into the grooves on the plate so that the ink is picked up. Finally, the print is peeled off the press.

have been an apprentice of the Master E.S., though the latter's technique was more decorative and employed longer and more sweeping lines.

During the second half of the fifteenth century drypoint was introduced. Engraving produces a hard and distinct line; drypoint, on the other hand, creates a ragged, softer line which is scratched on the metal with a fine needle. When printed, the effect is rather like a pencil drawing and has the attraction over engraving of being more spontaneous. An early exponent of this technique was the Dutch artist known as the Housebook Master, so-called after a series of prints he made depicting household articles. He was active around 1480.

From the fifteenth century onwards painters influenced printmaking increasingly. Andrea Mantegna (1431-1506) produced a great number of engravings in his workshop, many of them derived from his paintings. Raimondi Marcantonio (c.1480-c.1534) translated the work of many artists into prints, particularly the paintings of Raphael (1483-1520), and his workshop became a model for later intaglio printers.

The next intaglio technique to be developed was etching and it evolved from the armoury made by Daniel Hopfer (c.1470-1536) and his two sons. The iron shields which they made were partially decorated with paint and in time the bare metal areas around the paint rusted so that pits formed in the metal. Eventually the Hopfers

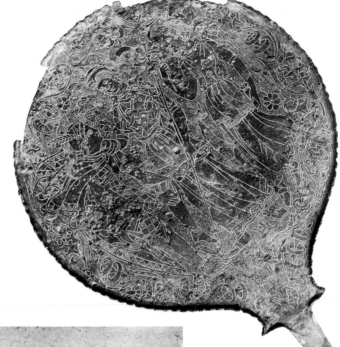

Top left *Landscape with Herdsmen* by Thomas Gainsborough (1727-88), a soft ground etching. In this method the plate is covered with a soft ground of tallow and grease. A sheet of thin paper is laid over it and in this particular case, the image drawn with a crayon. Where the design is drawn onto the plate the ground lifts off so that the plate can then be etched. The technique has the charm of being very spontaneous.

Above Etruscan mirror (450 B.C.). Engraving was used as a means of decoration long before printing was conceived of. The back of this Etruscan mirror, made of bronze, has been decorated with engraved images and a white ground applied to emphasize the design.

Left *Square Brown Coat* (1980) by Michael Exall (b. 1950). The print incorporates the techniques of etching, aquatint and mezzotint. Two plates and three colours were used. On the first plate a linear design was etched and then an aquatint was worked over it. The black lines and the buff background were printed from this plate. A mezzotint was worked on the second plate and the red of the coat lining then printed. The red was also used to intensify the shadows on the rest of the coat.

adapted this rusting to create designs. The shields were covered with wax and designs were scratched or drawn on top thus exposing the metal. Vinegar and vitriol were then applied to the whole shield and ate into the metal so that when the wax was removed, a clear, incised design was left. It was a logical step to use this technique for intaglio printing, and by the beginning of the sixteenth century it had become common practice throughout Europe.

These techniques were employed by Rembrandt (1606-1669) who combined all of them together in some of the 300 plates he produced during his lifetime. His spontaneity and range of technique constituted a major break with earlier artists and anticipated the extraordinarily expressive work of Goya (1746-1828) some hundred years later. One of Rembrandt's preoccupations was with tonality and he strove to extend printmaking beyond the linear manner of the previous century. Aquatint represented an attempt to find a means of printing tones of varying densities, using dots to create tonality. In this it is somewhat similar to the modern newspaper image. Aquatint is not a linear technique though it has been combined with linear etching.

In some ways the mezzotint was an extension of aquatint, being concerned primarily with the definition of tonalities. It was invented by Ludwig von Siegen of Utrecht (c.1610-1676) whose first dated mezzotint was made in 1642. The method involves a piece of flat hard metal with a curved serrated edge which is rocked over a plate to create a roughened surface which, when inked,

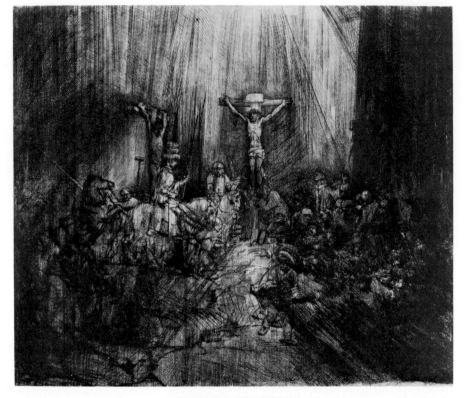

Above *Three Crosses* (1653) by Rembrandt (1606-69) etching, drypoint and engraving. The dark areas were produced using drypoint.

Below *Soldiers* by Daniel Hopfer (c. 1470-1536), an early etching. The plate was iron etched with vitriol. The etch probably took two to three days.

produces a deep black print. Tonal gradations are created by scratching off the burr (the ridges of rough metal) to varying degrees. Highlights can be produced by polishing the surface smooth.

Prince Rupert, a nephew of Charles I, brought the invention to England, and its ability to produce subtle tonalities made it a popular medium for the reproduction of paintings. It became a copyist method of printmaking and died with the invention of photography.

Above left *Lord Camden* (1835) by William Ward. The subject of this mezzotint was taken from a contemporary portrait and illustrates well the suitability of the technique for accurate reproduction. In the detail there can be seen the tiny directional marks which were made by the rocker.

Below left A magnascan calculates automatically the correct tone and colour values of an original image and then translates the information into electrical impulses. These lead to an engraving diamond stylus which scoops tiny cells out of the printing cylinder.

Below *Four types of gravure plate.*
1. The conventional gravure plate. All the cells have equal surface areas but variable depths. This type of plate is usually used for short runs of high quality black and white or colour illustration.
2. In variable area gravure the size of the cells varies but not the depth. This type of plate is widely used for textile printing.
3. Variable depth-variable area gravure. The size as well as the depth of the cells varies. These plates are very durable and are suitable for long print runs.
4. Electrically engraved plate. The plate is engraved with a diamond stylus which scoops out cells of varying size and depth.

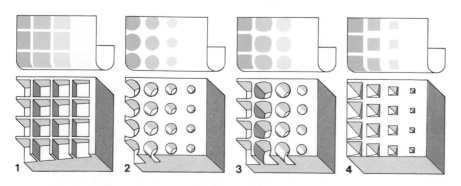

1 2 3 4

At this point printmaking and printing went their separate ways. Printing became the large industry we know it to be while printmaking was reserved for fine art and the production of limited edition prints. Photochemical processes, which were developed in the 1840s, led printing into the sphere of industry and the small printmaker could find little demand for his work.

The first photographic intaglio plates were made using a substance called 'Bitumen of Judea', or aspheltum, on metal plates. This was applied as a varnish normally soluble in an oily solvent. On exposure to light, however, the varnish hardened and became insoluble in the oil. Parts not hardened by light could be washed away. Images cast by shadows could be projected on to the plate, the area around the shadow becoming permanent in the aspheltum. From then on the process was the same as for etching.

In 1875 Karl Klic (1841-1926) invented dust-grain photogravure, the forerunner of modern methods. Klic used a gelatine or carbon print on paper which could be transferred onto metal. Because of the transfer action the image was a fully developed relief image in gelatine. The ink retaining structure was provided by an aquatint resin grain which was laid under the gelatine. The plate was then etched in the same manner as an aquatint.

Modern photogravure printing takes place on huge presses, transferring the image from ten or more cylinders in line and sometimes running at 50,000 revolutions per hour. Two exposures are used before transferring the gelatine relief image to the cylinders before etching: the first through a mechanical screen, the second through a transparent positive of the image, so hardening the gelatine in varying depths in relation to the tones on the positive. After etching, the cylinder has a printing surface of tiny cells equal in area but varying in depth, thus when printed giving the tonal or colour variations required.

Over the last few years electronics have been introduced to enable the cylinders to be engraved mechanically. A scanning apparatus moves over the image which is to be reproduced or printed, and in a computer the varying reflected densities of the tone or colour are translated into electrical impulses which are led to an engraving diamond stylus which scoops tiny cells out of the cylinder surface. Many periodicals are now printed from cylinders produced in this way.

The latest of the industrial innovations is engraving by a laser beam, the intensity of which controls the cell depth on the cylinder.

These methods are industrial and should not be confused with printmaking as an art form. This form of art has changed little over many years. Though photographs are now accepted as an aid for printmaking, the old techniques of intaglio printing still depend on the skill of the craftsman and his individual approach.

Below *Young Girl* by Paul Cesar Helen (1859-1927). This print was worked entirely in drypoint. The extraordinary fine quality of the lines was achieved by scraping off the burr.
Bottom *Flowers Against a Stormy Sky* (1979) by David Wilkinson (b. 1937). This print combined etching with aquatint and embossing. It was produced using three plates and seven colours.

Right *Cloisters Elne* (1980) by Valerie Thornton (b. 1931). The print combined the techniques of etching and aquatint. It was printed using two plates and six colours. The mottled effects were caused by foul biting during the etch. This effect. which is usually eliminated by printers, was exploited in this particular case to convey some of the textural quality of the walls.

Right *Turnip Court* (1980) by Graham Clarke (b. 1914). This print was made with one plate only. The linear design of the print was produced with an etching, and the colours were then painted in by hand.

Below *Autumn Eve, Lamorna* (1979) by Alyson Stoneman (b. 1948). This print combined the techniques of etching and aquatint. It was printed using two plates and four colours. Each plate combined both the techniques while two colours were used on each. The colours used were black, yellow, orange and green.

Engraving

Engraving is the oldest of the intaglio techniques of printmaking. Metal is removed from the plate in narrow grooves by the burin or graver.

The burin consists usually of a square steel rod fitted into a wooden handle at one end so that it can fit snugly into the palm of the hand. At the other end it is cut at an angle of 45° from one corner of the square to the other. This produces a sharp point and three cutting planes. Square burins are the most common, though other shapes are introduced for special effects. When engraving, the burin is held at a very shallow angle to the plate and is pushed forward as an extension of the hand; with the forefinger and thumb steering it into the desired direction.

The most important aspect of these tools is that they should be sharp and properly prepared. To do this the two bottom planes are sharpened on a fine oilstone with a light oil used as a lubricant. When both planes are true, the angled facet of the cutting edge is put flat on the stone and moved back and forth at the correct angle and without rocking. Repeated sharpening of the two bottom planes during engraving is necessary. Only sharp tools work efficiently.

It is advisable, when inexperienced, to practise on scrap plates. You must learn to control the burin and you will be able to discover the varied types of lines which can be cut.

An incomplete line is made by pushing the burin gently forward into the metal and slightly downward. As a result, a fine spiral of metal will come away from the plate. You can then relieve the pressure, bit by bit, so that the burin reaches the surface of the plate. This will result in a line which is pointed and fading out at both ends.

Hard lines can be made by cutting into the metal in the manner described above but then stopping when the burin reaches its deepest point. You can then turn the plate and retrace the line in the opposite direction, so deepening the point of

Engraving Once the plate has been prepared you can begin to engrave your design. The equipment required is simple. You should acquire a sandbag on which to rest the plate when you are engraving it and burins with which to engrave. Two should be enough to begin with; one with one sharp edge which can be used for jabbing and another specifically sharpened for line cutting.

entry of the first cut. When cutting all these lines you will be left with fine spirals of metal which can be removed with a scraper.

The deeper the lines are cut, the darker they will come out in print. If lines are not dark enough they can be re-cut and deepened. To produce a curved line you should turn the plate and not the burin. To do this the plate is held in one hand and rested on a sandbag while turning. Dots can be made by jabbing the burin into the metal and turning the plate.

Shadow and tonal effects are obtained by engraving lines quite close and parallel to each other, gradually increasing the distance. Cross-hatching is another way of creating tonal variations. Lines are drawn parallel to each other in one direction, then more parallel lines are drawn at right angles to these. If the area needs to be darker still, further lines can be drawn at 45° to the earlier ones. The process can be continued until sufficient darkness has been achieved.

An engraving produces a mirror image of what has been created on the plate, so the design must

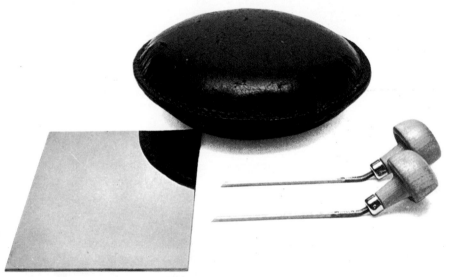

Bevelling The sharp edges of the plate must be bevelled to an angle of 45° or they may cut the blankets of the press. Hold a scraper with the blade at the correct angle and draw it along the edge of the plate. A file may be used instead of a scraper for bevelling.

Sharpening tools 1. Lubricate an oilstone with a small dab of oil. Rub the planes on each side of the cutting edge of the burin evenly across the stone.

2. Place the angled facet at the end of the burin on the oilstone and move it back and forth. Keep it flat on the stone and do not tip the angle of the tool as you work.

Engraving the plate 1. Hold the blade of the tool between thumb and forefinger with the wooden handle resting in the palm of the hand, steadied with the little finger.

2. Rest the plate on a sandbag while cutting so that it can be freely turned. To cut a curved line, maintain steady pressure on the burin and slowly rotate the plate.

Below The plate and the print taken from it illustrate the variety of tones and textures that can be achieved by line engraving. The engraver only has lines, straight and curved, together with dots of varying sizes and shapes to render form and tone without falsifying either. The following techniques are commonly used in engravings.
1. Square graver cuts, uneven in depth to avoid the appearance of a mechanical tint.
2. Partial crosshatching. (The secondary cuts are not right-angled to the first.)
3. Continuous lines broken with additional cuts to give greater tonal contrast.
4. Stippling made by turning the graver after entry.
5. Dot stippling. Variations of tone are achieved by altering the proximity of the dots and the pressure used to make them.
6. Curved lines thickened by increasing the depth with the flange.
7. Cuts made by a coarse multiple graver. The white areas are made by rocking the tool.
8. Marks made by a fine dot wheel-roulette.

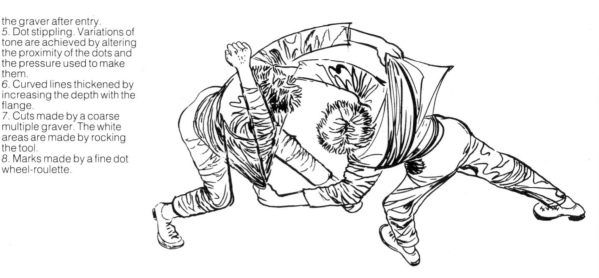

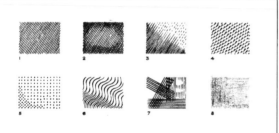

Above and below The print of the two wrestlers with its few strong lines which appear on the paper like gashes, is starkly contrasted with the more traditional portrait illustrated below in which the lines have been organized so that the figure is defined by carefully modulated tonalities. Both the viewpoint of the subject as well as technique of the top print give some idea of the extent to which the art of engraving can be modified and experimented with.

3. To cut a straight line, push the burin smoothly through the metal, keeping the tool at a shallow angle to the plate and guiding it with the forefinger. It should not be necessary to force the blade.

4. A small burr of waste metal is thrown up as the line is cut. Remove the burr carefully with a scraper without marking the clean metal on either side of the cut.

Removing scratches 1. Even a tiny scratch or incorrect cut in the metal will print. To remove unwanted marks rub over the scratched area with a burnisher.

2. As an alternative method of removing scratches, gently rub the surface of the plate with a small snakestone.

3. Bring up the surface of the plate with metal polish on a piece of cotton wool. This cleans and polishes the plate enabling you to see whether the plate is smooth and free of scratches.

be considered carefully. The simplest way is to prepare the drawing on transparent paper and then, with the help of carbon paper, transfer it through the back onto the plate. The weak, greasy lines act as a very mild resistant if the metal is immersed in a weak nitric acid solution for a few seconds. After cleaning with methylated spirits or benzine, the image will come up shiny against the dull background.

Experienced engravers develop their own styles and techniques. For some the line is only a small part of the whole design, a means to an end, as in the work of Etienne Cournault (1891-1948). For others the line is the image and the content; sometimes delicate, sometimes strong and deep with sweeping curves. This can be seen in the work of Stanley Hayter (b. 1901).

In addition to the tools and equipment mentioned previously, the following are necessary: burin (square and lozenge-shaped), carbon paper, pen or hard pencil, nitric acid, etching needle.

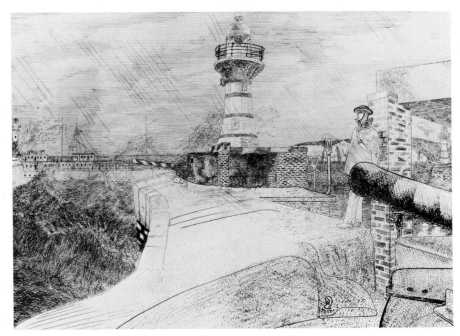

Drypoint

The drypoint engraving is the most direct and straightforward of all the techniques of intaglio printmaking. The method simply involves making a mark on the plate by scratching it with a sharp needle. Any scratch which has had ink rubbed into it will, under pressure, transfer its mark to paper. Drypoint developed after engraving as a method of intaglio printmaking in its own right. Nevertheless it is often used in conjunction with other techniques.

In theory only one tool is necessary, a hardened steel needle. More sophisticated needles, however, with diamond or sapphire points are available on the market: they never need sharpening but are expensive. The point of the needle should be round, without flat sides or facets, so that metal is not removed from the plate. There are other tools which can be used for special effects, such as roulettes – tiny spiked wheels which can be rolled over the plate, making small dots.

On a polished plate the finest scratch will come out in the print and, unlike engraving, the burr which is created on the side of the line is an important part of the general effect. Not only will the scratch hold ink, but the burr also, so that the lines on the print will be softer than in an engraving. By holding the needle at different angles to the plate, different lines can be made. If you hold the needle straight, an equal burr will erupt on either side of the the line, making it a soft line when printed. If you incline the needle to one side, the burr is thrown up on one side of the line only, creating a rough furry effect on that side. As in engraving, close lines or crosshatching will give dark results, and deeper lines will print blacker than lightly scratched ones.

Above Four drypoint needles. The two top ones are straightforward needles while the lower two are shaped like chisels so that wider lines can be made.

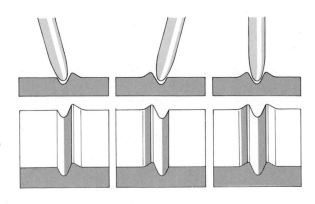

Right If the needle is held upright (1), the burr will erupt evenly on both sides of the line. If the needle is leant to either side (2, 3), then the burr will rise unevenly on one side of the line.

Left *Harbour Defences* (1941) by Anthony Gross (b. 1905). A whole range of techniques have been employed, including stippling and crosshatching to achieve a deep tonality.

Right *Labyrinth* (1970) by Bartholomew dos Santos (b. 1931). This image was created with the use of aquatint and etching which were combined on the same plate. The etching was used to define the outlines while the aquatint was used for laying on the colour.

Compared to engraving, drypoint lines are not difficult to remove. The burr can be burnished back into the lines or removed altogether. The area can then be repolished. Nevertheless, erasing a scratch is a laborious task.

A drypoint print has a most spontaneous look about it, similar to a pencil drawing, and it has the advantage over the other intaglio processes of not requiring elaborate technical expertise to either work or print. Rembrandt employed the method extensively in conjunction with his etchings especially in his later, darker works, and indeed, until the nineteenth century it was used primarily to accentuate dark tonal areas. Twentieth century artists such as Henri Matisse (1869-1954), Marc Chagall (b. 1887) and Pablo Picasso (1881-1973) have used the drypoint technique with outstanding success, producing vigorous and spontaneous prints.

Any student of intaglio printmaking should try to persevere with this technique, for often it is suitable for special effects where no other method will do.

Drypoint Hold the drypoint needle like a pencil and scratch directly into the surface of the plate. This technique may be used to reproduce a traced design in metal or as a spontaneous drawing process.

Transferring a design to the plate 1. Place a sheet of carbon paper on the plate and lay over it a tracing of the original design. Work from the back of the tracing to compensate for the reversed printing.

2. Draw over the design with a hard pencil, lifting one corner to check the progress of the drawing. This method is suitable for tracing onto hard ground for etching onto a clean plate for drypoint.

Degreasing 1. Put the plate in a sink and sprinkle on a handful of French chalk. Soak cotton wool in ammonia and work over the plate to mix up a thick white paste. Rub the paste over the whole surface.

2. Hold the plate under running water and wash off all the chalky paste. If the plate is still greasy it will repel the water and the process must be repeated until the surface is quite clean.

3. When the plate is thoroughly rinsed place it on a sheet of clean blotting paper and blot dry.

Applying hard ground 1. Place the clean plate on a hotplate and let it warm through. Dab over the surface with the ball of hard ground so that it melts onto the plate.

2. Spread the ground across the surface of the plate with a leather roller, working in all directions. Do not overheat the plate.

Etching

Hard Ground

In an etching the grooves on the plate are made chemically by acid which corrodes and eats into the metal. It was not used as a method for print-making until late in the fifteenth century, long after engraving. It is done by coating the plate with an acid-resisting film which is called the ground. Into this ground an image is drawn with a needle so that the metal is exposed underneath. The plate is then immersed in a bath of acid which erodes the exposed metal. When the desired depth has been obtained the ground is cleaned off so that prints can be taken from the plate.

Before applying any ground, the plate has to be prepared as for an engraving, and also degreased, otherwise the coating will not adhere evenly and might come off during etching. A mixture of ammonia and whiting rubbed over the plate is best for this. The plate must then be washed under cold running water and dried.

There are several grounds on the market but it is quite easy for the etcher to mix one himself. A good hard ground recipe can be made using two parts beeswax, two parts Syrian bitumen or aspheltum, and one part powdered resin. It is best to use Syrian aspheltum as others might make the ground too soft. The beeswax is melted in a saucepan and the other ingredients are then added. The mixture is simmered, with regular stirring, until it becomes a smooth and creamy substance. This takes about 20 minutes. It can then be cooled by pouring it into a container with lukewarm water. When it is cool enough to be handled, it should be moulded into small balls and left to set. In the past, artists have used numerous recipes, but the above mixture is simple and straightforward and used by most etchers today.

Before applying the hard ground, the plate must be heated on a gas or electric hotplate. The ball of ground is stroked across the metal or dabbed on to it in spots about 2½cm/1 inch apart. Where it touches the plate it will melt and leave some

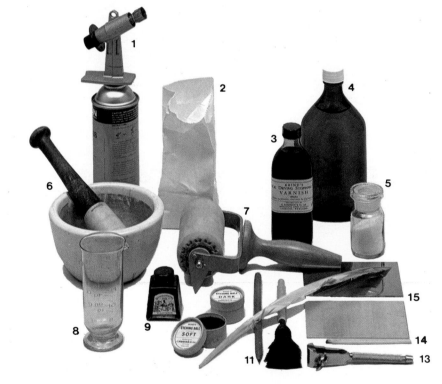

Equipment Some of the equipment needed for intaglio etching. An adjustable gas blow lamp *(1)* for heating the plate, and white chalk for cleaning *(2)*; stop-out varnish *(3)*; acid *(4)* for etching; granulated sugar *(5)* for sugar-lift aquatint; a pestle and mortar *(6)* for grinding up lumps of bitumen into a fine dust; a leather roller *(7)* for spreading the ground; a measuring jar *(8)*; drawing ink *(9)*; ready prepared grounds *(10)*; a needle *(11)* for drawing the image; a brush or feather *(12)* for removing bubbles during etching. A metal clamp *(13)*, tapers *(14)* for blackening the surface, and metal plates *(15)*.

ground behind, and this can now be spread out evenly with a leather roller. Do not use gelatine or composition rollers as they will not stand up to the heat of the plate. If the metal is too hot, the ground will begin to smoke and bubble, and then the heat must be reduced at once.

The next step is to smoke the plate. To do this, about a dozen candle tapers are tied together and lit. The plate is held firmly in a clamp upside down in one hand and the flames of the tapers are allowed to play over the ground while being moved back and forward under the plate. This makes the ground darker and more even in appearance so that the image made by the needle can be seen clearly. Once cool, the plate is ready to receive the image either by direct needling or by using tracing paper.

3. Even out the coating of ground by drawing the roller smoothly across the plate, each stroke following the same direction.

4. Secure the plate in a clamp and hold it upside down. Use lighted tapers to smoke the ground from underneath until the surface blackens. Keep the tapers moving slowly or the ground will scorch and become flaky.

Drawing on the plate 1. Work into the ground with an etching needle to draw back the waxy surface and expose the metal. The needle should lift the ground but not scratch into the plate itself.

2. Paint out flaws in the ground with stop–out varnish to prevent foul biting. The bare metal on the edges of the plate must also be protected with varnish.

3. Plates are available which have adhesive coating on the back as a protection from the acid. If there is no coating, the back of the plate must be painted with stop–out varnish and dried before etching.

Right *Portrait with Signatures* (1966) by Salvador Dali (b. 1906). This print was made using the etching technique.
Below *Haddock's End* (1980) by Graham Clarke. This print was made by etching on one plate and then hand colouring.

Above right If an *échoppe* is twisted and turned when it is being used, lines of varying thickness can be made.
Above When you are etching, you can control the depth of lines by stopping out lines and allowing others to etch more deeply. The deeper the line the darker it will print.

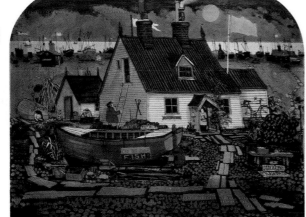

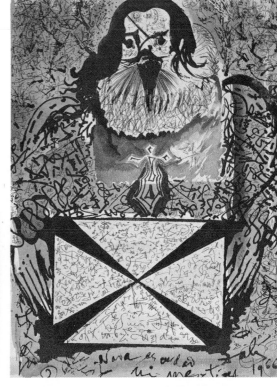

Etching the plate 1. When all the varnish has dried etch the plate in acid. Use a piece of string slung across the back of the plate to lower it into the acid bath.

2. As the plate etches bubbles form on the metal which slow down the biting. These must be brushed away using a wooden-handled brush or a large feather.

3. When the biting is complete use the string to lift the plate from the acid bath, letting the acid drain back into the dish. Rinse the plate thoroughly under running water.

Cleaning off ground 1. Place the plate on a sheet of blotting paper and rub away the ground with a rag soaked in white spirit.

2. White spirit lifts both ground and varnish. Use a clean rag to clear all traces of ground and wipe away varnish from the edges and back of the plate.

Soft ground etching 1. Put a clean, degreased plate on the hotplate. When it is warm apply the soft ground ball across the centre of the plate.

2. Work the ground across the plate with a roller until it forms a thin, even layer over the whole surface.

3. Let the plate cool and lay it on the bed of the press. Place textured objects such as string, silver paper, feathers or coarse cloth onto the plate.

4. Cover the plate with a sheet of greaseproof paper and spread the blankets on top. Run the plate through the press.

5. Turn back the blankets and lift the greaseproof paper. Carefully pick off the objects, leaving the impression of texture in the ground. Stop out blank areas of the plate and etch it in acid.

By needling the ground, the metal is exposed. The etching needle is one of the simplest tools around and can be made by setting an old gramophone needle in a wooden handle. Even an ordinary sewing needle will do. They must not, however, be too sharp or the plate will be scratched and raise a burr. A slightly blunt tip will cut through the ground without scratching the plate. On the other hand you must make sure to expose the bare metal. If insufficient pressure is used, an unevenly etched line will result. Different sized points will produce different thicknesses of line, so it will be a good idea to have several needles available. Jacques Callot (1592-1635) invented the *échoppe* which, when turned during needling, gives the effect of thin or bold lines, similar to the effect of an old-fashioned pen nib.

The longer the plate is immersed in the acid (etched), the deeper the lines will become and the blacker they will print. Given this, the design can be made accordingly by immersing the complete image for a short time and then painting out with an acid-resisting varnish all the lines that you want to print lightly. The plate can then be immersed again in the acid, so deepening the remaining lines. By repeating this process, a wide range of tonal values can be created.

In between the etches the plate must be examined carefully, and any areas where the ground is lifting should be painted out with the stop-out varnish. This varnish can be made by mixing one part resin and three parts alcohol. This mixture can be bought from most graphic art suppliers.

Soft Ground

Another method of making an etching is by using the so-called soft ground technique. A special ground is prepared for this which remains soft after application to the plate. Furthermore, it is not smoked.

The ground is made by adding one part tallow or grease to three parts hard ground, and is put on the plate in the same way as the hard ground, by

Right *Momento Vivere* by John Taylor Armis (1887-1953). This etching, portraying the North Transept of Evreux Cathedral, is remarkable for the fine detail that it shows.

6. Clean the plate with white spirit and take a proof of the image. The textures are reproduced in some detail, etched into the plate.

Drawing on soft ground
1. Draw up a design on tracing paper and lay it over a plate coated with soft ground. The image will be reversed in printing so work from the wrong side of the tracing.

2. Draw over the tracing with a pencil. The pressure makes the ground adhere to the tracing paper, producing lines of exposed metal. These have a softer quality when etched than lines drawn into hard ground.

heating the metal, stroking with the ground and then rolling it out evenly. It should be carefully handled as the slightest pressure with the fingers will remove the ground.

To make the image, a sheet of thin paper is placed on the ground and the design drawn onto the paper with a grade HB pencil. Where the pencil is pressed onto the paper the ground adheres to the back of it. When the design is finished the paper is removed, taking with it the ground over which the pencil was drawn.

After carefully stopping out any scratches in the ground, the plate is ready for etching. The texture of the paper and the pressure of the pencil will result in a much softer line than that achieved with the hard etch. Many different textures can be used on the soft ground, for example, linen, net or lace, all of which create interesting effects.

Etching Acids
The acids which are used for the etching of the plates must be stored and handled with great care and bottles or other containers should be clearly labelled. A tap and sink should be near the etching area which itself should be well ventilated. When mixing acid with water, always add the acid to the water, not the water to the acid. It is advisable to wear gloves to protect your hands when working with acids.

The thickness or sharpness of lines to be etched can, to a great extent, be controlled by varying the strength of the acids. Strong acids are inclined to widen the line; weaker acids will take longer to etch but the lines will remain sharper. For fine detail a weaker solution is preferred.

For the etching of copper or zinc the most commonly used solutions are Dutch mordant, ferric chloride and nitric acid. Dutch mordant was first used some 150 years ago and consists of a mixture of nine parts water, one part hydrochloric acid, and one-fifth part potassium chlorate crystals.

This acid etches slowly but accurately. Stronger solutions can be used but these are a little more difficult to control. Never mix the solution in a room which is badly ventilated. It is best really to do it near an open window or preferably out of doors. Mix the potassium crystals with some water in a heated saucepan until all the crystals are dissolved. Then pour the rest of the water into the etching dish and add the hydrochloric acid. Lastly, pour the mixture of water and potassium crystals into the etching dish. A gas is given off when the last is added, so do avoid breathing in any of the fumes. It will settle after a few minutes. When etching copper in the acid the solution will turn a pale green and become slightly darker with the etching of each successive plate. Eventually a new bath will have to be prepared.

Ferric chloride is the safest bath for etching. It does not give off fumes and is safe for the skin,

1–4
5–8
9–12

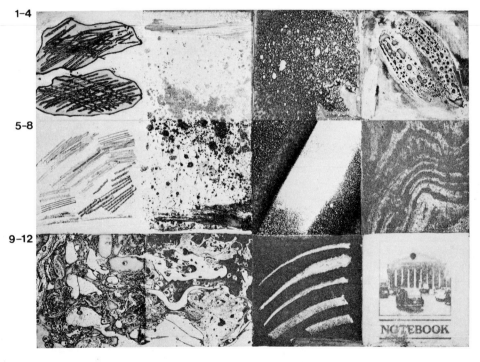

Preparing the acid bath
1. A strong solution of acid for etching on zinc consists of 10 parts water to 1 part nitric acid. Measure out the water first and slowly pour in the acid.

2. Pour the acid solution into a flat-bottomed plastic dish. The acid bath should be kept near an open window or in a fume cupboard to draw off the fumes.

Etching techniques
1. Hard ground line etch.
2. Hard ground with oil of lavender or turps splattered or brushed, combined with aquatint.
3. Stop-out varnish splattered with a brush.
4. Sugar-lift aquatint in oil.
5. Roulette run over hard ground.
6. Hard ground with oil of lavender or turps splattered or bushed, combined with open bite.
7. Spray paint.
8. Offset from relief print of woodgrain combined with aquatint.
9. Marbling with open bite.
10. Marbling with aquatint.
11. Crayon drawing with aquatint.
12. Newspaper cutting with aquatint.

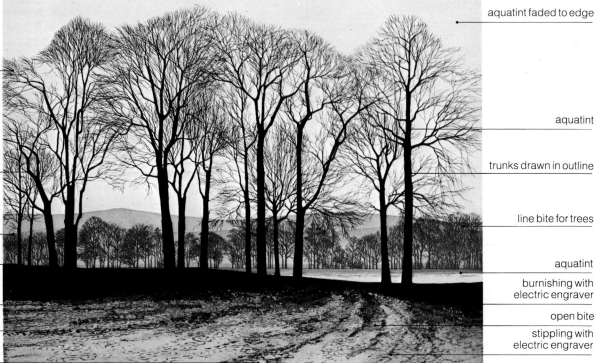

Edge of the Lake by Kathleen Caddick, etching and aquatint. Two plates were used: the first plate to be worked was printed second.

line bite for branches

crosshatching to prevent open biting

aquatint edge softened by burnishing

key line

overheated aquatint with stop-out varnish and lithographic crayon

open bite

stones drawn in line

aquatint faded to edge

aquatint

trunks drawn in outline

line bite for trees

aquatint

burnishing with electric engraver

open bite

stippling with electric engraver

Acid effects The three solutions which are most commonly used for etching bite metal in different ways.
1. Hydrochloric acid is the most generally used.
2. Nitric acid is the most violent and makes bubbles as it bites. If they are not brushed off pitting will occur and lead to irregular lines.
3. Ferric chloride is used for a slow accurate etch. It creates the finest lines.

though it leaves a brown stain. On clothes this stain is difficult to remove and should be washed off immediately. Ferric chloride can be bought in liquid form and should be used at a density of between 38° and 45° Beaume, as measured with a Beaume hydrometer.

When using ferric chloride, put the plate in the etching bath or tray upside down and keep it from touching the bottom by resting the four corners on pieces of rubber. By doing this the iron oxide which is formed in the lines during etching will fall to the bottom of the tray. If this does not happen, the lines will become clogged with iron oxide and etching will slow down and even stop altogether.

The most commonly used bath is nitric acid. It is simple to prepare and the strength of the solution can be varied according to the etcher's need. For etching zinc you can use ten parts water with one part nitric acid for a strong solution, and twenty parts water with one part nitric acid for a weak solution. For copper the proportions should be ten parts water with five parts nitric acid for a strong solution, and twenty parts water with five parts nitric acid for a weak solution.

Nitric acid always produces a gas when etching metal and this leaves tiny bubbles on the plate which must be brushed away with a feather. If this is not done the lines may etch unevenly. Nitric acid is also more prone to undercut the lines during etching. This could mar close, fine lines so that they join together to create one wide one. This happens where there are a lot of fine lines close together. The acid eats down and then sideways

into the shoulders of the relief lines.

Technique
Fibreglass or plastic photographic developing dishes are suitable as etching trays and can be bought quite cheaply. Before etching the plate, ensure that the bevelled edges are well painted out. The plate should be lowered into the acid very gently, normally using a piece of string. During the etching, leave the ends dangling over the edges of the tray so that the plate can be easily lifted out of the acid again.

It is very difficult to control the exact depth of etching. Most acids will work faster when warm than when cold, while their effect lessens the more they are used. During etching it is sensible to check the depth of the grooves regularly and also look out for lifting of the ground. Undercutting has already been mentioned and should be looked for, especially in areas which have been crosshatched. If not checked, a crosshatched area might finish up etched all over with no lines left.

Etching times for the different solutions vary widely. A strong nitric acid solution will etch a deep line after only six or seven minutes, while in ferric chloride an equally strong line will probably take as long as 15 or 20 minutes. Dutch mordant times are even longer. For a shallow line, 10 or 12 minutes are needed, and for a deeper line as much as 45 minutes or an hour is required.

Equipment and material which you will need for etching include an etching needle, échoppe, hotplate, leather roller, brushes, stop-out varnish, hard and soft ground, and carbon paper.

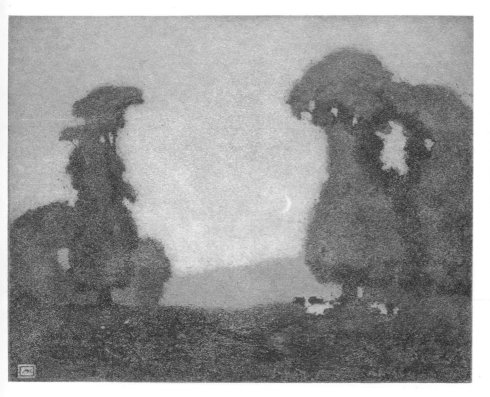

North

East

South

West

Above *Approach of Night*
(1910) by Alfred Hartley
(1855-1933). The medium of
the aquatint has been
exploited here to create the
hazy effect of evening mist.

Right *Hebridean Suite*
(1980): *North, East, South,
West* by Michael Fairclough
(b. 1940), aquatint and
etching. Two plates and six
colours were used.

Aquatint

The technique of aquatint is used for obtaining tonal areas on a print. Simply explained, it means the etching into the plate of hundreds of tiny pits which give the effect of tonality. The effect is similar to that found in newspaper illustrations.

A very fine layer of either resin or bitumen dust is sprinkled on the clean plate. When heated, this dust melts and becomes fixed to the plate and can resist acid. When the plate is etched only the bare metal areas around each resin or bitumen particle etches. Powdered resin gives the finest results. It can be bought in clear lump form so that it has to be ground finely with a mortar and pestle before use. Powdered bitumen or Syrian aspheltum produces a coarser grain, but it is easier to see on the plate because of its darker colour.

The best way to apply the dust is to put it in a bag made of nylon, muslin or any other fine mesh material. Hold the bag over the plate and gently shake or tap it so that the dust floats down and settles on the plate. Make sure the plate is chemically cleaned and degreased. Choose a draught-free area for this so that the dust floats straight down. Depending on the material of the bag, you can alter the size of the grain, but in all circumstances make sure the grain is applied evenly all over the plate. The most professional way of dusting the plate is to use a dust box. Most boxes have a kind of paddle in the bottom half which creates a small dust storm in the box when it is revolved. The plate is put into the box after an interval of about a minute. This allows the

Aquatinting 1. The best way of laying aquatint rosin evenly is in a dust box. A rotating panel inside the box raises a cloud of dust. When the plate is inserted the particles of dust fall evenly on the surface.

2. Close the box and wind the handle. Open the door and check that the panel lies horizontally forming a bed. Insert the etching plate on a metal tray and close the door of the box.

3. Wait 1½ minutes for the dust to settle on the plate. Open the door and lift out the tray. Be careful not to disturb the dust on the plate itself.

4. Alternatively a coarse coating of rosin dust can be laid by wrapping the rosin in a loose weave cloth and shaking it gently over the plate.

5. Transfer the plate carefully on to a raised wire mesh tray and heat from underneath with a bunsen burner. Keep the burner moving and do not overheat. The dust gradually forms transparent globules on the plate.

coarse grains of resin or bitumen to drop, leaving a fine dust to settle evenly on the plate. Depending on the kind of grain wanted, the amount of time the plate is left in the box can be varied. Usually this will be between two to five minutes.

The plate is then removed carefully from the box and placed on a wire frame, suspended approximately one foot above a working surface. Using a gas bunsen burner the plate is heated from below. This melts the resin or bitumen dust. The dust can also be melted on by placing the plate on the hotplate. The melting of the resin on the surface is recognized easily as the white or opaque spots become transparent. If the plate is over-heated the particles will merge together and leave no room for etching in between. The same happens if the dust is too thick and the particles too close together.

The plate is now ready to receive the image; in many cases an outline design will have already been etched into the plate by the line etching technique and you simply decide what strength tone is required in each specific area, and what length of etch for each of these tones is needed.

The first step is to stop out the areas which are to remain white on the print. The plate is then immersed in the acid for the lightest tone. After washing and drying the first tone is stopped out, and after making sure the stop-out varnish is still intact on the white areas the plate can be etched again for the second tone. The process is repeated until all the tones have been etched. The plate can now be cleaned and printed.

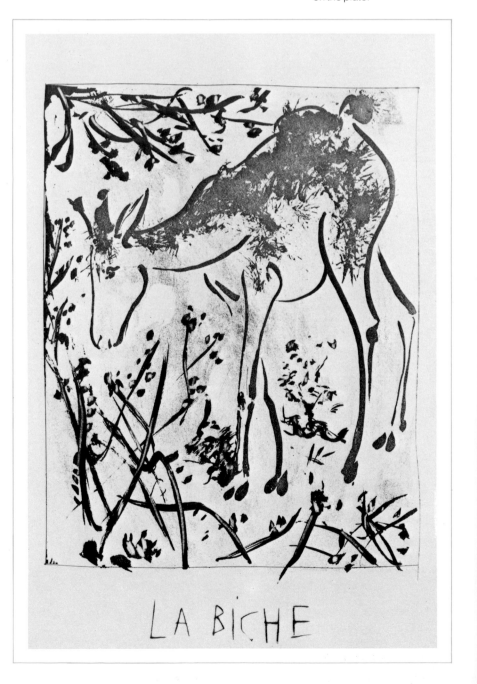

La Biche by Pablo Picasso (1881–1973) This print was done by means of the sugar-lift aquatint. Because the ink and sugar solution is brushed onto the plate the design can acquire a considerable spontaneity.

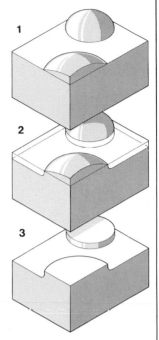

6. Use stop-out varnish to paint out areas which will print in white. Protect also the back and edges of the plate and immerse it in acid for about 15 seconds.

7. Rinse off the plate in water and blot it dry. Stop out light grey tones and return the plate to the acid. Again the biting should be timed in seconds.

8. Repeat the process until the required number of tones are bitten into the plate. Each successive bite gives a darker tone. Aquatint etches quickly and will print black after only a few minutes in the acid.

9. When the biting is finished wipe off stop-out varnish with white spirit and remove the rosin with methylated spirits. Proof the plate to check the quality of the tones.

Sugar-lift aquatint 1. Mix up a solution of 5 parts sugar with 4 parts Indian ink in a glass jar. Add a few grains of soap powder and a drop of gum arabic and stir the mixture well.

2. Paint directly onto the plate with the sugar solution to make the required design or shape.

3. Paint stop-out varnish over the whole surface of the plate to cover the design and the bare metal. Let the varnish dry completely.

4. Immerse the plate in hot water and brush it lightly until the sugar solution melts and lifts the varnish. Dry the plate and aquatint the areas of exposed metal.

Above *1.* After the plate has been covered with a layer of bitumen dust it is heated so that the dust adheres to the surface, forming an acid resist.
2. The plate can then be etched in the ordinary way.
3. When etching has been completed the dust and the stop-out varnish are removed from the plate with methylated spirits.

Tonal gradations or even cloud effects can be achieved by brushing on the acid rather than submerging the plate in an acid bath. A concentrated nitric acid solution is normally used for this technique. Regular washing of the plate under running water is necessary to keep control of the quick etching acid and to ensure that only the desired areas of the plate are being etched.

Another technique is the lift ground sugar aquatint. For this, sugar and drawing ink are mixed with a few drops of Teepol. The solution can be painted or penned on to the plate to form an image or design. When dry, stop-out varnish is painted in quick strokes all over the plate including the design. After allowing the varnish to dry, put the plate in warm water and gently rub the surface with a large soft brush or cotton wool. The varnish will lift off over the sugar and Indian ink mixture, leaving the design in bare metal. A resin or bitumen aquatint grain is applied to the plate by dusting and then melted on. The plate can then be etched in the normal way.

Equipment which you will need, as well as normal etching materials, include resin or bitumen, a dust bag or dust box, drawing ink, granulated sugar, mortar and pestle, and a bunsen burner.

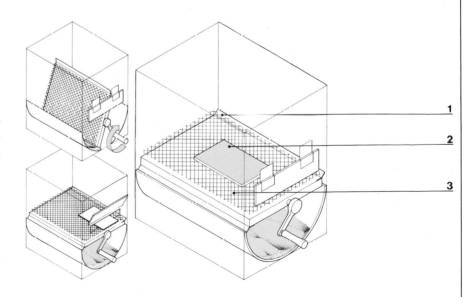

Dust Box A dust box contains a paddle *(1)*, which can be revolved so as to stir up the bitumen dust located in the bottom half. After a short interval, during which the coarser particles will settle, the plate *(2)* can be inserted. A thin layer of dust will settle on the plate while the remainder floats down through a wire mesh *(3)* on the paddle. The length of time you leave the plate in the box will depend on what kind of grain you want. It should vary between two and three minutes.

Mezzotint

This technique produces a tonal print which is made mechanically and not by etching. It has the reputation of being merely a copyist technique used for the reproduction of paintings but this opinion has become somewhat outdated.

Good mezzotints do look very much like black and white photographs. A plate is prepared to print an all-over black by producing minute little dents and burrs made with a special tool called a rocker. This is shaped like a large rounded chisel with a serrated cutting edge. Rockers vary in the size of their teeth, so different effects can be made.

The tool is rocked over the plate in many different directions, roughening the complete surface.

The image is created by working backward from black to white, using scrapers and burnishers. The smoother a surface is made, the lighter it will print. This technique can result in a beautifully smooth tonal print. Any areas which are over-scraped or burnished can be re-worked with a roulette. If a large number of prints are to be made, the plate will need to be steel-faced.

The special equipment and materials which are needed include mezzotint rockers, roulettes, burnishers, as well as most of the tools and materials used for intaglio printmaking.

Equipment A rocker *(1)* will be needed to create a texture on the plate. A set-square *(2)* and a ruler *(3)* are needed to draw up a grid. Burnishers *(4, 5)* are used for rubbing the plate in order to create different tones while roulettes *(6)* are used to erase mistakes on the plate.

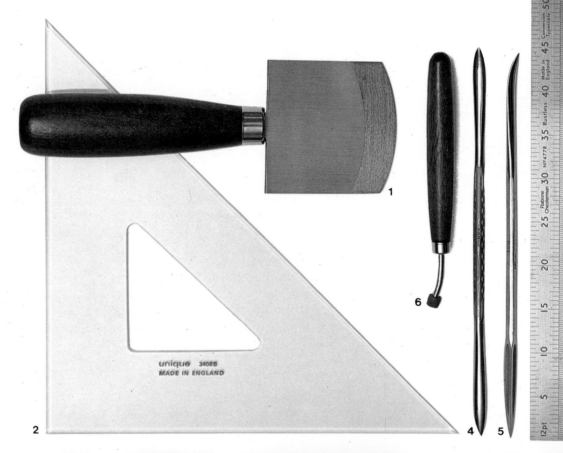

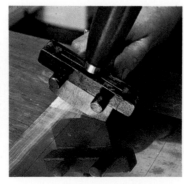

Rocking the plate 1. To achieve an even pressure the mezzotint rocker can be attached to a weighted pole which may rest either in a horizontal frame or across the worktop.

2. Hold the pole directly behind the rocker and rock it from side to side, gradually moving across the plate in a series of parallel lines.

3. When hand rocking use the forearm as a rest and grip the handle of the rocker. Make the rocking motion with the arm and hand, not from the wrist. This is a more strenuous method.

4. The plate is divided into a complex grid and must be rocked in a minimum of 32 different directions, working across the whole plate in parallel lines, to obtain the full texture.

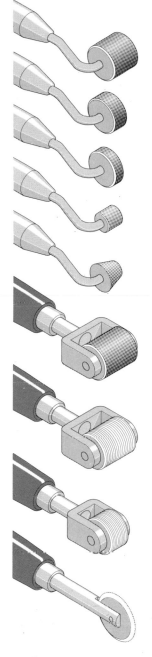

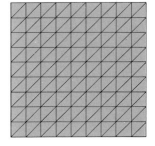

Above Four stages in rocking a plate for a mezzotint. A grid is built up of parallel lines worked over the entire surface.

Right *Long Meg* (1979) by Susan Jameson (b. 1944). This print was done using a mezzotint plate. Five colours were combined on the one plate.

Left *Roulettes* A roulette is a tool with a revolving wheel of small metal teeth corresponding to the points on the rocker. To correct an area of tone which is too heavily scraped run the roulette over the metal.

Drawing on the plate 1. When the rocked texture is complete, draw the design on the plate with a soft pencil. This can be erased in the same way as an ordinary drawing if necessary.

2. Work over the drawing with a metal point to inscribe the lines lightly into the plate.

3. Rub the plate with a burnisher to create different tones, varying the pressure to form a range of greys and white highlights. The plate prints black so you work from dark to light.

4. Alternatively a scraper may be used as a drawing tool to remove fine layers of the textured metal. The use of a scraper or burnisher is a matter of personal preference.

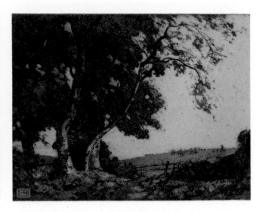

soften and be pressed into the grooves of the plate and so reach the ink.

The easiest way, and really the best, is to soak the paper in a dish, about ten sheets at a time. When soaked, remove one sheet and place it on a flat surface between two sheets of blotting paper. Place the next dampened sheet on top of this with another sheet of blotting paper covering it, so making a pile of the ten sheets, finishing with blotting paper. Lastly, a sheet of glass is added and a heavy weight put on top of it all. This ensures that most of the moisture is absorbed by the blotting paper while at the same time the printing paper is kept sufficiently damp. Sometimes this procedure is completed the day before printing. Most art shops will advise on the purchase of intaglio printing paper.

Some printmakers and art colleges grind their own inks, and when large amounts are used this is considerably cheaper. An imitation Frankfurt black pigment is mixed with a small amount of raw linseed oil. This mixture is then ground, a little at a time, on a flat, hard surface. Old-fashioned litho stones are ideal but if not available a thick sheet of glass is suitable. A muller is used

Above and right *Drooping Ash* (1909) by Alfred Hartley (1855–1958). The colour print was taken from three separate plates. The three stages can be seen in the three illustrations above. The first plate was made as an aquatint and was used to print the colour beige. The second plate was also made as an aquatint and used to print the green. The last plate was made as an aquatint and an etching and then printed in brown. The finished result can be seen in the illustration on the right.

for this grinding process until the mixture becomes smooth in consistency, almost like butter. Before printing, a few more drops of raw linseed oil are added so that the consistency of the ink allows it to drop slowly from the palette knife used for the mixing. Ready-to-use inks can be purchased and the beginner will probably find these easiest. The ink can be applied to the plate with a dabber, but a roller can be used equally well. The plate must be kept warm on a hotplate while ink is rubbed or rolled on to it. Near at hand or next to the hotplate you will place the jigger, a wooden box about the same size as the hotplate, often with a metal top and one end open.

With a pad of tarlatan or scrim the plate is slowly wiped in circular motions. This forces the ink into the grooves, at the same time removing some from the surface. A second clean pad is used to remove more ink from the surface. The plate is now removed from the hotplate and placed on the jigger where it can be given another wipe with a third clean pad. At this stage, hand wiping is introduced. You use the outer palm, below the little finger, and rub the plate almost as if brushing crumbs from the table.

Taking a print 1. Place the plate on a clean sheet of newsprint on the bed of the press.

2. Use two folded scraps of paper between thumb and forefinger to lift the sheet of printing paper, holding it by opposite corners. Lay the paper over the plate.

3. Lower the blankets over the plate and paper and smooth them out.

4. Run the plate through the press making sure no creases appear in the blankets. Pull the blankets back from the bed.

5. Lift one corner of the print, again using a fold of paper to keep it clean, and check the quality of the proof.

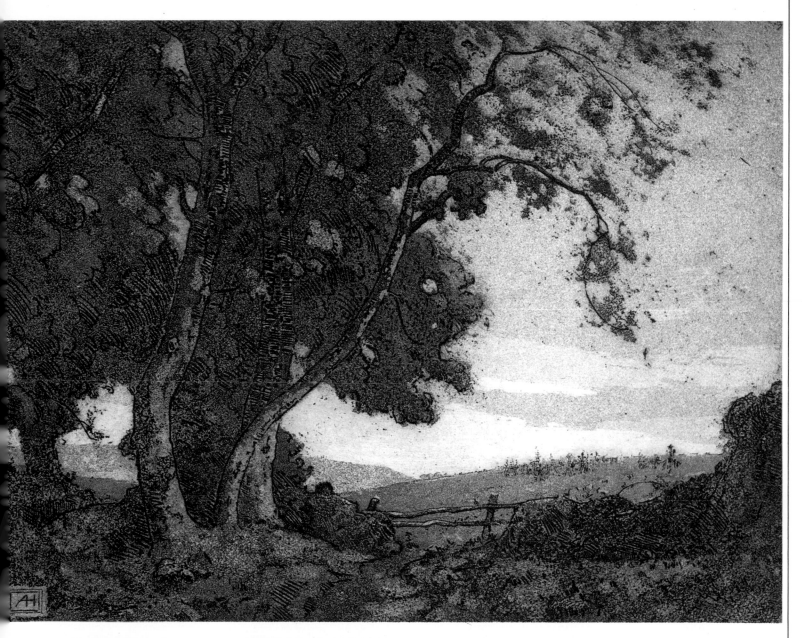

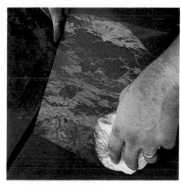

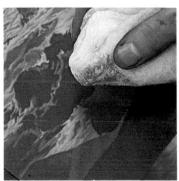

Printing in colour 1. The plate may be printed in more than one colour by dabbing coloured inks separately into different areas. Use a clean muslin dabber to ink the first section of the plate.

2. Wipe off the excess ink with scrim to prepare the surface for printing. Wipe away from those parts of the plate which are still clean.

3. Dab in another colour with a clean dabber and wipe with scrim as before. Several colours can be applied in this way but be careful not to wipe one colour over another.

4. Take a print of the plate on damp paper in the usual way. The colours will bleed into each other a little but the separate areas will show a clear change of hue.

The box part of the jigger should hold some French chalk. A very small amount of this could be put on the palm of the hand and smoothed out before wiping the plate. It gives the surface a final cleaning before placing it on the press ready for printing.

A last wipe is sometimes given with a clean pad of mutton cloth or even a piece of newspaper, but in both cases some ink can be lost from the grooves or tones, making the print rather pale. Though opinions vary, the ideal print should have a slightly grey even tone over the complete plate area. This will set it off against the paper.

The printing press is the one piece of equipment most amateur printmakers find the greatest obstacle. They are expensive, difficult to obtain, and very heavy to move. Some small modern table models are now available but even these can cost as much as £300 ($650) for a simple model.

A press is very simple in design, consisting of two heavy rollers one above the other, with a sheet of rigid metal in between which acts as the bed. The inked plate is put on the bed with the sheet of dampened paper on top of it. The paper must be larger than the plate. Three layers of felt blanket are put on top of this. The complete sandwich of bed, plate, and blanket is then run between the two rollers under great pressure. The high pressure required is the reason for the enormously heavy construction of intaglio printing presses.

The felt blankets should, ideally, be made of wool, the two outside blankets being normally 3mm/⅛ inch thick and the middle one 6mm/¼ inch. They can be dry-cleaned or washed when dirty. If they are worn badly they should not be put in direct contact with the printing paper as the weave of the cloth will transfer to the paper.

When printing, the pressure between the rollers should be set carefully. Too much will cut the paper on the edges of the plate while too little will result in a bad quality print. Pressure should also be even from side to side. Always ensure that the edges of the plate are clean and place the plate on a thin, clean sheet of paper on the bed. The printing paper is carefully put on top of the plate, using paper tabs to carry it so that it stays clean. The felt blankets are then lowered onto the paper and care must be taken to make sure that there are no creases. The ends of the blankets are always kept in position and held by the rollers, so the press can be used in both directions for printing.

The prints are placed between dry blotting paper with a flat board and weight on top, to make sure they will dry and flatten out evenly.

A simple printing press for small plates can be made by adapting an old-fashioned wringer or mangle. Some Victorian ones are quite heavy, and as long as the rollers are not too badly worn, satisfactory prints can be obtained. Some beginners even use more modern wringers with rubber rollers. As long as the bed is rigid and held horizontal, a print can be made.

Colour Printing

Colours can be printed by these processes even though the popular idea of an intaglio print is that it should be black and white. The simplest technique for colour printing is to keep to two basic colours only, one for the etched image, the other for a background tint. For this method the plate is inked up normally and the surface cleaned. The second colour is applied to the clean surface with a hard roller. Normally a thin lithographic printing ink is used for this. The plate is then printed in the normal way. Using small rollers or dabbers, more colour can be added to the plate before printing, but some of the sharpness of detail can be lost.

Another way is to cut the plate into separate pieces. A fretsaw with a blade which cuts metal is ideal. Each piece is inked up with a different colour ink and then placed back together on the press bed like a jigsaw puzzle, and again all colours are printed in one operation.

A more complicated technique involves producing a separate plate for each colour. The plates have to be identical in size and a key drawing is made which can be transferred to each for registration of the image. Each colour print is then run through the press separately. Between the printing of each colour the leading edge of the printing paper is held between the rollers together with the blankets. The lightest colour is usually printed first, then the next plate is registered on the bed and the paper and blankets carefully lowered in position so that another print can be taken. The process is continued until all plates are printed. Speed is essential for this method because the paper must remain damp and must not shrink during printing. Ink all plates before printing so as to save time between the printing of each colour.

Many of the intaglio prints illustrated in this chapter and others which you will find in art galleries incorporate more than just two colours and a single plate and you may well aspire to making such prints. Some prints are made using as many as three plates and a whole range of colours. In addition, many of them incorporate more than one of the intaglio processes. Line engraving, etching, aquatint and mezzotint are sometimes all combined in one print. Sometimes a different plate is used for each technique though often more than one technique might be combined on a single plate. A wide range of colours might be applied to the plate and result in a print of great subtlety. Sometimes, as we have seen, a plate may be cut in the manner of a jigsaw to enable the number of colours to be increased. One word of warning, however: these techniques require enormous skill and it can only be acquired after years of practice. When you begin intaglio printing you would be well advised to stick to one technique at a time before attempting these more complex aspects of printmaking.

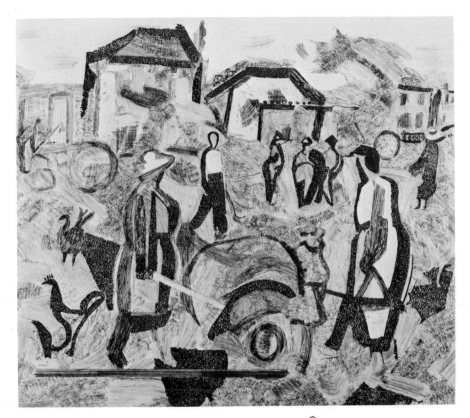

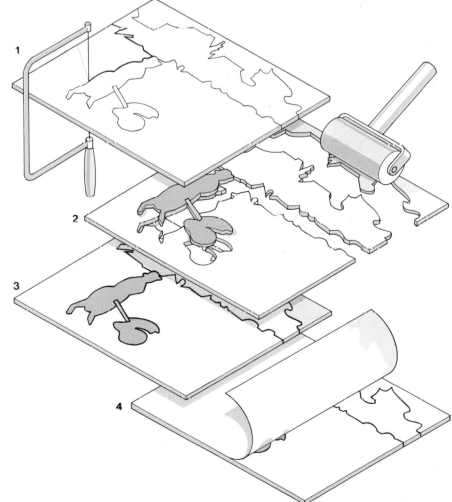

Top *A Woman with a Wheelbarrow)* (1956) Anthony Gross (b. 1905). This print was designed to be printed in one colour but if the plate were to be cut into various parts it could then be printed in a greater number of colours. It has simply been used as an example to show how the process works.
Above Firstly, you must delineate those areas which you want to cut out.
Right *1*. Cut out those areas of the plate which you want to emerge as coloured in the final print.
2. The pieces are removed from the rest of the plate and inked up.
3. They are put back in position together with the other pieces of the plate.
4. The plate can now be printed in the usual manner.

Planographic Printing

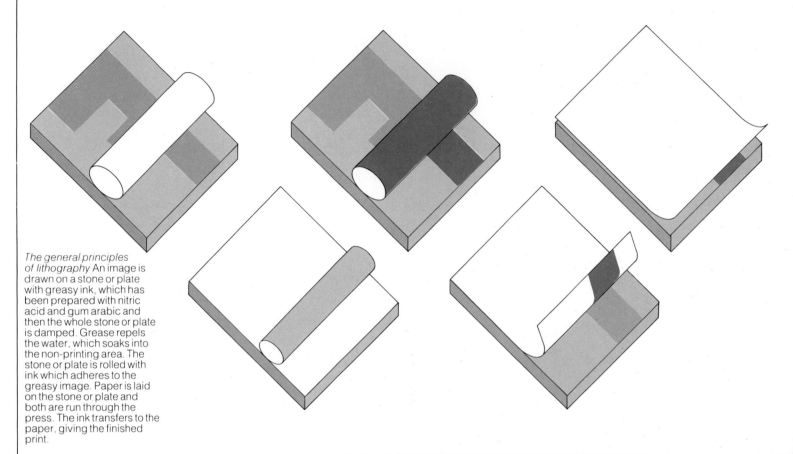

The general principles of lithography An image is drawn on a stone or plate with greasy ink, which has been prepared with nitric acid and gum arabic and then the whole stone or plate is damped. Grease repels the water, which soaks into the non-printing area. The stone or plate is rolled with ink which adheres to the greasy image. Paper is laid on the stone or plate and both are run through the press. The ink transfers to the paper, giving the finished print.

Lithography is closer to painting and drawing than any other printing process. Images are drawn directly onto stone or plate giving a freedom of expression that has proved very attractive to artists schooled in traditional brush techniques. At the same time, lithography has stimulated the development of commercial reproduction and benefited from technical advances in related fields, particularly photography.

Aloïs Senefelder (1771-1834) is the man credited with the discovery of the lithographic process. Born in Offenbach, Bavaria, Senefelder was a playwright who devoted his life to pioneering and perfecting lithography. His desire to find a more economical way of duplicating his play scripts led him to experiment with local limestone slabs, discovering the principle of planographic printing almost by chance. In planographic printing, as distinct from the traditional methods of relief and intaglio, the image and the undrawn area are on the same level; the process is chemical, based on the antipathy of grease and water.

The first uses of lithography were almost wholly commercial; initially artists were slow to react to the new process. Early lithographs, such as those by William Blake (1757-1827) and Henry Fuseli (1741-1825) published in London in 1810, show a limited use of line and crayon. Francisco Goya (1746-1828) was the first major artist to produce lithographs which displayed qualities

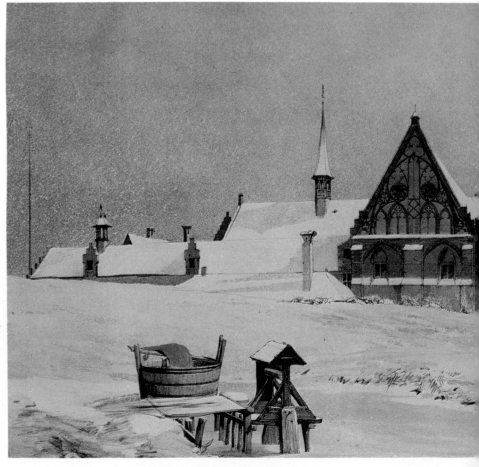

Lithography is a process which has many varied applications and possibilities. **Above** This portrait of Senefelder by Graham Sutherland (1903–1980) was commissioned by Felix Man, the authority on the history of lithography.

Left *Byloke, Ghent* (1839) by Thomas Shotter Boys (1803–1874) is the first great work executed in Charles Hullmandel's process of colour lithography. Shotter Boys was the archetypal topographical draughtsman of the nineteenth century. Landscapes such as this were collected and bound into volumes and were popular with travellers.

Above right The commercial aspect of lithography is typified by this Victorian chromolithograph by Richard Ansdell, printed by J. B. Day. Artists were trained to interpret works in lithography, using as few stones as possible. These reproductions and popular illustrations found a wide market. **Below right** *Fruit Seller* (c. 1895–1899) by Pierre Bonnard (1807–1947), one of a series of 12 lithographs entitled *Quelques Aspects de la Vie de Paris*, published by Vollard.

unique to stone, especially evident in *Taureaux de Bordeaux* (1825). After the Napoleonic Wars, the romantic artists, Jean Louis Géricault (1791-1824) and Eugène Delacroix (1798-1863) came to work at the presses of Charles Hullmandel in London. Hullmandel established exceptional standards of printing from stone and his researches finally led him into the realm of colour printing, where his work with Thomas Shotter Boys (1803-1874) reached a peak in the nineteenth century.

In the early nineteenth century the process began to gain popularity in France. Many workshops flourished, and, among these, Engelmann's Paris workshop was most important. Godefroy Engelmann (1788-1839) developed chromolithography (the four-colour system) using Newton's colour theories, and patented the process in 1837. Lithography proved an ideal vehicle for a new and popular form of social satire, executed with great skill by such artists as Honoré Daumier (1808-1879) and Gavarni (1804-1866).

The mid-nineteenth century saw no major aesthetic developments in either France or England, but there were several significant technical developments. Alphonse Louis Poitevin produced the collotype method of printing a photographic image (fixing the image on a gelatine surface) and, later, in 1852, cooperated with the printer Lemercier in the introduction of the photolitho process on stone. The first mechanically operated presses appeared about 1850 and brought with them great potential for printing commercial work. The following decade saw the arrival of artists such as Jules Chéret (1836-1933) who began to specialize in the design of lithographic posters, establishing what has since become an acknowledged art form.

Lithography reappeared as an important medium for artists in France as the Impressionist movement got underway. The publisher Cardaret persuaded Edouard Manet (1832-1883) to produce lithographic images which displayed the freedom found in his paintings. This innovative approach paved the way for succeeding generations of artists who were interested in graphic design. Henri de Toulouse-Lautrec (1864-1901) was encouraged to try poster lithography after seeing Pierre Bonnard's (1867-1947) poster, *France-Champagne* (1890). Inspired by the Japanese woodcuts exhibited in Europe for the first time and depicting popular entertainments in flat, decorative colours, Lautrec went on to produce lithographs of Parisian life in the 1890s, using the medium to create compositions revolutionary in style. Lautrec's posters, with their bold areas of colour defined by clear outlines, transformed the art of advertising.

Encouraged by publishers, many other artists gathered in Paris at this time made lithography an important element in their lives. Edgar Degas (1834-1917) developed his own method of transferring drawings to stone, while Odilon Redon (1840-1916) concentrated most of his creative

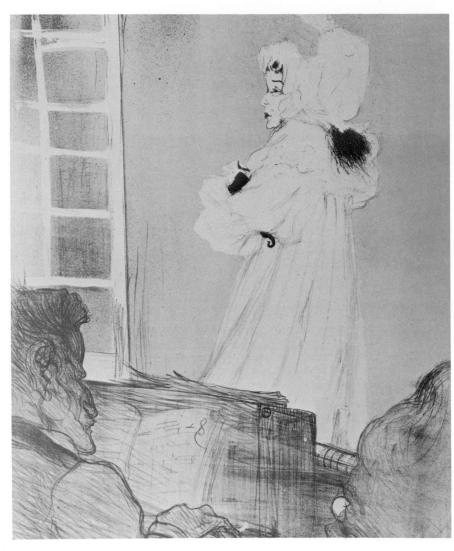

Above *Miss May Belfort* (1895) by Henri de Toulouse-Lautrec (1869–1901), one of a series of six lithographs Lautrec made of this performer from the Cabaret des Décadents, who dressed in baby clothes and carried a cat during her act. Lautrec often studied such models for weeks, producing a series of prints which varied in intensity. This crayon drawing on stone was hand-printed and shows both a sensitive use of lithography and powerful draughtsmanship.

efforts on lithography. Bonnard contributed to such periodicals as *La Revue Blanche*.

J. M. Whistler (1834-1903) took the ideas developed by the Paris school of artists across to England, interpreting the atmosphere of London in lithographs produced in cooperation with Thomas Wey, his printer. Lithography also flourished in other European cities, particularly Vienna. The Secessionist artists, and later the group known as 'Die Brücke' led by Ernst L. Kirchner (1860-1938), chose lithography to express their ideas. Individual artists also made significant use of the process – Emil Nolde (1867-1956) employed a broad brush technique, Georges Rouault (1871-1958) adapted the *manière noire* to lithography (covering the stone with ink, then producing a white negative drawing by using a scraper), while Edvard Munch (1863-1944) often used the process in conjunction with woodcuts.

Between the turn of the century and the outbreak of the First World War, broad developments took place in technology. The four-colour lithographic system was perfected and an American, Ira Rubel, devised what eventually became offset printing. By 1900 grained zinc had become a

Right This 'polyautograph', *Enoch*, by William Blake (1757–1827), produced around 1807, is a rare example of an early lithograph and was executed on stone with pen and ink. After the Napoleonic Wars, artists were temporarily discouraged from working in the medium, due partly to the poor response which greeted the first published lithographs.

common replacement for stone, bringing advantages to both artists and the commercial world. Rotary printing, the mechanization of offset printing, followed from these developments.

After the First World War, publishers such as Vollard maintained the interests of artists and the public in printmaking, but it was only following the Second World War that it took on a new lease of life. In Paris Pablo Picasso (1881-1973) began a series of lithographs which displayed his powers of draughtsmanship and imagination. Jean Miro (b. 1893) and Marc Chagall (b. 1887) began to make prints as well; by 1948 most practising painters and sculptors were regarding printmaking as a normal extension of their work. Such establishments as Mourlot Frères provided the technical expertise. Between the wars in England, Curwen Press and Baynard Press had given similar encouragement to such artists and book designers as Graham Sutherland (1903-1980) and John Piper (b. 1903).

In the postwar years, Paris gradually lost its importance as a focal point for developments in painting and sculpture. London and New York produced significant movements such as

Above left *Seated Figure VI 'Alcove Corner'* (1974) by Henry Moore (b. 1898) and published by the artist, shows how Moore is able to treat three-dimensional subjects lithographically, experimenting considerably with washes of ink to create the impression of form and distance.

Above right This typical still life, *Lilies* (1971) by David Hockney (b. 1937) is a direct and forthright example of a lithograph drawn on a zinc plate, showing a vigorous use of crayon in terms of colour.

Abstract Expressionism and Pop Art which recreated opportunities for printmaking. Galleries and art dealers became more internationally based and print workshops were established in London, New York and Los Angeles to provide facilities for artists. Robert Rauschenberg (b. 1925), Jim Dine (b. 1935) and David Hockney (b. 1937) are artists who, in recent years, have made full use of the photographic and autographic developments in lithography. Henry Moore (b. 1898) also uses the process to express his interest in the human form.

Artists and printmakers today have greater opportunities than ever before to explore their ideas. Aside from educational facilities, there are workshops in Europe and North America, some experimental, some commercial, which provide places where artists can attempt lithography, both traditional methods, and the new processes of photolithography and continuous tone work. For commercial lithographers, the development of high precision presses and electronic devices, will demand different skills and bring their own characteristics to what Senefelder termed 'a chemical form of printing'.

Lithography is a planographic process: that is, the image and the non-printing areas are on the same level on the stone or plate. The process is a chemical one, transforming the artist's work into an ink-attracting layer while the remainder of the surface is kept free from ink by applying a film of water. It is this antipathy of grease and water which characterizes the process.

Lithographic Surfaces

Since the discovery of lithography by Aloïs Senefelder in the eighteenth century, artists have been drawing on stone, particularly limestone from - the quarries of Kelheim in Bavaria. Senefelder found this material to be an ideal surface on which to draw, with a naturally fine grain to hold the greasy drawing, yet porous enough to absorb water used at the printing stage. Because of these unique qualities and the fact that the quarries have been worked out, lithographic stone is now rare. Samples can still be found in printers' workshops or at sales and auctions.

Stones vary in size according to the size of the press but those which will take an A4 (297mm x 210mm/11¾in x 8¼in) sheet are adequate for the beginner. All stones must be at least 6⅓cm/2½in thick to allow regrinding and prevent possible breakage.

Since the late nineteenth century zinc plates (aluminium in North America) have been a common replacement for stone. Chemically, stone printing differs from plate printing but to produce a printable lithographic mark both processes require the use of drawing materials which contain grease or soap (fatty acids) in various combinations. Both also depend on gum arabic solution to ensure clean and satisfactory printing. This is applied to the undrawn areas.

Much of the success of lithography depends on careful preparation of both stone and plate.

Preparing the Stone

Preparing the stone for drawing involves clearing away previous work and giving the stone the correct grain for a new image. The simplest way of removing the old image is to grind two stones of similar size surface to surface. In a sturdy trough, equipped with running water and a sludge trap (to catch waste sand), sprinkle the lower stone with coarse sand or silicon carbide mixed with a little water. Grind the upper stone over the lower one in the shape of a figure eight to ensure that the entire surface of the lower stone is covered. The action must be even and consistent over the whole surface; not much pressure is needed but you may need to replenish the grinding paste with sand and water from time to time to prevent the mixture from drying out. To check that the old image has been removed, rinse off the paste with water and rub the stone with a cloth soaked in some pure

Right *The antipathy of grease and water* Lithographs are made by drawing on zinc plate or stone with greasy inks and crayons. The surface is damped and the grease repels water. When printing ink is rolled over the image the greasy materials attract ink but the bare grainy surface of stone or plate is protected by the water and the ink is rejected.

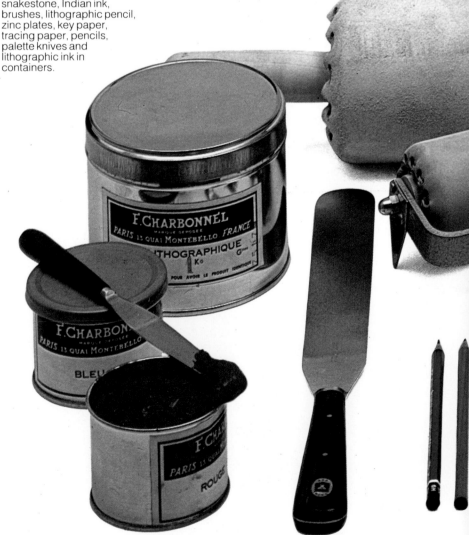

Basic materials for lithography include **(clockwise from top left)** calfskin rollers, lithographic stone, white spirit, sponge, gum arabic solution lithographic ink in stick form, lithographic crayons, snakestone, Indian ink, brushes, lithographic pencil, zinc plates, key paper, tracing paper, pencils, palette knives and lithographic ink in containers.

Preparing the stone 1. Damp the stone and sprinkle it with silicon carbide. Work over the surface with a top stone, grinding in a figure 8 motion until a thin white slurry develops.

2. Continue to polish the stone with a block of snakestone, held firmly in both hands. Rub the snakestone back and forth evenly across the whole surface.

3. Use fine-grained silicon carbide and a small piece of lithographic stone to lay the final grain. Rub gently with a circular motion until the surface is smooth and clean.

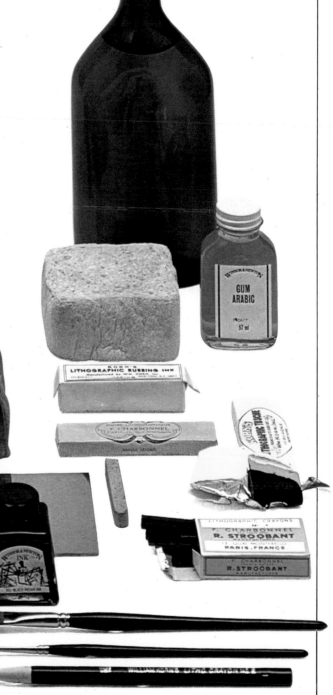

Left *Regraining plates*
The process of cleaning and regraining a used zinc plate must be done professionally as the machinery needed, apart from being extremely expensive, is heavy and noisy and requires special drainage facilities. The machine has a large rectangular trough with a flat bed. The zinc plates are washed out with acid to remove the old image and are then clamped into the bed. A large quantity of marbles – in this case hardened steel ball bearings – are poured over the plates. The machine is set in motion to agitate the marbles and certain lubricants and abrasives are added at intervals. When the process is complete after about 55 minutes the marbles are run out through a gate in one side of the trough and the bed is tipped and rinsed thoroughly with water to clean out slurry and prevent oxidization of the plates. The plates are then lifted out and washed individually and set to dry.

turpentine and a little black printing ink. This will emphasize any latent image. If no image shows, the stone is ready for polishing. If the image still persists, continue grinding until the surface is completely clear, otherwise the old image will reappear when the stone is printed.

An alternative method of grinding is to use a levegator. This is a cast metal disc held by a vertical handle which is rotated over the stone in combination with abrasive and water.

After the old image has been removed, the coarse surface of the stone is polished smooth with a stone known as snakestone. First wash away all grains of sand from the lithographic stone, as these can scratch it during polishing. Hold the polishing stone in both hands and rub it up and down the whole surface of the lithographic stone, which should be liberally sprinkled with water. Replenish the water occasionally to allow smooth polishing. The stone should become glass-like to the touch fairly quickly.

Next, the stone must be grained, or given a slightly rough surface. A fine grain abrasive (220-350) will produce a surface which is suitable for delicate crayon, frottage, pen drawing and washes. Coarser grains (100-220) give surfaces which suit soft grades of crayon and which print flat solid areas. Carborundum powder, though more expensive than sand, is ideal for graining as it is very abrasive and works quickly. The method is similar to that used for removing the old image. A piece of lithographic stone, small enough to fit in the palm of the hand, is used in conjunction with the selected grade of grit, and, again, water is added to form the abrasive paste. Work over the whole stone in small circular movements, adding a little water from time to time. Test the grain by rubbing an HB pencil over a small area on the edge of the stone; the pencil mark will reveal the quality of grain which has been achieved. Test for any surface unevenness with the edge of a metal rule. Hollows must be ground away, or the printing will be impaired. Finally, the edges of the stone should be bevelled with a file to remove any sharp

corners. Wipe the surface with a sponge and plenty of clean water to remove grinding slurry and allow it to dry, then cover it with a piece of clean paper until you are ready to begin drawing.

Preparing Zinc and Aluminium Plates
A plate can be ground using the method described above, if it is first anchored to a lithographic stone, but this takes time. It is easier to buy plates from a supplier – the type of grain will be specified. Plates can be reground by the supplier as many as seven or eight times before the metal wears thin. Before beginning drawing, prepare the plates by removing dust or oxide with a commercial chemical solution. A saturated solution of alum and water, with a few drops of nitric acid added, will also serve the same purpose. Apply the solution over the whole plate; repeat two or three times and then wash the plate in clean water. Dry thoroughly, cover with clean paper and store in a dry place.

Lithographic Drawing

Materials
Lithographic materials must contain grease or soap in the form of fatty acids in order to function on the stone or plate. Traditionally they are pigmented with black (carbon). Many materials can be adapted for lithographic drawing – wax crayons, oil pastels, candles, shoe polish and Chinagraph pencils are only a few you can use.

A supplier can provide a number of materials designed specifically for lithographic drawing, including lithographic crayons (which come in ascending grades of hardness, numbered one to

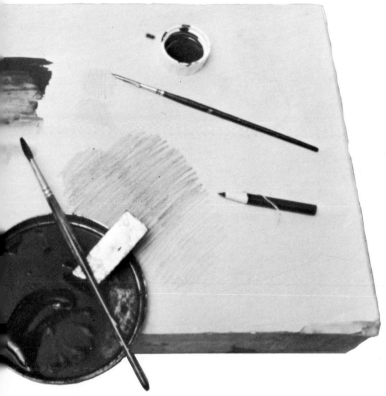

available in a variety of surfaces and has been used by artists since the early nineteenth century, although it was first developed by Senefelder much earlier. One side of the paper is gummed; the image is drawn directly on this surface and later transferred to stone by applying pressure and moisture. The backing paper is then peeled away, leaving the image on the lithographic surface. Lithographic drawing paper has the added advantage of eliminating the need for regrinding if the drawing does not work out satisfactorily, but some artists find that an element of freshness is lost if the drawing is not done directly on the stone. A simple version of this paper can be made by coating sheets of good cartridge paper with three layers of very dilute gum arabic solution applied with a sponge or soft roller. The sheet should then be dried on a flat surface with the edges taped down to keep the paper even.

Lithographic transfer tracing paper, used for tracing information onto stone or plate especially in colour work, is supplied by stockists. It can be made by applying red oxide pigment to one side of a sheet of ordinary tracing paper, making sure that enough adheres to last for several prints.

Technique
After they have been prepared for drawing, both stones and plates are sensitive to grease and any thumbprints, fingerprints or hand impressions could show up in the finished work. Use a piece of paper as a bridge on which to rest your hand when drawing. The edges of the stone or plate should also be protected by painting gum arabic solution around the perimeter to a depth of about one inch. This margin gives the printing rollers room to feed the image and also provides some space for registration marks. Dry the gum before drawing.

Drawing for Monochrome
Make preliminary sketches on the stone or plate with charcoal, Conté or carbon black pencil, as these do not print lithographically. Any areas you intend to leave white can be painted out at this

five), lithographic crayons in pencil form, liquid and solid forms of lithographic ink, soft grease blocks (for frottage and rubbed textures) and hard lithographic drawing nibs. Charcoal pencils, Conté pencils or carbon pencils are non-greasy and therefore ideal for any preparatory work on stone or plate which is not meant to print.

Sharp knives, burins and razor blades are needed to scrape negative areas. Watercolour or oil painting brushes can be used to apply ink.

Lithographic stones are usually too heavy and cumbersome to be transported from place to place. A method which enables artists to make drawings outside the studio and transfer them easily onto stone involves the use of lithographic drawing paper. Lithographic drawing paper is

Drawing materials for lithography **(clockwise from top right)** Dip pen and autographic ink; lithographic pencil; stick ink, dissolved in distilled water; rubbing block and lithographic crayons – together with the different effects these materials produce on the surface of the lithographic stone.

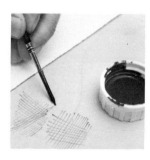

Drawing on stone 1. Lithographic crayons are used in the same way as pastel or chalk in drawings on paper. Vary the pressure on the crayon to create a variety of dark, grainy tones.

2. Use a clean rag to pick up black from a rubbing block and rub an area of dense, solid tone over the stone surface.

3. To work on a detailed drawing with fine linear qualities use a dip pen and autographic ink.

4. Lithographic ink in stick form is dissolved in distilled water to produce a thick black liquid which is applied to the stone with a brush. To make thin washes of grey tones add more water to the ink.

5. A range of hard and soft pencils are available which may be more suitable than crayons for detailed work. The drawing material is encased in coiled paper which is gradually peeled away.

Test plates 1. An artist who is unfamiliar with lithography makes a test plate to investigate effects. A variety of ordinary drawing materials will leave a sufficiently greasy mark to make a print.

2. A resist method of drawing with gum may be used. Thin brush strokes of gum are applied to the plate and dried, then a crayon is used to draw on the plate. When the gum is washed away parts of the image lift.

3. The gum resist method is also effective with ink washes. Again the gummed areas are first painted on and dried. Ink washes are applied over the top and when they are dry the gum is washed off.

4. Pools of water are spread on the plate with a soft brush and oily ink is dropped into the water. The ink spreads into irregular shapes and when the water is dried off a textured wash settles on the plate.

5. Cardboard or plastic masks may be used to form stencilled designs. The mark is laid on the plate to protect the grained surface while the drawing materials are freely used around the masked shape.

6. A variety of subtle effects are obtained by combining crayon with ink drawing. The crayon produces broken, grainy tones while the ink forms fluid lines and areas of wash.

7. Drawing with a brush into damp glycerine gives soft-edged shapes. The ink spreads into the glycerine but is controlled by its viscosity.

8. A design is drawn on card with thick, wet ink. This is pressed down onto the plate and the card is rubbed over the back to print the image. If the plate is wet the marks are more diffuse and textural.

Transferring a drawing to the plate 1. The required part of a design is transferred to the plate by means of a tracing of the master drawing and a sheet of red, lithographic transfer paper, or key paper.

2. Place the key paper face down on the plate with the tracing over it. Draw over the tracing and lift one edge carefully to check process. The red line made by the key paper is only a guide and does not print.

stage with gum arabic solution using a fine water-colour brush. The gum should have dried thoroughly before you proceed. Only use turpentine-based inks in conjunction with gum; water-based inks penetrate the film, depositing grease.

Begin drawing with the hardest grade of crayon. Softer grades tend to fill in the grain quickly; harder grades give more opportunity for detail work in the early stages of drawing. For 'dry' forms of grease, such as lithographic crayon or rubbing blocks, the work should be drawn firmly into the grain of the stone or plate.

Different drawing materials can be used in various combinations on a stone surface, according to the effect required. Working on stone also enables you to scrape or cut the surface with knives or points to alter the texture; at a later stage, diluted nitric acid can be used to diminish tonal qualities by working over the area with a brush.

Remember that if you are drawing for the direct printing method, the impression will be reversed compositionally (laterally reversed), but will remain the same if proofed on an offset press.

The materials used for drawing on stone can be used for drawing on grained metal plates but slightly different effects will be achieved. Diluted

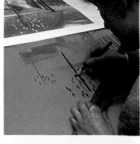

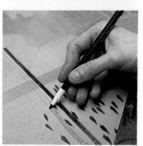

Drawing on the plate 1. Draw directly on the plate over the traced image using a master drawing as a guide.
2. Rest on a wood support or paper to keep surface grease-free.

washes of lithographic drawing inks dry on plates by evaporation leaving a characteristic linear edge; on stone the drying process takes place by evaporation and by absorption, giving a more even texture. Nitric acid cannot be used to etch zinc or aluminium plates; they have a different chemical composition from stone.

Plates can be printed by the direct method, but they are particularly suitable for colour printing by the offset method. The grain on metal plates must be treated carefully – unlike stone, it is 'imposed' or raised on the surface and is not a part of the total composition of the plate.

Drawing for Colour
A separate stone or plate is required for each colour in a colour lithograph. The process is fairly complicated and most artists begin by producing single-colour prints before attempting more complex compositions. It is a good idea to make a series of colour sketches to help decide which colours to use and where the colour areas will be.

The stones or plates are drawn individually but must print in sequence on the proofing paper, in overprinted as well as juxtaposed colours. Some lithographers prefer to see each colour proofed

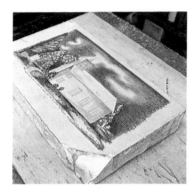

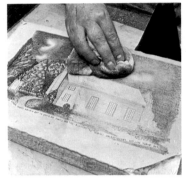

Washing out the stone 1. When the drawing on stone is complete cover the whole surface with gum etch solution, applied with a sponge. Let it dry and stand for a minimum of 8 hours to process the drawing.

2. Soak a rag in turpentine and wipe over the image to remove the black drawing material from the surface of the stone.

3. Rub over the stone with aspheltum on a clean rag, working it into the greasy image. This reinforces the grease on the stone.

4. Wash off aspheltum and remaining gum with water to clear the whole surface of the stone, leaving only the greasy image now stained light brown by the aspheltum.

before they draw the next; others draw a series and have them proofed as a group.

It is important to state each colour sufficiently. For example, a stone or plate which will be printed in lemon yellow must be emphasized when it is drawn, so that the colour will show up well in relation to the others in the proofing sequence. Even though the image will be drawn on each colour stone or plate in black, the artist must bear in mind the eventual colour and try to anticipate the desired effect.

All colours must fit together correctly and consistently. A simple method of registering involves tracing the outline of the image (same size) on grained film or strong tracing paper with a technical pen or fine ball point. Make two crosses on either side of the drawing to act as registration points. Place the tracing in position on the stone or plate and secure it at the top edge with a piece of tape. Insert a sheet of lithographic tracing paper between the tracing and the lithographic surface chalk side down and follow the line of the drawing with a fine stylus or ball point pen, pressing firmly. This will deposit a non-printing red ochre line onto the stone or plate, which can then be used as a guide for the lithographic drawing. Repeat the operation for each stone or plate. Do not forget to draw in the registration marks on each stone or plate and do not use carbon paper for tracing – it is greasy and will print.

Right *Life Class No. 3* (1968) by Allen Jones (b. 1937). The key image is executed on stone to exploit the surface texture, while the colour variations are done on zinc plate.

Processing

Stone

When the drawing has been completed, make sure that the surface of the stone is dry, either by using an electric dryer or a fan made from stiff cardboard. Dust the surface with a fine layer of

Processing the plate
1. Non-printing areas of the plate are gummed while the image is drawn to protect the surface. When the drawing is complete the plate must be processed to fix the image.

2. Dust over the whole image with French chalk to make sure it is completely dry and will not smudge during processing.

3. Cover the plate with a thin layer of gum, applied with a clean sponge. The gum adheres to the bare plate but is rejected from the greasy drawing.

4. Dry the gum with a hairdryer or fan. It must be completely dry before moving onto the next stage.

5. Wash out the image with aspheltum to remove the black drawing material and encourage the greasy qualities of the image.

11. Dust the inked image with French chalk.

12. Sponge off the plate with clean water. At this stage corrections may be made to the drawing by erasing unwanted marks.

13. Corrections to the drawing are made on the damp plate before it is etched. Rub out errors with an eraser stick made of bound compressed pumice powder.

14. Rest hands lightly on a damp sponge to avoid direct contact with the plate. Use a small eraser stick for fine corrections.

15. When the image is satisfactory the plate can be etched. Pour zinc plate etch onto a damp sponge:

plain talcum powder or French chalk.

Complex images are best processed by a knowledgeable lithographer, but the following is a simple method which incorporates many standard procedures while leaving room for improvisation and adaptation.

First apply a film of gum arabic and nitric acid (2% solution) to the stone. This layer chemically forms a water-attracting surface on the undrawn areas of the stone at the same time as hardening and clarifying the drawing. To prepare the solution soak gum arabic crystals in cold water for 12 hours and store the solution in a covered jar. When the solution has reached the consistency of drip honey, place enough in a small dish to cover the stone and add a few drops of pure nitric acid using a glass dropper. After mixing the solution thoroughly, test by applying a small amount to the side of the stone. If there is a slight effervescence after 30 seconds, the proportions are correct. Too much acid in the solution would destroy the work, not enough would not process the stone properly. When the mix is correct, apply it to the whole surface of the stone with either a soft cloth or a sponge, making sure that a thin, even layer covers the work as well as the undrawn areas. Leave the stone for at least eight hours. The pre-

cise nature of the chemical action is not fully understood, but the gum appears to form some sort of bond so that a layer of water is held on the surface during printing.

The next stage is to dissolve the basic material of the drawing by wiping the stone gently with a soft cotton rag soaked in pure turpentine. This leaves the ink-attracting image embedded in the grain of the stone, which is then protected by applying a little liquid aspheltum solution. When the aspheltum solution has dried, wash away the surface gum, turpentine and aspheltum using clean water and a sponge.

The image is now ready to be inked with printing ink, using a lithographic roller. Damp the stone with water and a clean sponge, then apply the roller firmly and slowly to the stone to allow the ink to make contact and reveal the image on the surface. Apply a final cover of plain gum over the entire surface of the stone and store it.

Plate
First dust the drawing on the plate with French chalk or talcum powder. The gum arabic solution which is used to process stone lithographs is also used for processing plates, but no nitric acid nor any other chemical is added. Apply the solution

6. Rub in the aspheltum over the whole drawing area, making sure all the black is removed from the surface of the plate.

7. Wash away the aspheltum with clean water and a rag.

8. Wipe over the plate with a damp sponge to prepare the surface for inking.

9. Lay out black proofing ink on a flat surface and roll it out evenly, picking up a coating of ink on a large roller.

10. Roll over the plate until the image has picked up an even layer of black ink. Keep the plate damp with a sponge but not too wet.

16. Work the zinc plate etch over the whole plate with the sponge. This protects areas of the plate which have not been drawn up and also removes any light smudges of grease remaining on the plate.

17. Apply a layer of gum over the surface of the etched plate.

18. Dry out the plate completely. It is now ready for printing.

to the plate in a thin, even layer, buffing it dry by hand or drying it with a heater. Providing the gum is dry, the plate can be processed straight away.

Dissolve the drawing away with turpentine. It is crucial to apply an even layer of aspheltum over the entire surface of the plate to protect the image. Use a soft cloth for this and then wait for the aspheltum to dry. This stage is even more important for plates than it is for stones, because the lithographic drawing is only in the imposed grain of the metal, rather than absorbed into the porous surface of the stone. After washing with clean water, the plate is dampened ready to receive the rolling up black which will establish the image.

Before storing, use a proprietary plate etch to condition the plate and ensure clarity of printing. These etches can be mixed either with gum or water – follow manufacturer's instructions carefully. Finally coat the plate with a layer of gum and it is ready for proofing.

Proofing

Direct Method
Today, most stone lithography is done on hand-proving presses by a method known as the direct method. These presses vary in design but are

Taking a proof from the stone 1. Coat a large roller with black proofing ink. Sponge over the stone with clean water and work with the roller across the image until it has picked up an even layer of black.

2. Lay the printing sheet over the stone and add sheets of newsprint or other soft paper as packing to cushion the movement of the press. Check the amount of packing needed before taking a print.

3. Lower the tympan of the press and drop the handle to apply pressure. Run the bed through the press so the pressure is evenly dispersed.

4. Lift the tympan and remove paper packing. Peel back the printing sheet from one end to check the quality of the proof.

similar in principle. The bed of the press holds the stone, which is inked up by the lithographer. The selected proofing paper is placed on top of the inked image and several sheets of soft backing paper are laid over it. The backing paper helps cushion the impression as the stone passes through the press. The brass tympan serves as an intermediate layer, ensuring that the leather scraper which is held in the machine applies even pressure to the stone when the bed of the press is pulled underneath. The rigid scraper box, which holds the scraper, also holds the pressure screw. This screw can be regulated by hand to match the thickness of different stones. A side lever lifts the bed of the press so that it comes into contact with the printing pressure and the stone is then drawn through the press by hand winding – an operation sometimes carried out by electric motor traction.

It takes practice to understand fully the mechanical operation of hand presses, although they are basically simple, strongly built machines. If you are working in a college or print workshop, take instruction before attempting to work these rather individual machines; if you intend buying one, consult a printing engineer. Once understood, they can be operated with accuracy.

The direct method can also be used to print

Right *Am See* (1978) by Thomas Kruger (b. 1918) shows a delicate use of lithography. The artist works on plate, using lithographic washes applied with airbrush to give atmospheric effects.

Far right *Kimono* (1980) by Linda Le Kinff (b. 1949) was drawn directly onto grained zinc. Using a complex interrelation of colours in overprint as well as juxtaposed, the artist creates the effect of rich oriental fabric.

Colour proofing 1. The ink is mixed on an old litho stone which provides a suitable smooth, non-porous surface. A quantity of each colour of ink and some tinting medium are laid out separately.

2. The inks are mixed with a large palette knife to obtain the required colour. The addition of a tinting medium lightens the colour and makes it more transparent for overprinted effects.

3. A small dab of ink on a scrap of paper is used to check the colour against the master drawing. The tone and colour of the mixed ink are adjusted if necessary.

4. In this example a mechanized proofing press is being used. Ink is spread along the inking rollers with a palette knife.

5. When the machine is set in motion the ink spreads evenly along the rollers. A hand-operated offset press has no inking rollers and the plate would be inked by hand as a separate stage of the process.

7. The plate, whether stored or newly processed, has been inked up previously in black. The black ink must be removed with turpentine to leave only the greasy impression of the image on the plate.

8. The press is now set in motion to damp and ink up the plate. The cylinder is then dropped to roll over the plate and pick up the image on the rubber blanket.

9. A clean sheet of paper is fixed into the paper bed on the press and the cylinder is rolled back over it to lay down the image.

10. The image from the new plate is registered against a previous proof. The registration mark on the proof is partially cut away and the whole proof laid over the new print with the registration marks aligned.

11. The press has moveable lays on the paper bed which are adjusted to mark the position of the proof. Each subsequent proof is fitted correctly into the lays to print the colour precisely in register.

6. The plate is fixed into a clamp at one end of the bed of the press and secured tightly.

12. A clean proof is then fitted into the paper bed and the machine set moving. The cylinder passes down the press to pick up ink from the plate and then rolls back over the paper putting down the image.

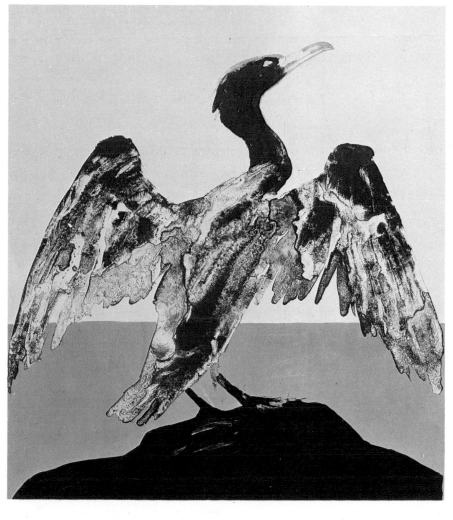

Left *Cormorant* from the *Seabirds* series (1974) by Elisabeth Frink (b. 1930) was the result of the artist drawing directly onto grained zinc with lithographic drawing ink, using the surface of the metal to convey the textural quality of the subject matter. The characteristic texture which comes from the evaporation of ink from the plate was left untouched.

from zinc plates as well as from stones, in which case the plate is supported by a stone in the bed of the press or by a metal block specially constructed for the purpose.

Offset Method

Plates can be used not only for direct printing but also for printing by the offset method – a method which is particularly suitable for colour work.

Two kinds of machine are available for offset printing. The first is entirely manual. A large rubber-covered blanket cylinder is drawn by hand over the inked plate, secured on a special metal bed. At the end of its track, the cylinder reverses direction, picking up the lithographic impression from the plate. This impression is carried further forward to the paper, held ready in grips to receive the imprint. The plate is then carefully dampened and re-inked by hand and a fresh sheet of paper placed in the machine, held in place by spring grips.

The mechanized versions of this machine vary in degrees of sophistication. Many are electronically operated and can be used only by qualified personnel; some have automatic inking and damping rollers but registration is done by hand. Before attempting to print with these more advanced systems, it is advisable to practise on the simple hand-operated types.

Colour Proofing

Colour lithography is similar to painting in many respects, but a great deal of patience and concentration is required to achieve the right quality. Progressives, or sequence prints, are an essential aid to the artist. They help him understand the anatomy of the work and are useful as a guide to colour balance and image registration. Prints can be affected not only by these factors, but also by the order in which the colours are imposed. Sometimes first attempts will work, but re-proofing is often necessary to formulate the artist's idea correctly, and, if a proof is to be editioned in quantity, professional help should be sought. Such work requires expertise and the use of machines not often available to the amateur printmaker. If only a small quantity is required, there is no reason why, with proper preparation, editioning should not be attempted by the individual.

Inks for colour lithography are composed of finely ground pigment, specially selected and combined with oils to operate in conjunction with the water used in the lithographic process. These inks are basically transparent; they can be made more so by using a special medium; made opaque by adding white; mixed, stiffened or made fluid, according to requirements. A wide range of colours is available from printing ink suppliers but the beginner will find that a selection of reds, yellows, blues, white, black and an extending medium will suffice.

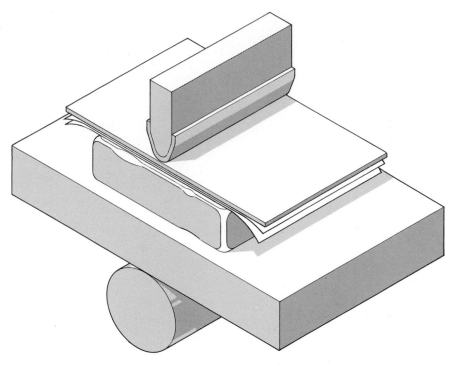

Above The flat bed press has a moveable bed which holds the stone or plate, a brass tympan which lies over the stone and print and a rubber strap which passes over the tympan to exert pressure. The paper is laid on the stone, paper packing placed on top, the tympan lowered and the bed run underneath the rubber strap. The bed can be moved mechanically or by hand winding.

Registration

For the direct method, simply print the register crosses on each colour print, using the method described earlier. Cut the intersection of the crosses so that when the sheet is reversed for laying on the stone or plate, the register crosses on the stone or plate can be sighted through the holes. Alternatively, needles can be pierced through the centre of the crosses and guided down to meet the centre of the crosses on the lithographic surface.

Most offset printing presses have registration provisions known as side and gripper lays. The deckle of the paper should be trimmed so that the sheets rest flush against these metal stops.

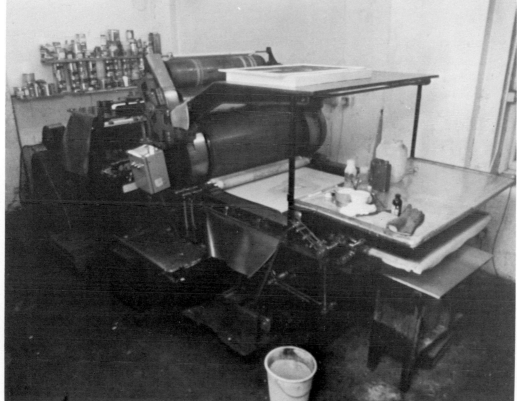

Far left The hand-operated offset press works by the basic offset principle whereby the plate and paper are on adjacent beds, the blanket on the cylinder runs over the plate to pick up the image and then goes back over the paper to lay down the image. The cylinder is passed by a winding handle; the plate must be damped and inked by hand.
Above left The proofing press operates on the same principle as the hand-operated press, but the ink is spread evenly by the rollers on the machine, rather than by hand. The only manual procedures are putting the ink on the rollers, sprinkling water on the damping roller and laying proofs on the paper bed.
Left The offset editioning press is completely mechanized except for the paper feed. The paper bed is above the plate bed; the paper is fed into the cylinder rather than the cylinder passing over the paper.
Above right The rubber blanket on an editioning press. On any offset press, the blanket runs over the plate, picking up the image and laying it on the paper.

Left *Pears* (1979) by William Scot (b. 1913) shows an economic use of texture. The line plate holds the image, a typical two-dimensional treatment of domestic still life.

Below and opposite *The proofing stage of a colour lithograph* Individually drawn stones and plates are printed in sequence with the aim of achieving the final realization of the original idea. Colour progressives are kept at each stage to indicate the 'anatomy' of the print. If alterations are necessary when the proof is complete, it is then a simple matter for the artist to examine each colour and decide where to make the required modifications. In this print of an eagle's head by Don Corderay, six individual colours form the final proof. The image was drawn on zinc and the detailed work is reminiscent of 19th century reproductive techniques.

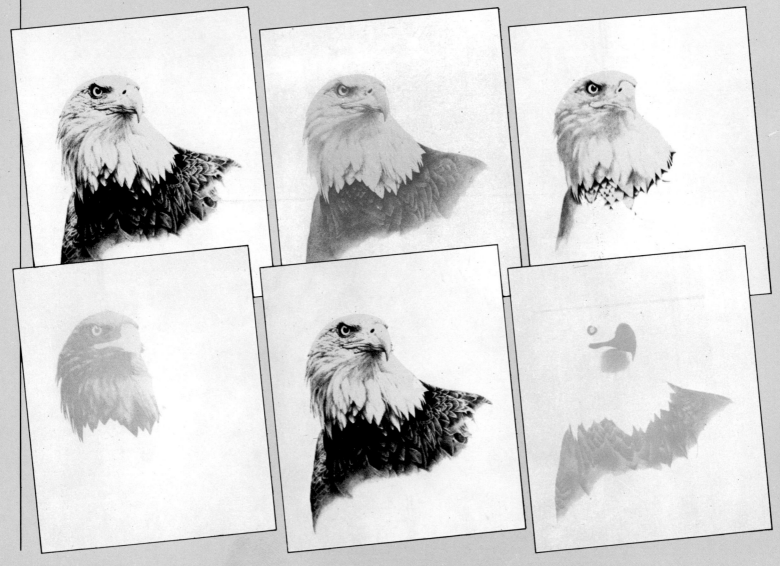

Another method involves taking an impression of the image on a piece of transparent film and then attaching it to the reverse side of the paper with tape. When the proof sheet is slipped underneath, the position of the next colour can be judged and the metal stops adjusted. The transparent film must be peeled away before the next proof is taken.

Inking Rollers

The black lithographic roller is important not only for processing but also for producing the rich black impressions characteristic of this printing method. These rollers, known as nap rollers, are made by stretching calf skin around a wooden stock. They hold a certain amount of water as well as printing ink, and improve with use.

Colour rollers have developed from the varnished types of nap roller. Today they are made of rubber or plastic and can be cleaned easily with solvents such as paraffin or white spirit.

Printing Papers

Proof the lithograph on the same type of paper as the one you intend to use for the edition so that the colour values remain the same.

There are two kinds of paper used for lithographic work: paper made by hand on a traditional frame and paper manufactured mechanically and known as mouldmade. Handmade stock is ideal for direct printing; its deckled edges and various textures have many devotees. It is made from linen rags or cotton linters and has only a little sizing added. Waterleaf is perhaps the best quality, but this is a matter of personal choice.

Handmade paper is not always suitable for colour printing because it has a tendency to stretch, giving problems with registration. For this reason it is advisable to use mouldmade paper, manufactured from the same materials but produced mechanically. Mouldmade paper comes in a variety of surfaces, colours, weights and sizes. For early attempts at proofing and printing, good white cartridge is often the most economical.

Top The inking rollers on an offset press. Ink is placed on the rollers by hand but is mixed and spread in an even film mechanically.

Right *Rinder III* (1969) by Sidney Nolan (b. 1917). The original image was drawn in the artist's studio on transfer paper. The broad primitive textures were the result of crayon rubbed across the back of the paper, frottage and some directly drawn elements. The quality and treatment reflect the artist's interest in the legends of Australia.

Right *Les Pêcheurs* (1980)
by Hans Potthof (b. 1911) is
an example of a lithograph
where the outline plate holds
the image and the colours
are subsidiary. The result is
compact and simple.

Below left *Breezes II* (1979)
by Robert Kipniss (b. 1931)
was directly drawn on
aluminium plate from
sketchbook material. The
use of brush and crayon is a
traditional approach; the
subject matter is suitable for
such economic treatment.

Below right *La culotte
bayadère* (1925) by Henri
Matisse (1869–1954) is a fine
example of draughtsman-
ship and shows a delicate
use of crayon. Matisse
worked mainly on stone,
often drawing first on transfer
paper and adding touches to
the stone after the image had
been transferred down.

Screen Process Printing

In screen process printing a stencil which acts as a mask is attached to a fine mesh which is stretched on a frame. Colour is forced through the open area of the stencil to print the image on the surface underneath.

Covering the cave walls at Tibrran, Gargas and Maltruieso in the Pyrenees are 200 prints of hands. These prints, in red ochre and black manganese, represent the first examples of transfer prints. More fascinating than this though, they show in their negative form the first use of the stencil process. The softened images, created by blowing colour through a reed or hollow bone around hands as they were held against the cave wall, are ancestors of the screen stencil of today.

Between 500 and 1000 A.D. the rise of Buddhism in the Far East, which encouraged mass reproduction of Buddha's image, gave a boost to the art of stencil making. In the caves of Tun Huang in western China, excavated from the sandstone hills and extending for half a mile, there are images of Buddha ranging from a few inches high to 21 m/70 feet. Some of the unfinished images show the typical pale grey lines characteristic of the perforations of stencils which were used to duplicate the pattern.

Open stencils cut from sheets of impervious material were often used in Japan to decorate ceremonial robes, walls, ceilings and pottery, the dyes being brushed across the open areas to produce a facsimile print.

The principles of screen-printing The technique of screenprinting is not complex. To begin with, a frame is needed over which a mesh screen of some type can be stretched. To create an image, a stencil of some kind has to be made. In the example above, a film stencil has been attached to the screen and the printing paper then laid underneath. Ink is then poured on to the screen at one end and pulled across the whole area of the screen with a squeegee. The screen is lifted up to reveal the printed image underneath.

Intricate paper stencils were discovered in Japan during the eighteenth century. They were extremely fine and delicate but always limited by the need to bridge the open or floating parts of the stencils (the central island in the stencil letter 0 is a good example of a floating part). This difficulty was overcome by using a system of tying the open parts of the stencil to the main sections of the cut stencil with fine strands of human hair or silk glued with a varnish called *shibu*. Colour was brushed through the open areas to produce the prints. The principle of using an almost invisible web of human hair was a deliberate attempt to eliminate conspicuous ties and produce a highly defined print, unlike the lettering and symbols which are applied to today's packing cases with stencils characterized by the bridges which interrupt surface continuity. The logical step was to replace the mesh of hair or silk with a woven silk fabric: this did not happen for 150 years.

In Europe during the Middle Ages simple crude stencils were the means of hand colouring playing cards and religious pictures. The Crusaders devised a stencil for printing their symbol, the Red Cross, on their uniforms. Their solution was to use pitch or ships' tar to paint out a resist area around a cruciform on a fine hair cloth. Their white tabards, or anything else on which they wanted to print a cross, were placed under this screen and red paint was stamped through the open mesh areas with a coarse brush.

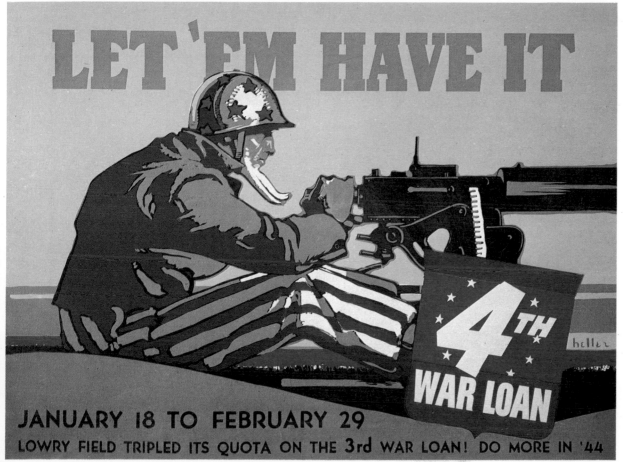

Above *Beach Scene*
(*c.* 1945) by Hyman
Warsager (1909–74).
Warsager made innovatory
experiments in screen-
printing and achieved effects
which were more akin to
painting than to silkscreen
printing. By working over
small areas and
superimposing colours as
well as exploiting the weave
of the screen he achieved
effects not usually
associated with the
silkscreen. **Left** *Let 'em
Have It* (1944) by Laurence
Heller (b. 1906). Designed as
an advertisement, this
image, clear in its outline and
bold in its colouring, is
perfectly suited to the
screenprinting technique.

This technique of using a bristle brush to force colour through the mesh of a stencil was a feature of the first silkscreen patent granted in 1907 to Samuel Simon of Manchester who employed stopping-out liquid to paint the negative image on to a mesh of bolting silk stretched on a wooden frame. The rubber-bladed squeegee, which spreads the paint more evenly, had not yet been developed. William Morris is a notable example of a designer who used the process extensively. Early in the twentieth century, stencilling was extremely popular in France and England.

The development and exploitation of the screen process took off the the United States at the turn of the century and there was a frenzy of activity on the west coast of America during the early 1900s. In 1914 the Selectasine method, for producing multicolour work by progessively painting out the open areas on a single screen, was invented by John Pilsworth of San Francisco who was granted the first patent. The use of the process spread rapidly from California to the East.

In the United States during the First World War the process came into widespread use for the production of banners, flags, pennants and bunt-

Above A Japanese paper stencil. This stencil was designed for printing, though many others were made for purely decorative purposes, the patterns being intensified when held up against the sun.

ing. It was also there that the first photographic silkscreen stencil was produced. From then on the silkscreen could be used for such industrial purposes as textile manufacture. The rapid growth of the American chain store and the need for standardized house style for fascia boards, tickets, showcards and advertising also helped to transform the industry, and many of the signwriters who first regarded the new process with suspicion became its new specialists.

One of the major disadvantages of the process during the early stages was that the results were lacking in quality and uniformity. The prints, because of the lack of definition of the images could not compete for the role played by letterpress and lithography in supplying quality printing for large businesses and advertising agencies. The paints were crude and dried slowly, being composed as they were of printer's mixes of coach paint, lacquers, litho oils and other unrefined ingredients. It was for this reason that an automatic screenprinting machine, patented in 1925, could not be used extensively. The prints, although produced more rapidly, were still not sufficiently refined.

Country Air by Bob Saunders (b. 1945). The silkscreen technique is usually associated with harsh, bright images. However, with the careful balancing of tones and colours, more gentle compositions can be produced. This delicate and subtle print, in which seven different colours have been used, portrays successfully the diffusion of hills and trees seen through a summer mist.

Below The development of modern silkscreen printing equipment has enabled the process to become commercially viable. The piece of machinery on the far right holds a screen, a squeegee and the ink supply as well as equipment for registering the screen and the printing paper. The prints are then dried in the machine which is attached on the left hand side. This drying machine is capable of drying up to 100 m/300 ft of printed matter per minute.

All this was to change with the invention by Louis F. d'Autremont of Dayton, Ohio, of a knife-cut stencil-film tissue. This eliminated the characteristic ragged edge of the print and the patent was granted to an associate, A.S. Danemon under the name Profilm. This was superseded by Nufilm created by Joe Ulano, a foreman in a New York printshop. Nufilm was quicker to use, adhered well to silk and was easier to cut.

This simple adaptation of the hand-cut stencil

immediately attracted great interest, and paint manufacturers, examining the potential market for their products, quickly produced ranges of specially formulated colours eminently suitable for screen process printing. Now the automatic presses could be used commercially for the first time and the industry boomed, developing into the versatile efficient form we know today — capable of printing on any surface and with production speeds of 3000 impressions per hour. Signs, wallpapers, transfers, tins, window stickers, inflatable toys, illuminated and fluorescent road signs, self-adhesive and embossed badges, glassware, name plates, self-adhesive stickers and textiles; all these and many more could be decorated by application of screen process printing.

The process has never been, however, an exclusively industrial one. In the 1930s the medium became popular with American artists. One reason was that, during the Depression, it enabled them to reach a large public who wanted to buy original, inexpensive prints. It was in the 1950s, however, that the medium was acclaimed by artists as a valid means of communication. Pop Art, concerned with images of urban culture, saw the silkscreen as a medium well-suited to the reproduction of its subject matter. The bold shapes, bright flat colours, as well as the impersonal quality of the technique, were irresistible to such artists as Andy Warhol (b. 1930) and Roy Lichtenstein (b.1923). Indeed, the ability of screen process printing to reproduce the powerful, instant image has made it one of the most popular printing techniques in the second half of the twentieth century.

1

2

4

3

5

1. *Bananas and Leaves* (1977) by Patrick Caulfield (b. 1936). Despite the stylized manner of the design and the flat quality of the colours, a considerable feeling of depth has been achieved by the use of a strong green for the leaves and a much softer colour for the shadows beneath.

2. *Cleanliness is Next to Godliness* (1964) by David Hockney (b. 1937). The figure in this print has been reproduced from a photograph and so one of the stencils will have been made with the help of a process camera. The other stencils will have been hand cut and painted onto the screen.

3. *January 1973* (1973) by Patrick Heron (b. 1920). This apparently simple design incorporates considerable

For instance, the purple area has been carefully graduated so that it changes from almost pure blue at the bottom to a reddish purple at the top.

4. *Harrison's Wharf* by Gerd Winner. This image has been taken from a photograph and is a good example of the more sophisticated use of photo stencils.

5. *Black Tiger* by Victor Pasmore (b. 1908). Pasmore, who began painting in an impressionist style, emerged as an abstract artist in the 1940s. The screen process has helped him in his experiments with shape and colour.

Frames

The basic screenprinting unit consists of an open frame with a fabric mesh stretched taut on one face, a flat baseboard, the hinging system joining them, and a flexible rubber or synthetic squeegee which forces the colour through the clear areas of the mesh and on to the paper held in register on the baseboard.

Frames can be made from wood, marine ply, light tubular steel or aluminium. Old picture frames stretched with organdie (transparent muslin) can be converted for the job. A wooden frame is the most straightforward type to make. It is important to choose kiln-dried timber which is free from knots and resin and checked for straightness. A 30cm x 45cm/12in x 18in frame will safely print an area of 23cm x 30cm/9in x 12in and is an excellent size to begin with. It is obvious that large frames will require heavier timber and as a guide 2½cm x 2½cm/1in x 1in pine can be used for frames under 45cm/18in, and 5cm x 5cm/2in x 2in for those up to 90cm x 120cm/36in x 48in. The cross-section does not need to be square, and for larger frames a 4cm x 6cm/1½in x 2½in proportion would be stronger and lighter, the 6cm/2½in lying flat on the printing baseboard.

Choose a strong jointing system such as mortice and tenon. It is absolutely crucial that the frame should be rigid otherwise both the screen and the stencil will be unstable, thereby making registration when printing almost impossible. Flat angle brackets can be used to brace the corners. It really is most important that the corners should be right angles. Sandpaper the surfaces so that they are smooth and, if the wood is water absorbent, it should be varnished with shellac or treated with linseed oil.

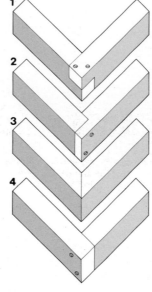

Left It is crucial that frames should be strong and absolutely rigid. Furthermore, the corners must be fixed at right angles. To achieve this you will need to use one of the four types of joint illustrated here. They are; *(1)* the end-lap joint, *(2)* the rabbet joint, *(3)* the mitre joint, and *(4)* the butt joint.

Below You may find it convenient to construct a master frame into which separate frames can be fitted. The main advantage of having this piece of equipment is that little dismantling is required when the printing frame has to be removed and cleaned.

Above Floating bar-frames can be used for stretching a screen onto the frame. The bars are attached to the frame by bolts and butterfly nuts and are adjustable.

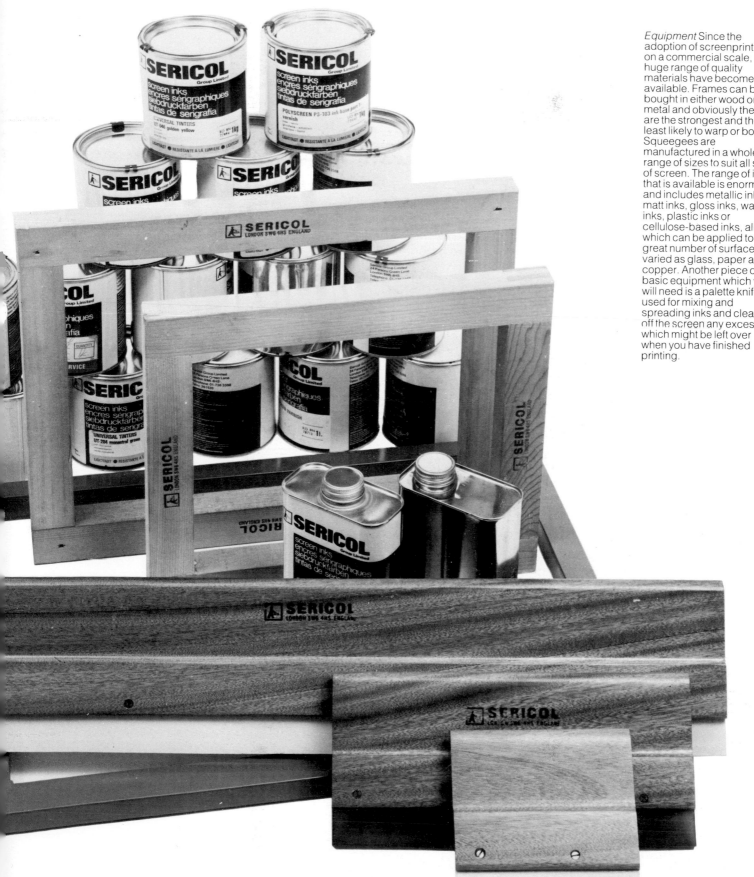

Equipment Since the adoption of screenprinting on a commercial scale, a huge range of quality materials have become available. Frames can be bought in either wood or metal and obviously the latter are the strongest and the least likely to warp or bow. Squeegees are manufactured in a whole range of sizes to suit all sizes of screen. The range of inks that is available is enormous and includes metallic inks, matt inks, gloss inks, water inks, plastic inks or cellulose-based inks, all of which can be applied to a great number of surfaces, as varied as glass, paper and copper. Another piece of basic equipment which you will need is a palette knife, used for mixing and spreading inks and cleaning off the screen any excess which might be left over when you have finished printing.

The Printing Table/Baseboard

The frame can be hinged to a table or baseboard which should have a smooth flat surface. Block-board treated with coats of shellac and then sanded and sealed is quite satisfactory. The base-board should be 5cm/2in to 9cm/6in larger than the frame on all sides. The best results occur when the board is perforated so that a motorized vacuum can be used to hold the paper flat and in register. This need really not be considered a necessity for the beginner.

The Hingebar

The frame needs to be attached to the baseboard. However, it must be done in such a way as to allow the gap between the bottom of the frame and the baseboard to be adjusted. This will allow printing paper of different thicknesses to be used. The best way to manage this is to fix a hingebar, made from the same size wood as the frame, to the baseboard. As long as you use coach bolts with wing nuts you will find adjustment of the hingebar quite easy. To the hingebar you can then attach the frame and when doing this it is advisable to use push-pin hinges. The pins can be removed and the frame

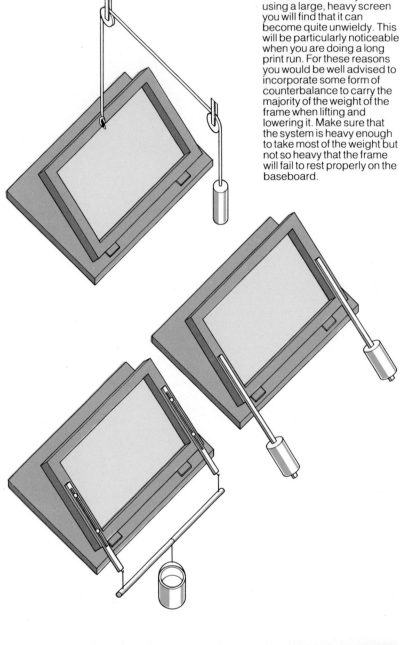

Counterbalances If you are using a large, heavy screen you will find that it can become quite unwieldy. This will be particularly noticeable when you are doing a long print run. For these reasons you would be well advised to incorporate some form of counterbalance to carry the majority of the weight of the frame when lifting and lowering it. Make sure that the system is heavy enough to take most of the weight but not so heavy that the frame will fail to rest properly on the baseboard.

Top right Adjustable screen cleats, attached to the baseboard, to prevent lateral movement on the screen frame.

Bottom right A simple prop can be devised to hold the screen frame in a raised position. This means that you can have two free hands with which to remove and register printing paper.

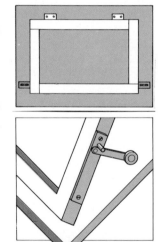

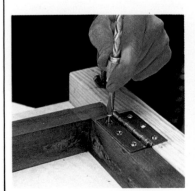

Construction of the frame 1. The sides of the frame must be glued and jointed securely together at right angles to form a true rectangle. Attach the frame to the hingebar, screwing the hinges down tightly.

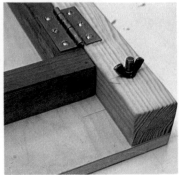

2. Fix the hingebar to a baseboard which should be a minimum of 5cm/2 inches wider than the frame on each side. A coach bolt and wing nut at each end of the bar enable it to be raised if necessary.

3. The frame may be hinged with push pin hinges which are held together by a pin through the centre. It is then easy to detach the frame simply by pulling out the pins.

4. A small piece of dowling inserted in the baseboard corresponds to a hole cut in the underside of the frame. These engage when the screen is lowered to prevent lateral movement during printing.

Stretching the mesh 1. Cut fabric to size allowing a 2½cm/1 inch overlap on each side of the screen. When attaching the fabric staple through a thin strip of card to avoid tearing the mesh.

2. Staple from the centre of one side of the screen towards each corner, pulling the fabric taut as you work. Put in the staples at an angle across the side of the frame.

3. Repeat the process along the opposite side of the screen so that the mesh is tightly stretched across the width of the frame. Secure the third and fourth sides in the same way.

4. Use a large pair of scissors to trim off any surplus fabric around the edges of the frame.

5. Fold the fabric around the corners of the frame keeping tension on the stretched face of the mesh. Secure the folds with staples.

easily disengaged from the hingebar. When printing on thick paper the hingebar can be raised by inserting a block between bar and baseboard. The insert is called a shim and can be made from card, wood or metal.

To facilitate removing a wet print and registering printing paper, it is a good idea to attach a prop bar to one side of the frame. This can be made from a strip of wood or metal about 9cm/6in long placed on the frame to allow it to stand at 45°.

To negate any lateral movement or imperceptible give in the frame, it is advisable to fix a short dowel into the baseboard protruding about 5mm/¼in. Drill a hole in the underside of the frame so that when it is lowered into printing position the dowel interlocks and ensures that no variations in registration occur.

Counterbalances

With large frames a prop bar is not really adequate and efficient counterbalancing systems are advisable. Among other things, they prevent the accidental and painful descent of large frames on to the printer's fingers. It is best to employ simple methods (see illustrations) which make use of inexpensive, readily available materials. Whichever system you choose, the weights must be positioned in an evenly balanced manner to counteract any distortion or warping of the frame, while still permitting it to be lowered for printing at a touch and returned to its raised position when the print has been made.

If you think that you will want to use frames of differing sizes, it might be a good idea to make a large master frame. Smaller screens can then be inserted and attached by flat metal plates, clamps, bolts, or wood strips.

Meshes

The amount of ink which is deposited onto the print is governed by the coarseness of the mesh and the type of material used, so care must be taken to choose an appropriate fabric.

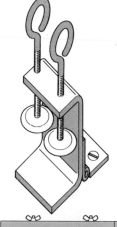
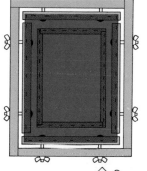

Top A hinge clamp, specially designed to enable different sized frames to be attached to the baseboard. **Centre** A four floating-bar screen can be used to stretch a mesh over a small frame. **Bottom** A mesh can be attached to a frame by using a groove and cleat. The mesh is forced into a groove and clamped into position by a cord.

Silk was the original fabric used in the silkscreen process, hence the use of the word serigraphy as an alternative, meaning literally 'silk drawing'. Silk bolting cloth and taffeta weave silk are still in use because of their ability to withstand heavy printing, their good tensile strength and the uniformity of the mesh.

All silks used in printing are classified by a number indicating the number of threads per linear inch/centimetre, and a code which relates to the weight of the fabric. Many manufacturers employ their own coding systems so a check is essential before buying. Various other fabrics have come into service now and the wide range includes nylon, terylene, polyester, metal-polyester, copper and stainless steel.

Organdie is the least expensive mesh to use but it has the disadvantage of being unstable. It tends to shrink when wet and then slacken off as it dries out. Good dressmakers' organdie or cotton organdie made for screenprinting with a mesh count of 90 threads per inch is suitable for beginners.

Synthetic Meshes are differentiated by the letters S, M, T and HD. The S gauge is widely used and is a thin thread weave. M is medium weave, T gauze is a twilled weave and is used if the screen is to be exposed to strain. The HD gauze is heavy duty.

Nylon is produced in finer grades than silk. It consists of a smooth monofilament thread with a taffeta weave and it is resistant to attack by chemical solvents and acids. It is elastic as well as extensible, and stretching should be carried out in two stages. It has the disadvantage of being slightly unstable. This limits its use for precision work.

Polyester is slightly less resistant to chemical agents but less extensible than nylon. It has the added advantage of being unaffected by moisture and comes in a wide range of mesh sizes. Its strength and stability make it popular for high precision work.

Metal Polyester is a very stable fabric requiring minimum stretch. It is extremely durable, and indirect stencils adhere well to it.

Metallic Screen Meshes made of bronze, copper or brass have all been used, but stainless steel is now used increasingly because of its excellent durability and resistance to abrasion and caustic inks. It has the added advantage of being woven very finely and uniformly. It is used particularly in printing on glass and can reproduce fine detail. The disadvantages of this material are its high cost, a smooth surface inhibiting stencil adhesion, and the difficulty of removing the stencil at the end of the run.

Left *The vacuum table* A vacuum table will hold printing paper flat and firmly in position. It is not difficult to make your own. A vacuum table is simply a thin, airtight box with a grid of small holes drilled through the top *(1)* and a larger hole cut in the bottom *(2)*. Entering the lower hole is the vacuum pump hose *(3)* which sucks air through the grid of holes. A system of baffle plates *(4)* allows the air to circulate at a constant pressure through the box. A valve system *(5)* can be incorporated so that the airflow, leading to the vacuum pump, is cut off when you raise the frame in order to lift the printing paper off the table. **Right** A precision vacuum printing table, which is used principally in industry, has attached to it a squeegee as well as equipment for registration. **Bottom right** A simple vacuum printing table without the refinements of the one above.

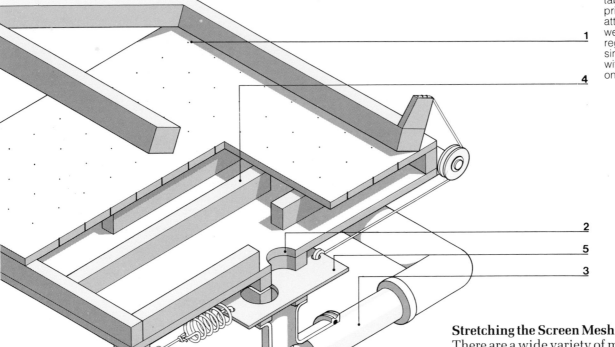

Stretching the Screen Mesh

There are a wide variety of methods for stretching the screen mesh. Among the most ingenious is the groove and cleat form. Basically, the top of the wood frame is routed out on all four sides, creating a 3cm x 5cm/1¼in x 2in groove. The mesh is laid over the frame and then a cord forces the mesh into the groove, holding it taut like a hoop. A wedge is commonly used to force the tight-fitting cord into the groove. The great advantage of this method is that no tacks or staples are needed so that the replacement of the mesh is easy.

Today's fabric stretching machines produce the perfectly drum-tight screens which are essential for quality printing. Some self-stretching frames have the advantage of doubling as printing frames. Another novel system operates on the principle of an expanding tyre, the mesh being loosely attached to special grippers on the outside perimeter. When the frame is inflated it expands, drawing the fabric to the exact percentage stretch recommended.

Above *Three types of silk fabric weaves*
1. The basic taffeta weave is a weave which has strength and durability.

2. The half gauze weave has an extra thread added to every other strand to give added strength.

3. The full gauze weave is the strongest weave: an extra thread is added to every strand.

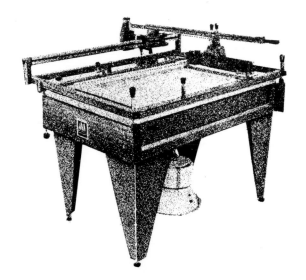

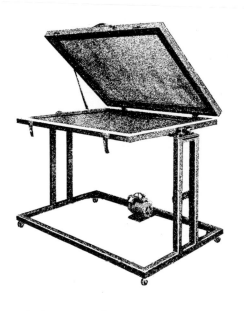

Degreasing the mesh The mesh must be conditioned to degrease it and provide a tooth for the stencil. The type of conditioner used here is rubbed on with a cloth and heat dried.

Taping the screen 1. Before printing, the screen should be sealed with gummed tape.

2. Fold the tape and smooth it in to the inside of the frame so that it adheres to both wood and mesh to prevent ink seeping under the edges. Add extra tape at top and bottom of the mesh to form a bed for the ink.

Below *The squeegee* This is the basic printing tool and consists of a synthetic polyurethane blade 5mm/¼in to 1cm /⅜in thick and 3cm/1½ to 5cm/2in wide, set in a wooden handle. Various types are available, designed for either one-hand or two-hand printing. The blades tend to wear out due to the actions of solvents, as well as the pressure resulting from the action of printing. The length of the squeegee is determined by the inside width of the frame though it should allow for a clearance at both ends of the blade to facilitate a smooth printing action. To maintain a straight 90° printing edge on a rubber squeegee it is enough for most purposes to grind the blade along a sheet of sandpaper or emery paper using a perpendicular piece of wood as a guide rail.

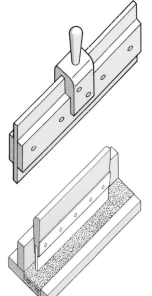

For the beginner the use of a staple gun or tacks might be the most straightforward. If you intend to use one of these, a pair of screen stretching or canvas pliers are a great help for gripping and tensioning the chosen screen fabric.

Another alternative is to use an adhesive. It is particularly important to produce a strong permanent bond between the silk, nylon, polyester or metal fabrics and the wood or metal frames, and a large variety of special screen mounting adhesives exist. The main groups are reaction adhesives and contact adhesives, both of which employ a catalyst plus a base, and a third group which is made up of vaporizing lacquers.

Treatment of the Screen Mesh

To make good screens which can produce high quality images it is obviously important to have a tight, well stretched fabric on the frame and to ensure that this mesh is given an appropriate treatment prior to the application of the stencil. The stretched screen fabric must be clean before

processing. Silk contains finishes and oils which must be removed before a coating or film stencil is applied. In the case of the metal and synthetic screens it is important to degrease and also precondition the mesh to achieve good stencil adhesion. There are alternative methods and products but most degreasing agents are caustic in nature. The action of mesh conditioners is to raise a tooth on the screen fabric, and a gentle rubbing with a fine grade wet and dry abrasive paper will also achieve this. Manufacturers' instructions should always be followed, but in the case of silk a thorough wash in water and liquid detergent or 2% caustic soda solution, subsequently rinsed from the screen, is perfectly satisfactory. An alternative treatment for stainless steel screens is to heat the screen over a gas flame until cherry red. This will remove the oily coating.

Taping

To prevent ink seepage between frame and mesh, a 5cm/2in gummed paper tape should be used to seal the inside edges and underside of the frame. The first strips should be fixed to the underside along all four faces, covering the wood and extending into the mesh area to a depth of approximately 2½cm/1in. Reverse the screen and apply gum strip folded in half so that one half covers the frame's inside edge and the other extends into the mesh.

Stencils

Screen process printing is a stencil process and is based on the principle of blocking out areas of mesh in order to prevent colour passing through while leaving clear open areas which do allow ink through. There are two basic types of stencil, direct and indirect. Direct stencils are made on the mesh, while indirect stencils are processed separately and adhered to the mesh at a later stage. A third type which uses a combination of both types will be discussed in relation to photo stencils.

Direct Stencils

The simplest direct method is to use a blocking out substance on the mesh. The design which you want is traced lightly on to the screen mesh. The negative design or the area which you do not wish to print is then blocked out with a liquid filler such as Lepages glue, P.V.A., Flash dry filler, lacquer or cellulose. It can be applied by brush, scraper or finger, depending on the textural quality which you want.

This leaves the open design image ready for printing. Make sure that the printing ink which you use is the reverse of the type of filler used to block the screen. For instance, if you used a water-based filler you must use an oil-based ink. Any pin holes which occur in the blocked-out areas, allowing tiny spots of ink to print, can easily be avoided by holding the screen up to the light and filling them in.

Images can also be made directly on the screen, using a candle or wax crayon to draw on the mesh. Textural effects can be rich and varied but the design produced by this method deteriorates quickly. Remember to use water-based ink.

Tusche Method

There is an alternative method which is both robust and combines the best of the two previous

Left The range of stencil materials is enormous. Some offer good adhesion to all types of mesh. Some are particularly suitable for fine line or halftone work while others are designed to stand up to long print runs.
Right When using the tusche method, a drawing is made directly on to the screen with either liquid tusche or a crayon and then covered with a coating of water-based filler. When the filler is dry the tusche drawing can be removed with white spirit. A positive stencil is left.

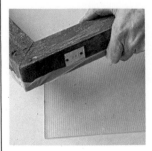

The tusche method 1. To create a textured design with tusche crayon place the screen mesh printing side down over a piece of corrugated plastic.

2. Draw over the mesh with the flat side of a lithographic crayon to reproduce the texture of the plastic on the screen.

3. Continue to work with the crayon gradually building up the design inside the printing area. You may prefer to draw freehand on the mesh with the crayon.

4. Raise the screen from the work surface by standing each corner on a small block. Work into the design with liquid tusche applied with a brush.

5. The tusche may be spread with a small piece of card as well as brushed on to vary the texture in the design. When the drawing is finished let it dry out completely.

methods. This is known as the tusche resist stencil. Unlike the wax resist method, it produces a positive printing image. Improvisation is aided by the fact that the positive image shows as a dark area throughout the early stages. The positive design is painted on with tusche which is a black litho ink with a slightly wax-like quality. A solid version of tusche is available in blocks and these can be used to rub relief surfaces on to the mesh. When the tusche sets, a water-based filler is scraped over the entire area of the mesh. A squeegee, a strip of stiff card, or a coating trough can be used for this operation. P.V.A. is a particularly effective coating. Allow the filler to dry thoroughly and then rub vigorously both sides of the mesh with a rag soaked in turps. The next step is fascinating. Tusche is solvent in turpentine and as it is attacked it clears from the mesh taking with it those areas of water-based filler which previously covered it. Open areas now appear which were previously covered by the tusche. The screen must be dried thoroughly before printing.

A variation of this method uses a latex-based ink available in Britain as art masking fluid or seroid in the United States, and a cellulose or water-based medium for coating and a hard eraser for removal. The procedure is simple. Soak a brush in soapy water, dip it into the masking fluid and draw the design on the inside of the screen. It must be raised to avoid contact with the table. This again is a positive process and the areas covered by masking fluid are those which will print. Allow the painted areas to dry for ten minutes, then coat the inside of the mesh with an even layer of P.V.A. or cellulose medium. The best results occur when this is done in one action, but additional coats may be given after the first is thoroughly dry. When the screen has dried, the latex is removed using either the hard eraser or your finger. As in the tusche resist process, those areas which were filled with latex become open mesh while the remainder of the screen remains blocked out by the P.V.A.

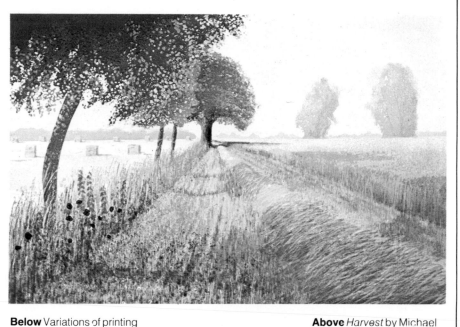

Below Variations of printing techniques using a hand-cut stencil.
1. Three-colour vertical blend.
2. Two-colour horizontal blend.
3. Painting on of filler followed by overprinting.
4. Tusche, incorporating blending.
5. Four-colour print created by progressively painting out the screen with filler.
6. Screen ink pre-mixed, overpainted.

Above *Harvest* by Michael Carlo (b. 1945). Screenprint from hand-painted stencils.

6. Coat the whole of the screen mesh on both sides with blue filler. Use a squeegee to spread the filler evenly.

7. Soak a rag in turpentine. Do not apply solvent directly to the mesh.

8. Rub the mesh with the rag to dissolve the tusche. Work from both sides until the mesh is completely clear of tusche. Do not apply too much pressure or the stretched fabric may sag or tear.

9. The blue filler is not affected by turpentine so only the tusche is removed, leaving the design clear in the screen mesh.

10. Take a print from the screen in the usual way. The texture of the tusche drawing is perfectly reproduced. The imagery obtained by this method has more freedom and spontaneity than a stencilled design.

Indirect Stencils

Indirect stencils are made away from the screen and are therefore separate from the mesh. The simplest example of an indirect stencil is a cut paper one. The paper needs to be thin, strong and impermeable. Having drawn a design on the paper, place it on a hard surface, preferably glass, and using a sharp stencil knife cut away those areas which you want to print. You must then carefully re-position the entire stencil; this means the cut pieces must be re-positioned on your baseboard. The whole stencil should adhere to the underside of the mesh after the first proof has been taken because of the viscosity of the ink. The areas which you want to print are now removed carefully and printing continues as normal. The edges of the paper stencil may flap, and small pieces of tape will help to hold it in position. This method of indirect stencilling is particularly good for laying down flat areas of colour, and as the paper stencil is easily peeled away at the end of a run, screen reclamation is no problem.

This is also the case with hand-cut stencil films and papers. Many forms of these are available under different trade names but they all share the common characteristic qualities of producing precise, highly defined images. Most of them

Balls Please by Michael Potter (b. 1951). This print conforms well to the silkscreen aesthetic. Simple in design, sharp in outline and clearly defined by a wide range of tone, it represents a striking example of contemporary screenprinting.

Printing with a paper stencil 1. Use a sharp scalpel to cut a shape out of a sheet of thin paper.

2. Centre the cut-out shape on the screen mesh and mark the outline with a pencil.

3. Lift the screen and rest it on the prop bar. Position printing paper and stencil under the screen and lower the frame to align the stencil to the drawn shape on the mesh.

4. Place registration stops on two sides of the printing sheet. Small pieces of adhesive card may be used which stick to the baseboard and butt against the edge of the paper.

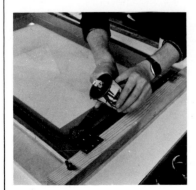

5. Lower the screen onto the stencil and pour ink along the top of the screen above the printing area.

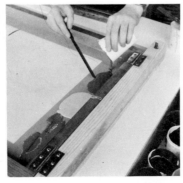

6. To obtain a graduated blend of colour, pour in separate pools of each colour side by side across the top of the screen.

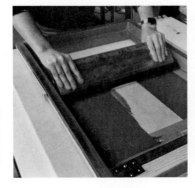

7. Pull the squeegee from top to bottom of the screen, drawing the ink evenly down across the mesh.

8. Push the squeegee back. Rest the screen on the prop bar and pull out the print. The ink glues the stencil to the mesh. Secure with tape.

Making a hand cut stencil
1. Place the stencil film matt side up and cut into the top layer with a scalpel to make the design, leaving the transparent backing film intact.

2. Peel away the cut shapes from the backing film, lifting the edges carefully with the scalpel.

3. Place the stencil on a flat worktop and position the screen over it, printing side down. Dab the mesh with clean damp cotton wool until the stencil adheres completely to the underside of the screen.

4. Dry the screen thoroughly and then peel away the transparent backing film, leaving the stencil on the screen mesh.

5. Use a piece of card to spread a coating of blue filler over bare areas of fabric around the stencil. When the filler is dry the screen is ready to print.

Left Compass adaptor *(1)*, knife holder *(2)*, adjustable double-knife for cutting widths of up to 2½mm/¹⁄₁₀in *(3)*, stencil knives *(4, 5, 6, 7, 8, 9)*, sharpening stone *(10)*, double knife for cutting parallel lines *(11)*, spring compass for cutting small circles *(12)*. **Below left** A range of compasses for both drawing and cutting.

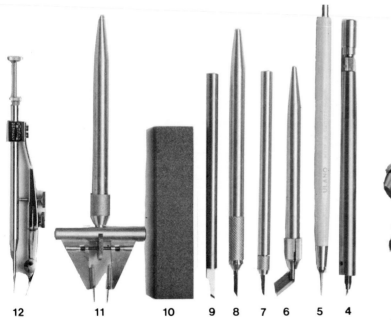

12 11 10 9 8 7 6 5 4

consist of a thin coating of stencil material on some temporary support such as transparent paper or transparent plastic which allows the design to show through, thus facilitating cutting. Peeling is simple and areas removed accidentally are easily replaced. Some types are water-based and these are easily affixed to the screen by wet sponge or squeegee covered with foam rubber. Others employ a mixture of water and methylated spirits, and the third type are attached to the screen by ironing them on.

The method for making the stencils for all types is quite simple. Position the stencil film/paper over the design with its backing sheet underneath. Using a stencil knife, cut away the design from the top layer only. Care must be taken not to cut too heavily as the backing sheet can be dented and this will affect adhesion of the stencil to the mesh. Peel the areas away which you wish to print, using your knife to lift the cut edges. Place the completed stencil on a piece of card slightly smaller than the inside dimensions of the frame. Lay the frame over it, ensuring that the film is in intimate contact with the underside of the mesh and positioned centrally. Using two pads of soft fluffless cloth, wet one with the recommended adhering liquid and wipe a small portion with one stroke and dry immediately with the other pad, using a light rubbing motion until all liquid has evaporated. Continue over the whole stencil area, working in one direction only to avoid wrinkling. When the stencil is dry, slowly pull away the backing sheet from the upturned frame.

Photo Stencils

Due to the rapid development in the field of photo stencils, screenprinting has expanded into new areas, particularly in industrial printing. The techniques of photo stencilling can, nevertheless, be of use and interest to the amateur printmaker.

Before discussing the different types of photo stencil, we must clarify one crucial point. When we describe something as a photo stencil, we refer to a stencil that is light sensitive so that exposure to ultraviolet light hardens the surface causing it to become impervious to water. The stencil material is exposed to light which has passed through a positive image. A positive image is one which is literally the opposite of a negative. That is to say, the printing images are opaque rather than transparent. These are carried on a transparent base so as to allow the light to filter through to the parts of the stencil which are to become hard and impervious. When washed, the soft stencil areas (those which have not been exposed to light because of the opaque image) fall away so that the image is clearly defined. This principle applies to all photo stencils whether they are coated directly onto the screen or indirectly processed away from the screen and fixed on later. There is a third process, a combination of these two, in which an indirect film is impregnated into the mesh.

Direct Photo Stencils

There are many effective forms of direct photo stencil emulsion now available. When you are using this form of stencilling, the mesh on the frame is coated with the photo-sensitive emulsion and, after drying, is exposed to a light source which passes through a positive transparency. The areas of the positive which are opaque and which are to be represented in print protect the emulsion so that it remains soft and can be washed away later. Those areas which are exposed to the light are hardened so that they become impervious to the printing ink.

Above *Paradox* (1975) by Derek Hirst (b. 1930). The flatness of the surround and the central image are contrasted with the three-dimensional shapes which are sandwiched between them. The grey tones were created using a halftone stencil.

Indirect Photo Stencils

Indirect stencils, as we have mentioned before, are so-called because they are made away from the screen and attached to the screen after they have been exposed and developed. They are mostly quick and convenient to process and are capable of reproducing sharp detail and very fine textures, particularly halftones. A further advantage of indirect stencils is that there is available a wide range of products designed specifically for a whole variety of printing requirements. Whichever type of indirect stencil product you use, the technique of application remains essen-

Preparing a direct photo stencil 1. Fill a coating trough with light-sensitive emulsion. Draw the trough up the screen at an angle to lay an even coating of emulsion on the mesh.

2. Dry off the coated screen in a dark room. Place the photo-positive on the exposure unit with the image reading the right way round as you look at it.

3. Position the light-sensitive screen over the positive. Close the exposure unit and expose the screen to ultraviolet light for the right length of time.

4. After exposure wash the screen out with water. The emulsion has been hardened by the light but those areas protected by the positive image are washed away.

tially the same. The stencil is usually manufactured in the form of a two-layer film. One of these layers consists of emulsion of the sort used when doing indirect photo stencils. The other layer is a transparent backing sheet which is removed after exposure. The emulsion side of the positive is placed in contact with the backing sheet of the stencil. The film is then exposed to light which is directed through the positive and onto the film. The film is then usually developed in a solution of hydrogen peroxide or in a developing solution provided by the manufacturer. This process of developing further hardens the areas on the stencil which were exposed to the light.

The stencil is then washed in order to remove the soft areas, the shapes of which will print in colour. The screen is then lowered down onto the stencil and any excess water removed by blotting. Further drying can be done with a cool fan. When the stencil is absolutely dry the plastic backing can be peeled away, gently.

Direct/Indirect Method

A third photo stencil method should be mentioned briefly. This combines both the previous methods and is known as the direct/indirect photo stencil. The advantage of this technique is

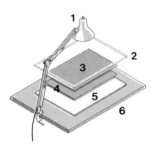

Exposing unit A lamp *(1)* should be equipped with a photoflood bulb. A plate glass exposure frame *(2)* should then be placed on top of the photographic positive *(3)*, the sensitized film *(4)*, and a rubber mat *(5)*. Underneath all these will be the baseboard *(6)*.

that the durable quality of direct photo emulsion is combined with the accuracy and fine detail of indirect photo stencil film.

The method of application is relatively simple. The screen mesh is laid down on top of the stencil film which is itself laid emulsion side up. A transfer medium is then squeezed through the mesh and onto the film. By doing this the mesh is impregnated with the film. With the ordinary indirect method the film is attached only by the drying process. When the transfer medium is dry the backing sheet can be removed and the screen is then ready for exposure. From now on the screen is processed in the same manner as a direct photo stencil.

Printing

The unit is now ready to print, and no matter which type of stencil has been attached to the screen mesh, there is a basic procedure to follow before printing.

First you must check registration. This is the positioning of the screen relative to the paper on which the image is to be printed. A simple method is to place a master drawing onto a piece of the

Preparing an indirect photo stencil
1. Place the film positive on the exposure screen emulsion side up and cover it with a piece of sensitized gelatine.

2. Centre the positive image under the gelatine stencil film and close the exposure unit. Expose the film to ultraviolet light.

3. Put the gelatine film in a bath containing a solution of 4 parts water to 1 part hydrogen peroxide. Leave it for about 30 seconds to harden the gelatine.

4. Wash out the film with water at a temperature of about 38°C/110°F. The unexposed gelatine washes away gradually until the image is clearly visible.

5. Place the gelatine the wrong way up on the printing face of the screen, so that the image will be right reading when the screen is turned over ready to print.

6. Blot the stencil with newsprint to remove excess water.

7. Turn the screen over and lay sheets of newsprint inside the frame. Work over the printing area with a roller to force the fabric on to the stencil, drawing the gelatine up into the mesh.

8. Let the stencil dry naturally and then peel away the transparent backing sheet, leaving the image in the screen mesh.

paper in the position which you require. Check the margins and alignment and when you are satisfied, fix the master to the control sheet where it remains throughout the printing sequence. Now draw four small right-angled crosses in the four margins. These are the register marks which must appear on all the screen stencils and positives of all the printing colours. It is imperative that the crosses register perfectly for each new colour. When the control sheet is placed on the print bed and aligned perfectly with the image carried on the transparent mesh, it must be fixed in position. This allows the use of stops or register guides, strips of tape, card, acetate, metal, which each print abutts during printing. In screen process printing three guides are normal, two being

Above Different ratios of the width of opaque lines to the width of space on halftone screens.
1. Width of the line is two-thirds the width of the space.

2. Widths are equal.

3. Width of line is 1½ times the width of the space.

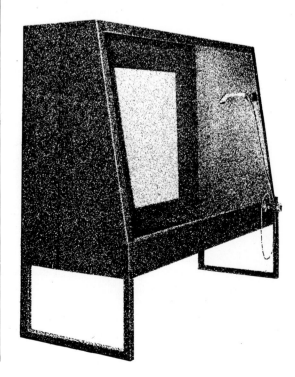

Top A photo stencil exposure unit has the advantage over homemade units of giving very short exposure times. **Above left** A transfer press designed for applying printed transfers on to textiles. **Centre** A high power unit for cleaning unhardened photo-resist off screens. **Left** A less sophisticated unit for cleaning screens. It incorporates an ordinary shower unit.

placed along the long paper edge and the other fixed towards the bottom of the short side. These must never vary until all printing has been completed. The ability to see through most screen fabrics is an advantage and many print tables in industry employ micro-register systems incorporating precision movement of the vacuum bed and hinging gear. Paper, however, is unstable and despite all these safety checks to ensure there is perfect colour registration, there may be some distortion if the printing lasts over a few days.

To achieve a clean, sharp print the mesh should not touch the surface of the paper when the frame is lowered into the printing position but should have a slight clearance to prevent the wet ink from attaching itself to the screen after the squeegee has forced the colour through. This clearance, or snap height, can be achieved by fixing strips of card under the frame. Some printing units incorporate adjustable screws fixed at the corners of the frame for this height adjustment.

Check the frame for movement and make sure that the hinge unit has no play in it. Check the edge of the squeegee for dents or nicks. Examine the stencil for pin holes, wear or uneven areas and

Filling holes in a stencil
Check for holes in a photo-stencil by holding the screen up to the light. To seal the holes, which would allow ink to pass through the mesh, dab in blue filler with a brush and let it dry.

Proofing 1. Attach the first screen to the printing bed. Position the photo-positive of the image on a sheet of printing paper. Put this under the screen and register the positive to the screen stencil.

2. Having established the position of the paper mark it on the printing bed by laying short strips of adhesive tape or card along two sides of the paper.

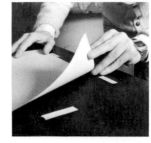

3. The marks remain in place during the whole printing process. Remove the photo-positive and lay a sheet of printing paper into the registration marks.

4. Lower the screen and pour ink along the top of the screen mesh above the printing area.

5. Place the squeegee behind the ink close to the top of the frame and draw it down across the mesh at an angle of about 45°. Lift the screen and return the squeegee to the top. Pull out the print.

6. Pull the required number of proofs in the first colour. To lay in the next colour attach the second screen to the printing bed. Raise the screen and fit a proof into the registration marks. Lower the screen.

7. Overprinting with opaque ink will completely obliterate the first colour. To obtain transparency in the second colour add extender base when mixing the ink. Pour ink along the top of the screen as before.

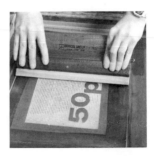

8. Spread ink evenly down across the printing area with the squeegee. It is essential that this is done in one smooth action.

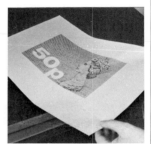

9. Lift the screen and return the squeegee to the top of the frame. Pull out the print. Repeat the process with the remaining proofs. This printing method is common to all types of silkscreen stencils.

mesh blockages. Finally, see that your colours are mixed thoroughly and are of the desired shade and consistency.

Before printing an edition or long run it is practical to pull a few proofs to enable you to check the qualities and accuracy of colour and register. Any minor adjustments of colour or registration can then be made before you actually begin your print run.

The printing process is relatively simple. Raise the screen and place stock against the registration guides. Then lower the screen on to the baseboard. Pour ink into the screen at one end so that it is spread evenly from one side of the frame to the other. Position the squeegee behind the colour and close to the frame. Then, standing at the opposite end, pull at an angle of about 45° towards you, maintaining a constant speed and without altering the angle of the blade. This may apear an extremely simple operation but it is, in fact, quite difficult and will probably require considerable practice. You should look for the speed with which the mesh springs away or snaps up from the print surface following the passage of the squeegee. If the print is slow in releasing the

Above The screen mesh must on no account come into contact with the printing paper when the frame is laid down upon it prior to printing. There should be a gap of about ½ cm/⅜ in between the mesh and the paper.
Above right When you are printing you should pull the squeegee towards you at an angle of about 45°.

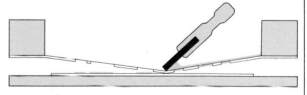

screen mesh, then adjustment must be made to the height of the frame and the squeegee angle altered. As a rough guide, a pull at angles close to horizontal gives a heavy deposit of ink, increasing possibility of the print sticking to the mesh and causing a lack of definition on the edge of the colour. A pull at too vertical an angle puts down a very thin, uneven layer of colour and may cause the squeegee to judder.

After you have pulled the squeegee down the length of the frame you can raise the screen, using one hand, and push the squeegee and ink towards the back of the screen with the other. This will deposit a flood coating of ink which ensures an adequate ink deposit for the next pull. Finally, remove the proof and place it in a drying rack.

1

2

3

4

5

Calcium Light Night by Eduardo Paolozzi (b. 1924). Illustrated here are seven stages in the production of a screenprint. The first stage (not illustrated here) consisted of an overall printing of matt black. On top of this was printed a translucent white, resulting in the emergence of a grey image *(1)*. Another layer of translucent white was printed giving a further differentiation of grey *(2)*. A translucent red was then printed *(3)*, followed by a layer of translucent blue *(4)*. At the next stage *(5)* another translucent white was printed, thereby adding a further range of tonalities. A printing of opaque white *(6)* added definition to the print. Further definition was brought out by printing an opaque cream. Finally, the print was varnished *(7)*.

6

7

Multicolour Work

The simplest method for reproducing multi-colour work is by hand drawn or cut positives. Nevertheless, any form of stencil can be used.

Firstly, you must decide how many colours you are going to print and then you must make a stencil and a frame for each. Registration is crucial when making multicolour prints but do remember, on the other hand, that perfect registration with silkscreen stencils is practically impossible, thus, there will always be some overlapping. This is part of the nature of screenprinting and most silkscreen artists have exploited this to their advantage, making a virtue of overprinting.

When printing a multicolour sequence first print the colours which will represent the largest areas. By doing this you will get a feeling of the overall tonality of the print early on. If you are going to use opaque inks it is important to print the light colours first, though should you be using transparent inks it matters little in which order you print them. On the other hand, you must anticipate the way in which the colours will blend when they overlap. If you intend to mix transparent colours over large areas you would be well advised to overprint them first on the same paper you intend to print on. By doing this you will have some idea of how the finished print will turn out.

The most complex image that you are likely to want to print is the one which incorporates continuous tones. The only way that this can be done is by breaking your tonal image down into tiny dots, the darker areas of the print being made up of closely packed dots, and the light areas consisting of smaller and fewer dots. To achieve this translation from a solid tone to a system of dots the image which you want to print is usually photographed through a halftone screen in a process camera.

When the process has been completed you will have a positive image on film from which a direct or indirect stencil can be made.

If you want to produce multicoloured images incorporating halftones you will again have to use a process camera. The camera is able to separate the colours in your image and you can employ up to six halftone separations for normal printing. Some silkscreen artists use up to as many as 20 separations and this involves the use of 20 stencils and frames. Using as many screens as this poses real problems of registration and colour mixing so that for the beginner the production of multicolour halftones is best left alone until some simpler images have been printed and the associated techniques mastered.

Cleaning the Screen

After you have finished printing you must clean the screen. It is advisable to wear rubber gloves for protection, as some solvents can irritate the skin. A spatula or piece of card can be used to scoop up any excess ink and replace it in the container. The

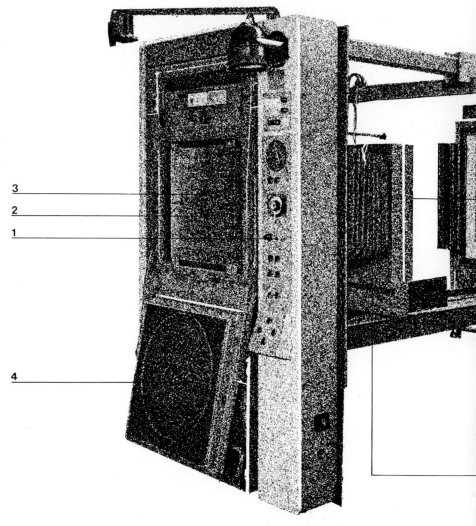

Above The process camera is used to break down tonal images (as in a halftone) into a series of dots. The image to be printed is photographed through a halftone screen. The basic parts of any process camera include control panel (1), door (2), ground glass (3), camera back (4), copyboard (5), lamps (6), camera bed (7), lens (8) and bellows (9).

Cleaning the screen
1. Hold the squeegee upright over a waxed paper cup and scrape ink down the blade with a palette knife, collecting it in the cup. Use thinners to wipe the squeegee clean.

2. Scoop any surplus ink out of the screen with a palette knife and pour it into the cup. The ink can be kept and used again to save wastage.

3. Wipe out the inside of screen and mesh with thinners and clean rags. Rest the screen on sheets of newsprint and work until the mesh is quite clear of ink.

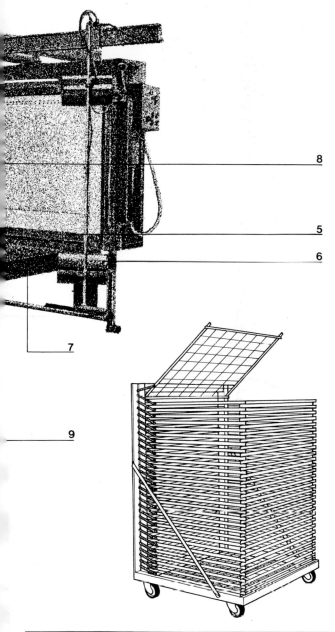

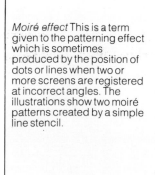

squeegee should be held in a vertical position above the container and carefully scraped with the card or spatula, allowing excess ink to be saved. The frame can be detached from the hinges and cleaned outside by placing it on a pile of newspapers and pouring on the appropriate solvents.

Turps substitute will remove oil-based inks, and those preparations containing toluene and ethyl acetate will effectively dissolve most screen inks. Stubborn hardened inks will be easily cleaned by the use of universal screen wash. Most solvents are highly inflammable, and cheaper types are highly toxic and should not be inhaled for long periods. If the screen remains on the baseboard, first place old card or newsprint underneath and rub the inside with rags impregnated with solvent, replacing newsprint until very little colour is left. Use a clean soaked rag on the underside of the screen in a counter-movement with the rag rubbing the inside mesh. Repeat until no trace of colour remains on the rags. Care must be taken in rubbing the underside as this is the surface to which the stencil adheres.

What to avoid
1. Smudging against the edge of the frame or the finger due to the print being lifted carelessly.
2. Flooding on the edge of the print caused by the squeegee angle being too horizontal.
3. Insufficient inking caused by the squeegee being too vertical.
4. A blocked stencil due to gelatine not being properly washed out of the mesh.
5. Offset double image caused by screen being lowered on to the wet print.

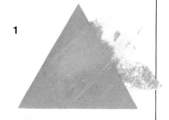
1

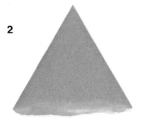
2

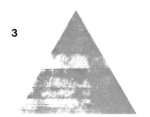
3

4

5

Left Commercial print drying rack. This type of factory rack is composed of hinged metal shelves. Prints are stacked shelf by shelf from the bottom up. The rack can be emptied quickly when the prints are dry.

Moiré effect This is a term given to the patterning effect which is sometimes produced by the position of dots or lines when two or more screens are registered at incorrect angles. The illustrations show two moiré patterns created by a simple line stencil.

Alternatives in Printmaking

Artists have always experimented with print-making techniques, materials and methods of originating images. Their desire to create certain effects has led them to make imaginative use of existing methods, to combine different processes and try out unusual surfaces: these extensions and adaptations are an integral part of the history of the medium.

Rembrandt (1606–69) tried different formulae for his etching baths and mixed techniques on one plate. His friend Hercules Segers (1585–1638) added colour either to different areas of his plates or to the finished pull; he also tinted the paper before printing. In Tahiti, Paul Gauguin (1848–1903) cut into packing cases when no other wood was available; Edvard Munch (1863–1944), much impressed with Gauguin's woodcuts, experimented by inking separate areas of a single block to produce colour variations. Georges Rouault (1871–1958) drew preliminary designs on paper for his suite *Miserere*, which were then taken away by his publisher, Ambroise Vollard, to be made into photo-etched plates. Rouault was so disappointed by the results that he completely reworked the plates by etching, burnishing, applying roulette work and aquatint. Picasso (1881–1973) used a similar approach in his litho-graph *L'Italienne*. Taking a zinc photolitho plate which had been used to print a poster advertising an exhibition of paintings, he added strong brush strokes to the image and scratched some charac-teristic figures in the background. The result was then published as an original print.

Mixed Media

Today, artists have far greater access to a variety of printmaking equipment than ever before. Colleges usually offer facilities for all the main pro-cesses. Inevitably, when such a choice is avail-able, artists come to realize that certain ideas are best expressed by combining more than one tech-nique.

The usual combinations are screenprinting on top of intaglio or litho; intaglio on top of relief, litho or screenprinting; and embossing (using a relief or intaglio press) on any print. The choice of technique obviously depends on the effect re-quired. Screen inks cover well and can be used to solve the problem of applying an opaque pale colour to a lithograph; metallic and fluorescent inks are also more satisfactory when screen-printed. Fine line work or a three-dimensional emphasis is best achieved by intaglio.

In the sixties, Michael Rothenstein (b. 1908) used a combination of hand-cut relief blocks, found objects and process engravings. More re-cently, he has been using screenprinting to con-trast with relief blocks.

Images Originated in New Ways

One of the most obvious differences between pre- and post-sixties printmaking has been the use of

Right *Picasso's Meninas* (1973) by Richard Hamilton (b. 1922) is an example of mixed media. In this case different sorts of intaglio printing were combined: etching, aquatint, engraving and stipple. The subject matter relies on visual quotation – the image is derived from a work by Picasso which itself is based on a painting by Velasquez. The print reflects the attitude in modern art that the image belongs wholly to the artist and can be borrowed, re-used or manipulated in any way he or she chooses.

Below *L'Italienne* by Pablo Picasso (1881–1973) shows a similar approach both in technique and subject. Picasso handworked a photolitho plate, adapting the work of another artist by adding his own characteristic figures to the original image.

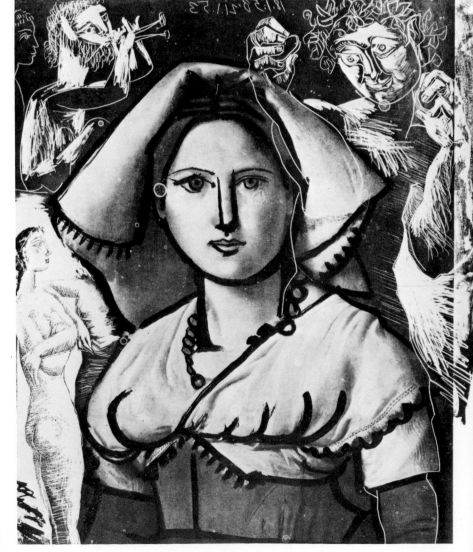

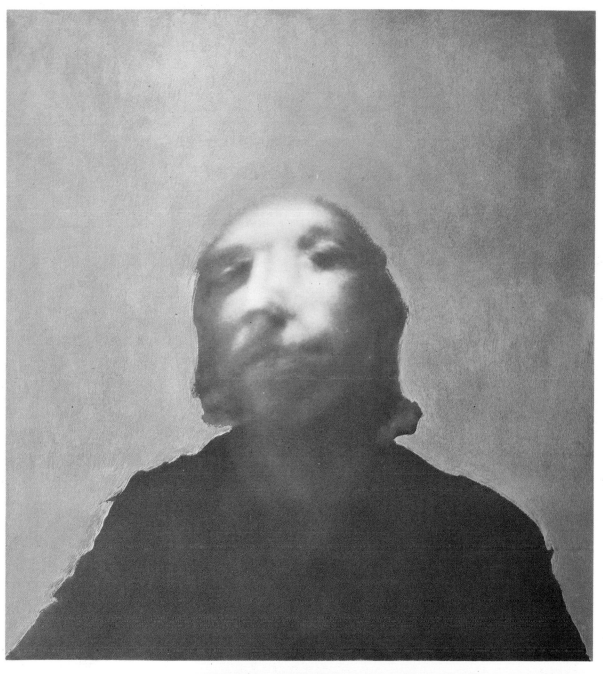

Left *Portrait of the Artist by Francis Bacon* (1970) by Richard Hamilton is a self-portrait in the style of Bacon, produced from a Polaroid snapshot which was subsequently made into a collotype.Screenprinting and some handworking was then added to the surface of the print. The distortion in the snapshot provides an imaginative way of using photography in printmaking.
Below *Inset Wheels* by Michael Rothenstein (b. 1908) is a print from linoleum and metal relief, with photolitho insets. Rothenstein has advocated printing from a variety of materials, either singly or in combination. He often prints his own work by hand, using an old Victorian press.

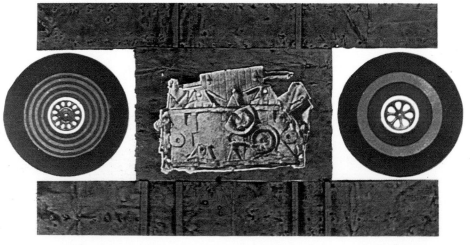

imagery derived from photomechanics – the use of previously printed material which employs a halftone screen or the use of halftones directly on the print. Most artists today regard the camera as a tool for collecting information much as the pocket sketchbook was to previous generations. In each case the photograph has to be made into a printing matrix. This usually involves the halftone screen, but other textural screens with random aquatint effects or parallel, horizontal and spiral lines – all photomechanical screens – can also be used to create the appearance of tone. Artists have benefited from the recent developments in continuous tone lithography (particularly at the Curwen Studio in London), though the strength of this technique lies in its use of drawn rather than photographic positives. Richard Hamilton's (b. 1922) *Portrait of Francis Bacon* is a good example of the inventive use of a photographic image to create a print using several different techniques.

Many other forms of image-making technology, apart from photography, have been exploited by printmakers. The typewriter was twenty-five years old in 1898 when it was first used to make a work of art – a picture of a butterfly. Josef Albers (1888–1977) thought very highly of the typewriter and used it in one of his courses at the Bauhaus Design School in Weimar in the twenties. In the late fifties, typed concrete poetry became popular but many purely visual images have also been made. Initially, the compositions had to be transformed into a photo-plate or screen if they were to be replicated, but nowadays word processors can be used easily for that task.

The use of the typewriter naturally led on to the use of all the other forms of office copiers and in-house printing machines. The blueprint, dyeline and similar proprietary processes used by architects to copy plans discolour rather quickly but are suitable for producing work intended to be ephemeral. Stencil copiers now have scanning devices to make photo-stencils from visual material, but the small-scale table-top photo-plate makers have caused the greatest revolution in this field. Once the four colour system became reasonably reliable, electrostatic printing systems (Xerox is one of the best known) caught the im-

Top *Typewriter* (1974) by Gary Blake (b. 1943) is a print both representing and produced by a typewriter. This mechanistic means of creating images has fascinated many artists throughout the twentieth century and is only one of a variety of office machines which can be used for experimentation.

Right *Untitled* (1979) by Chris Briscoe shows how a sequence of moving lines in three dimensions can be transformed into a two-dimensional image by a computer. The print-out was duplicated by photolitho.

agination of artists, and is widely used today in North America and Europe. If the artist has access to the colour printing controls, some very unusual effects can be produced, but in Britain the manufacturer's licensing system has made it difficult to gain such access, save in a few colleges. Xeroxing is not always used to produce an edition as such, but is often a means for trying out colour variations for a project which will eventually be realized in more conventional ways.

X-rays, electron-microscope photographs, television and video-originated images have all been made use of by artists, but the tool explored with the greatest originality has been the computer. Art colleges attached to universities often have access to computer time. The computer is perhaps most able at plotting the sequential changes possible in a complex shape seen from many angles and produces a print-out on paper. Since computer time is so expensive, copies are most often printed by photolitho or screen process printing.

Right *La Main du Homard Cosmographique* (1965) by Serge Béguier, a photomontage from *The Portfolio Chopin,* based on a concrete poem and a photograph of the hand of Henri Chopin. Photography has been directly incorporated into many modern prints, and can be seen as a form of printing in its own right, and not just one of the tools which aid the artist.

Paper Manipulation

A significant development in the last few years has been the revival of interest in paper. During the initial enthusiasm for screenprinting when anonymity of the printed surface was sought, characterless paper (often smooth machine-made cartridge paper) was used. Intaglio has always had a more direct and physical relationship with paper, and once the first excitement with screenprinting subsided and artists reassessed the possibilities of other printing methods, interest revived again in the vehicle carrying the image.

This interest went further than the choice of a paper with character. There was a time during the fifties and sixties when handmade paper mills were closing all over the world. Artists and craftsmen tried to preserve and revive these skills, often collaborating to produce a batch of special paper for an edition. In some cases, printmakers made their own paper. The paper for Richard Smith's (b. 1931) *Russian II* (1975) was specially made at Hayle Mill in Kent. It is thick, oatmeal-coloured and has a lively, bumpy surface which makes an interesting contrast with the square, uncompromising intaglio print. String joins the three sheets.

Below left *Russian II* (1975) by Richard Smith (b. 1931) was made by a combination of intaglio and collage and printed on specially made paper. This print is an example of experimentation with techniques, materials and the way the finished print is assembled. The three sections which make up the print are joined at the top by string.

Below right Colour Xerox has inspired many artists to experiment with the odd colour effects that can be achieved by using this process. This print by a first-year student at the London College of Printing was produced by drawing in four colours on cartridge paper with grease pastel and then printing colour variations using a four-colour Xerox machine.

Left *Diving Board with Still Water on Blue Paper* (1978) (*Paper Pool* no. 12) by David Hockney (b. 1937) is one of a series of formed paper prints made by pouring wet pulp into preformed moulds. This huge print, reflecting the artists preoccupation with a favourite theme, swimming pools, is in six sections.

Below *The Garden* from *Bluebeard's Castle* (1972) by Ronald King (b. 1932), with poems by Roy Fisher. This pop-up book is composed of nine designs, screenprinted onto specially folded and cut-out paper, assembled into book form. Each image represents one of the secret rooms in the story of Bluebeard and demonstrates how paper can be manipulated in a striking way within a book format.

Robert Rauschenberg (b. 1925) made two suites of formed paper prints at the mills of Richard Le Bas in France in 1974. In *Pages* he used five shades of grey paper pulp to make free form sheets and in *Fuses* he incorporated previously screenprinted tissue with the wet pulp on the mould, together with spooned-on dyes. Though these suites were issued in editions of varying sizes, there is considerable difference between prints.

In 1979–80 in the United States, David Hockney (b. 1937) made *Pools* on a favourite theme, swimming pools, by pouring pails of coloured paper pulp into large moulds in predetermined areas to form the images. Several sheets placed side by side made up the giant, mural-sized print.

Paper has also been torn, stitched and folded in conjunction with printed areas to make prints with a tactile, three-dimensional element.

Other materials have been used by printmakers in much the same way as paper. Metal foil on a paper backing and sheet plastics which simulate paper have been used as print vehicles. Other types of sheet plastic have been screenprinted before, or sometimes after, vacuum forming. In vacuum forming, heat-warmed plastic is stretched in a frame; as the plastic reaches melting point, it is sucked down across the object to be formed. A good example of a vacuum-formed object is the liner inside a chocolate box.

Collage and Assemblages

Another preoccupation of the late twentieth century has been collage – particularly, in printmaking, in the context of Pop Art. The photo monteur, John Heartfield (1891–1968), pioneered the use of

collage in his book and poster designs. Many different types of objects and pre-printed images have since been glued to prints or assembled with them. Joe Tilson (b. 1928) has tied or stuck paper clips, advertisements, postcards, small plastic toys, rubber bands and plastic bags to his prints. The German artist Hundertwasser (b. 1928) has embellished his screenprints with foil blocking in many different metallic colours (usually seen on the spines of books). A recent print by Tim Mara (b. 1948) in the 1980 Barcham Green Printmaking Competition was a combination of embossing, etching and screenprinting with the addition of 'hundreds and thousands' (tiny multi-coloured sugar balls used for cake decoration which left their impression and dye-patch on the damped printing paper). Dieter Roth (b. 1930) applied a banana to one of his prints: it was, of course, intended to decompose.

Unfortunately, many prints that feature collage will not survive for long. Untried chemical adhesives present the greatest danger; almost all of them have a disastrous effect on paper in the long term. Curators of contemporary print collections are already shaking their heads as the collages disintegrate and paper discolours.

Collected Works

The presentation of prints has also undergone revolutionary scrutiny. Artists still issue prints in single editions (if the image proves less popular than expected, the practice of a second or third edition has largely been suppressed) and suites of prints are still grouped in specially made portfolios and solander boxes. What has changed are the materials now used to make these containers. Plastics, particularly interesting contrasts of opaque and clear sheet, are often moulded to make boxes. Some boxes are designed to hang on a wall like a frame; the topmost print can be changed to alter the display. In the early sixties, Editions Alecto, the publishers of Jim Dine's (b. 1935) *Toolbox*, and Petersburg Press, the publishers of Eduardo Paolozzi's (b. 1924) *Moonstrip Empire News*, were pioneers in this field with their striking and innovative presentation boxes.

Another important development in presentation has been the revival of the book form for suites of prints, often with an accompanying text. Other artists are interested in the book form because it allows sequential viewing of a number of images. Hockney's *Grimm's Fairy Tales* and Jim Dine's *Dorian Gray* are both good examples of prints presented in book form. Ronald King (b. 1932), in his striking pop-up book, *Bluebeard's Castle*, has explored the effects which can be obtained by paper folding and box making.

Non-standard Editions

Some artists have reacted against the standard definitions of printmaking terms, such as 'edition', 'artist's proof' and 'number'; logically, their

Left *Will the Future Ruler of the Earth Come from the Ranks of Insects?* (1970) from *Zero Energy Experimental Pile* by Eduardo Paolozzi (b. 1924) shows a mixture of materials and techniques. Lithography and screenprinting were combined on Astralux (a high-gloss coated paper) which was then laminated onto perspex.

Opposite right *Landscape Screen* (1969) by Jim Dine (b. 1935) is composed of five imaged double-sided screenprinted panels, each panel measuring 183 x 45 cm/ 72 x 18 in.

Right *Stews* (1970) from *News, Mews, Pews, Brews, Stews & Dues* by Edward Ruscha (b. 1937), one of six organic screenprints. An extreme use of materials in printing has been screenprinting with food. For *Stews*, Ruscha used baked beans blended with daffodils, mango chutney, tulips, leaves and stalks, caviar, cherry pie filling, strawberries and tomato paste. The ingredients were drawn across the screen in the same way as ink to form a print of the word 'stews'.

Far right *Bathers* (1967) by Richard Hamilton shows how artists can alter prints in an edition by treating each print individually. In this series, the artist added acrylic paint by hand to each print after they were screened.

techniques can be extended beyond the traditional constraints involved in producing an edition of a hundred identical prints. Eduardo Paolozzi used screenprinting to make his colour variations. In 1963 he made his first edition in which each print has an individual colour combination; his well known suites, *As Is When* (1965) and *Universal Electronic Vacuum* (1967), exploit this possibility further.

This attitude naturally leads to a reassessment of the role of unique prints and monotypes. These are usually excluded from the printmaking canon, but today many artists are deliberately making prints which differ from each other as a way of overcoming what they regard as a too mechanistic production of images. The master image is usually in a repeatable form, such as an intaglio plate, and each print is then modified in a variety of ways. William Blake (1757–1827) used this technique in the creation of his so-called 'large plates'. Monotypes are significantly different from unique prints in that each impression has to be redrawn on the glass or metal sheet.

Other Additions

Lately there has been a revival in the application of various types of tints and textures to the

1, 2 and 3. The development of a simple monoprint
1. First, a colour is rolled up flat on a glass surface. Paper is placed over the glass and the print taken by rubbing over the back.
2. A sheet of corrugated glass is then inked in a second colour and the print taken in the same way. Ink will adhere to the highest surfaces of the glass and produce a pattern.
3. Lastly, a third colour or more is applied to a glass surface by squeezing ink straight from the tube. The print is then taken and the final effect shows a build-up of colour in patterns.
4. Another type of monoprint can be produced by applying ink to a glass or stone surface in an even layer and placing paper over the top. The image is drawn through the back of the paper using a rounded point like the end of a large paintbrush, keeping the hands away from the paper. Extra colour can be added by inking up cut-out card shapes and applying them face down to the surface of the print, applying pressure.
5. This vacuum-formed print by a first-year student at the London College of Printing, the design was screenprinted onto opaque white plastic and drawn down over wooden shapes in the bed of the vacuum frame under vacuum pressure.
6. *Video Discs* by Peter Sedgley (b. 1930) consists of screenprinted rotating discs. The print element is only one part of the finished work, which could be better classified as kinetic sculpture.
7. *Link* (1974) by Robert Rauschenberg (b. 1925) from the series *Fuses* is a formed paper print made by using separately coloured pulps and magazine images screenprinted onto Japanese tissue. The free-form shapes were designed to sit in transparent boxes.
8. This marbling effect was achieved by smearing screen process inks on a glass surface using a palette knife and taking a print directly from the surface. The result could be used as a textured ground for overprinting.
9. A simple transfer print can be made by soaking a page from a colour magazine (when the ink is still fresh) in solvents and then rubbing from the back to transfer the image to paper. The finished print shows the mark of the burnisher. Glossy magazines are not suitable.

1

2

3

5

6

7

finished print. Jim Dine, in *Woman with Dog: Stage Two*, watercoloured an embossed heart in five different colours by hand. Other artists such as Terry Willson (b. 1948) add coloured crayon lines, using a template as a guide for positioning. The nineteenth century technique of *pochoir* or stencilling has also become popular again. The basic design is printed lithographically, or by some other method, and colour is added through a stencil by means of a sponge, brush or spray. Ivor Abrahams (b. 1935) uses flocking to create a curious three-dimensional effect in his prints of hedges and gardens. In his screenprinted series, *Bathers*, Richard Hamilton applied acrylic paint to the prints.

Printing with Non-standard Materials

Michael Rothenstein caused a sensation among printmakers when he advocated printing from

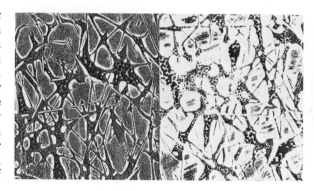

Above A simple relief print can be made by using a piece of plywood or thick card as the base of the block. Textures can be added to the surface; in this case, impact glue creates the pattern. The block is then inked and a roller taken across the surface to pick up the impression. The print is produced by taking the roller across paper. A soft roller will pick up more detail *(left)* than a hard roller *(right)*.

Right Another type of relief print can be made by cutting out jig-saw shapes in cardboard. Ink each shape separately, in different colours if preferred, and then fit them together again. Place paper over the top and take a print by burnishing. A thin layer of P.V.A. applied to the card will prevent it from getting soggy. Remove strips from the card to create patterns and textures.

Above Relief prints can be taken from a variety of surfaces. Here a feather has been inked with a hard roller and then the impression has been transferred to a soft gelatine roller. The print is made by rolling out the design on paper in single and overprinted images.

Right Cork cut (1928) by Ben Nicholson (b. 1894). Printing from different surfaces creates a variety of textural effects. Cork can be used as a substitute for linoleum. In this illustration, the simple lines of the design make an interesting contrast with grain of the background.

found objects in his books *Frontiers of Printmaking* and *Relief Printing*. Rothenstein used weathered wood and crushed metal, together with metal stamps and built-up blocks; other artists have gone on to explore printing from clothing, other fabrics, food and parts of the body. Peter Schmidt (1931–79) made extensive use of compositor's type units such as spaces, rules, flowers and punctuation as well as the letters themselves. Printing plates or blocks made from collaged materials and adhesives are so common that in North America the intaglio-printed forms are known by their own term: collagraph.

Embossing has also re-emerged as an area of great interest. The Japanese were masters of blind and coloured embossing in the *Ukiyo-e* prints of the eighteenth century; today, old methods have been adapted to new materials. Embossing offers a perfect medium for minimalist artists; others have used it in combination with colour to heighten or decorate only certain areas of a print. Shallower embossing can be done on a relief print using soft blankets in the bed of the press and almost any engraved surface will create an embossed effect, as do woven mats, coarse fabric, stamped metal sheets or plant forms.

Fringe Printmaking

The distinct categories of printmaking are now becoming blurred as repeatable techniques are used in conjunction with variable ones. Printing is also being done on surfaces hitherto associated only with painting and sculpture. Gerd Winner (b. 1936) and Andy Warhol (b. 1928) have both screenprinted on canvas. The results have then been stretched and framed like paintings, sometimes in small editions and sometimes as unique colour variations. Peter Sedgley (b. 1930) screenprinted on rotating discs, but these *Video Discs*, as he has called them, are really kinetic sculpture which happens to utilize print. Other artists have printed transfers or decals which are then applied to ceramics and fired. These, together with other three-dimensional works, are generally called 'multiples' but are hard to distinguish in principle from other works called 'prints'.

Obviously, nothing is sacred in printmaking any longer. Most artists in the past had access to only one of the printing processes and consequently experienced some restrictions; without question, the range of technology available today has opened up new vistas and spurred the imagination. It is still worth remembering, however, that technique is only a vehicle for ideas and should enhance rather than dominate.

Looking ahead, the Printmaker's Council has stated, 'The artist printmaker has the inalienable right to decide himself on the methods he uses to make a print. These can be autographic, mechanical or photographic. He can use any process in existence today or which could exist in the future.'

Left *A Firm Foundation is Our Geneva* (1934) by John Heartfield (1891–1968). Heartfield was a pioneer in the use of photomontage. In this print, cut-up photographs were collaged together with drawn elements and reproduced as a collotype. The title refers to the second International Disarmament Conference in Geneva, 1933.

Mounting and Display

Edgar Degas (1834-1917) once stated that 'the frame is the reward of the artist'. A frame should emphasize the particular qualities of a print which make it individual and attractive, enhancing and complementing the image without overpowering it. It also defines the area of the picture in relation to the background on which it is hung, and protects it from damage or deterioration. Thus for aesthetic and practical reasons, the choice of a frame and the subsequent positioning of the framed print on a wall are important parts of the whole process of printmaking.

Mounting
Choosing a Frame
Frames today are no longer confined to basic geometric shapes but can be as large as a mural or small enough to house a miniature. They can be as flat as a sheet of paper or deep as an alcove. They can be triangular, oval, pentagonal, hexagonal, octagonal, or freely contoured, and made from any of the vast range of natural and synthetic materials now available.

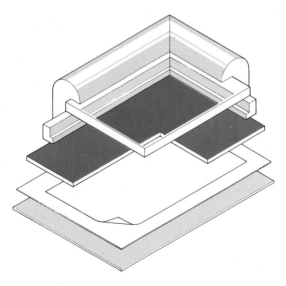

Above Exploded diagram of the type of frame known as a shadow box, suitable for framing prints with a raised or collaged surface. An inner frame or fillet holds the glass in place, away from the surface of the print. The inner frame is usually a plain sloping moulding, often lighter in colour than the outside frame. Fillets or spacers can be thin hardboard (masonite) or thick cardboard.

Types of mouldings
Mouldings vary enormously, as this range of corner samples shows. Wooden frames can be plain or stained and varnished; they can be gilded or finished with gesso and painted; lines can be added to give depth and colour. Even metal frames (usually aluminium) come in different colours and finishes. Most framemakers carry a range of samples and it is worth spending time making your selection.

Different textures and materials can be applied to the surface of the mount, or used to cover the frame. They can be used as decorative borders or cover the entire surface of the mount to provide an unusual background for the print. Materials that give interesting effects include hessian, silk, velvet, brocade, ribbon – even leather and suede can be attractive. Experiment with a variety of textures to see how the finished result will look when combined with the print. Remember to keep decoration simple if the print itself is not bold or complex.

The choice of a frame should be given as much thought as the choice of furnishings for your home. It is easy to go out and buy a frame to fit a print but surprisingly few people try out a variety of types to assess different effects.

Whether you choose your frame mouldings to make up at home or buy or commission a specific frame from a maker, bear in mind the effect you are trying to create. Good framemakers have a selection of made-up corner pieces and coloured mats, as well as finished frames, and it is worth spending time before making a final choice. There are eight basic categories of frames:

A variety of techniques can be employed to create a balanced effect when the frame is combined with a mount. These examples show a range of possibilities. Fine lines or bands can be drawn on the mount to lend definition, the mount can be covered in material, both frame and mount can be covered in wallpaper, borders of braid or ribbon can be added, frame and mount can be painted with a design.

1. Simple wood frames – many hardware stores stock wooden mouldings with a rebated edge, in lengths ranging from 2m/6 feet to 5m/15 feet. Pine is inexpensive and can be stained and coloured.
2. Plastic frames.
3. Reproduction frames.
4. Antique frames.
5. Frames with contoured mouldings made from plaster or gesso.
6. Frames incorporating carving, ornamentation or gilding.
7. Polished alloy or bronze.
8. Moulded perspex.

patterns and textures with wire brushes.

Strips of card or wood fillers can be inserted between the moulding and the mount to give depth or make a decorative border. They can also seal the gap between mount and frame.

Mounts

Mounts or mats are flat pieces of board or card with a window cut in the centre through which the print is visible. Their function is to allow safe handling of the print and to prevent damage, which could occur if the glass in the frame came into contact with the surface of the print. They also help to focus attention on the print by isolating it slightly from the frame, and can lend definition to an unobtrusive or plain moulding.

Mounts should be made from the special board known as conservation or museum board which is made entirely from rag fibre. Never use cardboard; most cardboard is made from wood pulp and is acidic. Over a period of time the print will deteriorate, becoming mildewed and stained. The backing board, which supports the print in the frame, should also be conservation board

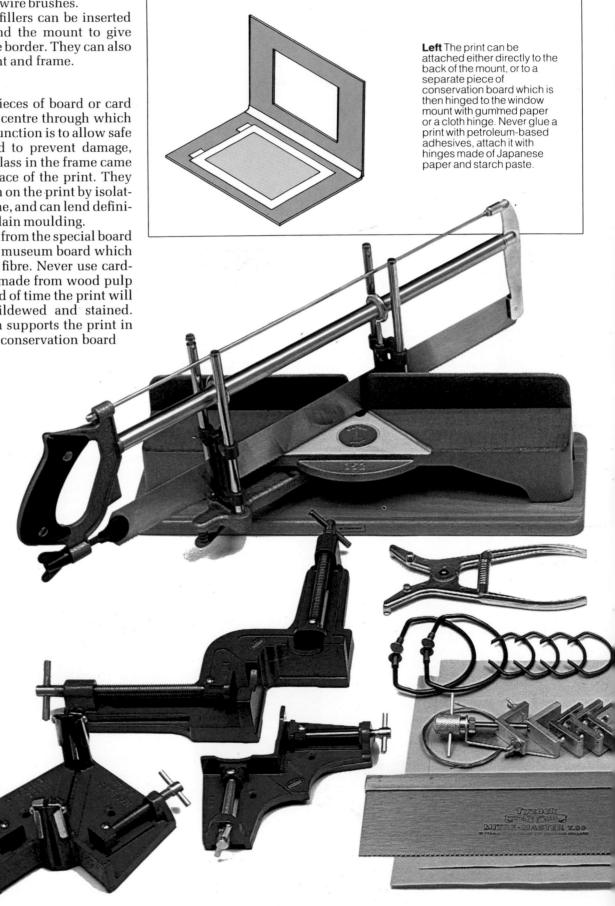

Left The print can be attached either directly to the back of the mount, or to a separate piece of conservation board which is then hinged to the window mount with gummed paper or a cloth hinge. Never glue a print with petroleum-based adhesives, attach it with hinges made of Japanese paper and starch paste.

Equipment needed for making and assembling frames **(left to right)** Combined mount cutter and clamp, simple clamps for securing mitre, adjustable mitre saw which runs in grooves for accurate cutting, pliers and spring clips for holding mitres together while assembling, corner pieces, wire and screws for clamping mitres together; 45° trisquare, hand drill, panel pin hammer; chisel, staple gun; bradawl, pin punch, glass cutters, steel rule.

The colour of the mount should be chosen carefully to complement the print. Lighter colours will tend to make the image appear darker and flatter; dark colours produce the opposite effect. Although conservation board only comes in white, ivory and grey, you can buy coloured rag paper and paste it to the board using pure wheat flour paste (not petroleum-based adhesive). Alternatively, materials such as leather, suede, silk, hessian or velvet can be used to make mounts and colour stippling or flocking added to create interesting and attractive variations.

The surface of a mount gets dirty fairly easily. Most smudges can be erased with a putty rubber, but grease or oily fingermarks should be rubbed away with powdered white pumice applied with a clean cloth.

Measuring the Mount

An important consideration is how much space to leave between the edge of the printed area and the inside of the window in the mounting board. It is important to allow enough room so that the print does not look pinched; care must also be taken not

Left, below Simple inexpensive block frames can be made by fitting a piece of glass over the mounted print and securing it by some means to a piece of backing board. Three methods of assembling this type of frame are illustrated here. Spring clamps can be bought from hardware stores and used to hold the glass and board together. Metal cornerpieces secured with screws can also be used, as can special double clamps that are tied together with stout nylon cord. Although these frames do not provide ideal protection and can let in dust, they are suitable for less valuable works and can be easily taken apart and reassembled.

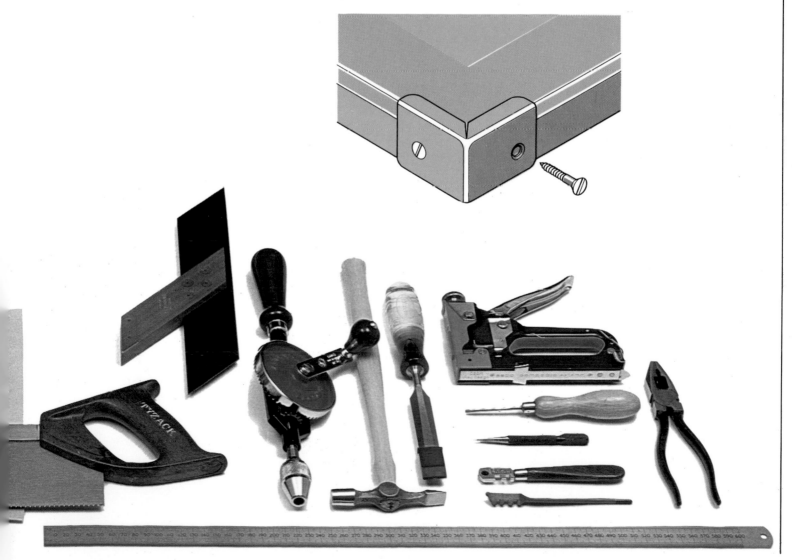

to cover up the artist's name or the title of the edition.

To determine the correct dimensions of the window, cut two L-shapes from thin card, longer and wider than the print. It is useful to have three sets of these templates – light, medium and dark in tone – to help you decide on the final colour for the mount. Place the print in a transparent plastic envelope so that you can take measurements without damaging it. Centre the print on a clean surface. Position the templates close to the image to form a rectangle. Move them out from the image until you reach a point where the print is set off by the mount without looking cramped. Measure the proportions of the inside rectangle – these will be the dimensions of the window you will cut from the mounting board. As a rough guide, a 45 x 50cm/ 18 x 20 inch print could take a 8½–10cm/ 3–4″inch mount; smaller prints like etchings might only need 4½–5cm/1½–2 inches. Many contemporary prints such as boldly coloured lithographs and screenprints demand larger mounts even if the printed area is relatively small.

When you have decided how big the window will be, experiment with different right-angled moulding samples to help you to see the print as a whole, decide which moulding to use and how wide a margin to leave on the mount. It makes good visual sense to allow the bottom margin to be wider than the top so that when the framed print is hung, the print appears weighted at the bottom. The mount should also be a different width from the frame, otherwise the frame will dominate the print and look heavy.

Cutting the Mount

From a piece of transparent plastic, acetate or drafting film cut a rectangle the same size as the window. Draw centre lines on it, dividing it into four. Turn the mounting board face down and mark the centre on the top and bottom edges. Join lightly with a pencil mark. Position the acetate rectangle so that the centre line coincides with the pencil mark on the mounting board. Measure down the width of the top margin established earlier on the central line and mark a line parallel to the top edge of the board, checking for accuracy with a set square. Register your transparent sheet to this. Place a ruler on the sheet and, using a set square, draw the rectangle onto the back of the mounting board. You should now have established the area to be cut away.

Most mounts have bevelled edges – the bevel sloping down towards the print – which give a more finished look than abrupt right-angled cuts. To cut out the window, use a steel straight-edged ruler and a sharp knife. The best type of ruler has one bevelled edge and is about 6mm/¼ inch thick. Do not use thin lightweight rules. To prevent the ruler from slipping, fix a strip of fine sandpaper to the underside with double-sided tape, or if the ruler has a hole in one end, attach it to a piece of

Types of hinges **(top to bottom)** Pendant hinge; pendant hinge on paper reinforcement; folded hinge; folded hinge on paper reinforcement. The length of hinges used will depend on the weight of the print. They must be able to support the print if the frame is accidentally knocked.

chipboard with a wing nut and bolt. This allows greater pressure to be exerted along its length. The knives which you use for cutting mounts should have rigid blades, preferably ones which can be changed quickly and easily. It is possible to obtain knives which have long blades sectioned at even intervals so that you can snap off the blunted edge as required.

Before making the first cut, practise on some old pieces of card. Hold the knife at a constant angle to produce the bevelled edge and apply an even pressure. Eventually you should be able to cut through a four-ply board with two strokes, the first of which scores the card establishing the line and the second heavier cut going straight through the card. To cut the mount, position the ruler along the pencil guidelines on the back of the card and cut at a slant so that the bevel will be sloping outwards. Remove the rectangle, setting it aside to be used for framing smaller prints and sandpaper the bevelled edges lightly so that the mount can be handled safely and the print will not suffer any damage through accidental contact.

Fixing the Mount

The print should be fixed in its final position behind the mount by attaching it to the backing board with two hinges stuck to the top edge of the reverse side of the print. Prints should never be fixed directly to either the mount or the backing board; not only would this prevent the possibility of reframing and remounting at some later stage, the print could easily become damaged and discoloured. Paper expands and contracts under different atmospheric conditions and the main function of the hinging system is to allow the print to hang freely. As an alternative, the print can be

Cutting glass 1. Measure up the dimensions working from a straight edge on the glass. Mark them with a felt tip pen.

2. Glass cutting tools have a small cutting wheel set in the head. When guided along a ruler the wheel is slightly distanced from the side of the ruler. Allow for this when making the cut.

3. Position the ruler and draw the cutting tool firmly along the surface of the glass.

4. Place the scored mark in the glass directly above the edge of a table or thick board and drop the glass gently, snapping off the waste piece along the cutting line.

5. The glass should be cut slightly smaller than the inside dimensions of the frame. If it is tightly wedged into the moulding it may crack.

hinged to a sheet of rag paper which is in turn attached to the backing board.

Hinges should be made out of Japanese paper. Cut strips of paper 1 cm/½ inch wide; the length will depend on the size and weight of the print. The hinges should be kept as small as possible but should provide adequate support if the mount or frame is knocked accidentally. Fold the strips in half and attach one half to the print, then attach the other half to the backing board. Always use a starch paste or water soluble glue; many valuable prints have become permanently stained by the use of the wrong sort of glue or tape. Never use pressure sensitive tapes like sellotape, masking tape, gum strip, spray mount, double-sided tape, rubber cement or synthetic glues. Ready gummed paper hinges made from long-fibred Japanese paper and water soluble glue such as wallpaper paste make good print hangers.

Equipment and types of glue suitable for attaching prints to mounts **(left to right)** Brush for mixing paste; flour and water for making starch paste; gummed paper; water soluble glues; gum arabic.

Glass

Glass protects the print and mount and filters out ultraviolet light. The type used in frames is commonly known as picture glass; lighter than window glass, it is about 5 mm/$\frac{3}{16}$ inch thick and is classified as 18 oz. Inexpensive wheeled tools for glass cutting can be bought, but cutting demands practice and most people find it easier to give the measurements to a professional.

Non-reflective glass is extremely expensive and not as efficient as picture glass. Because it blocks out light, fine detail or subtle colouring in a print is not always visible.

Perspex or plexiglass is also expensive and has the disadvantages of being easily scratched and of collecting dust from static electricity. However, it does block out some of the harmful effects of ultraviolet light and is flexible and virtually unbreakable.

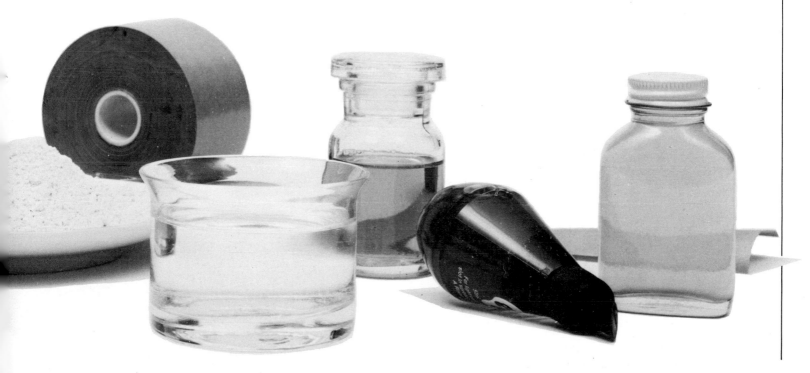

Cutting a mitre 1. Secure one end of a length of moulding in a mitre clamp. Make the 45° angle cut with a tenon saw.

2. Measure the required length of moulding from the cut end along the inside of the rebate and mark it with a pencil.

3. Use a set square to draw the 45° angle on the top side of the moulding, working from the original pencil mark.

4. Draw a vertical line down the flat side of the moulding from the mark on the top to show the outer edge of the mitre.

5. Fix the moulding into the mitre clamp aligning it so that the saw cuts down the waste side of the pencil marks. Make the second cut. Repeat the process to cut lengths of moulding for all four sides.

Making a Frame

The tools used by professional framemakers are often expensive. Basic household equipment will do the job just as well. Make sure you have enough free working space; it is surprising how much room even a small framing job seems to require.

When you purchase your mouldings from a supplier, check the lengths for straightness and any imperfections, and remember to allow a little bit extra for the mitred corners.

To cut the mitre accurately, you will need a mitre box for clamping the moulding in place before cutting the 45° angle. The least expensive are made out of wood, but after a while they become damaged from repeated sawing, so it is worth investing in a metal box with two clamps. A tenon saw with small teeth will ensure a smooth cut; panel saws are useful if you need more free-

dom of movement.

To hold the mouldings in place, fix them in a vice or make a simple tourniquet from string and wedges. Join the mitre corners with a synthetic aromatic resin such as polyvinyl acetate to ensure a permanent waterproof bond. These resins can be removed easily in their liquid state with water. Use a small flat-headed hammer to fix retaining nails on the picture backing, as this operation requires horizontal strokes.

Below left *Making a frame without clamps* A tourniquet made from heavy cord and a piece of dowelling can be used as an alternative way of clamping the mitred corners of a frame together. Glue and assemble the frame; place the tourniquet in position and twist to apply pressure.

Backing Paper

Backing paper is used to protect the print from dust and is glued to the outside of the backing board to create an airtight seal. It is often used to record authenticating details of the edition: dates, sale price, name of artist, technique and method of production.

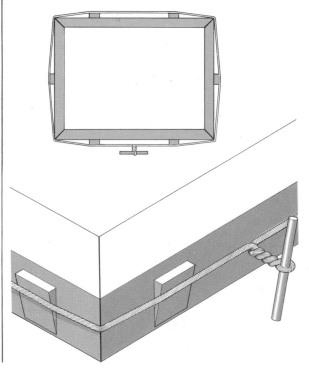

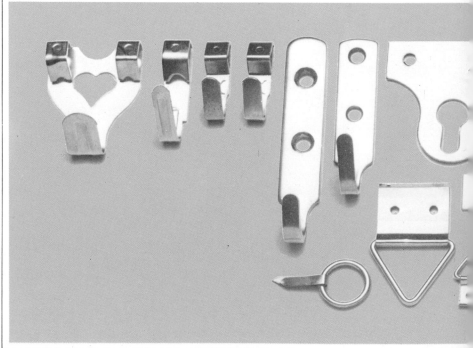

Assembling the frame
1. Check the fit of the mitred joints in the clamp. Spread glue on each end of the pieces of moulding.

2. Fit one long and one short length of moulding into the clamp to form an L-shape. Tighten the clamp and wipe away any excess glue.

3. Make small drill holes in the moulding and hammer in pins to secure the joint. Angle the pins slightly to prevent them from pulling out or splitting the wood along the grain.

4. Make a second L-shape with the remaining two sides. Then join the halves of the frame to form a whole rectangle. Ensure true jointing by resting all four sides on blocks at the same height as the clamped sides.

An alternative method of securing a mitre 1. Clamp the mitred ends together and make two small cuts across the corner. Fill them with glue and insert a small piece of wood veneer into each cut.

2. Wipe away excess glue and chisel off the protruding pieces of veneer. Rub the wood with sandpaper until the veneer is flush with the moulding.

Fitting backing board 1. When the glass and print are in position in the frame put in a sheet of hardboard previously cut to size. Hammer brads into the moulding just above the board to hold it in place.

2. A heavy stapler can alternatively be used to secure the backing board. The staples are driven into the side of the moulding and slightly overlap the board.

3. Cover the edges of backing board and moulding with strong adhesive tape. This provides extra strength and finish to the frame.

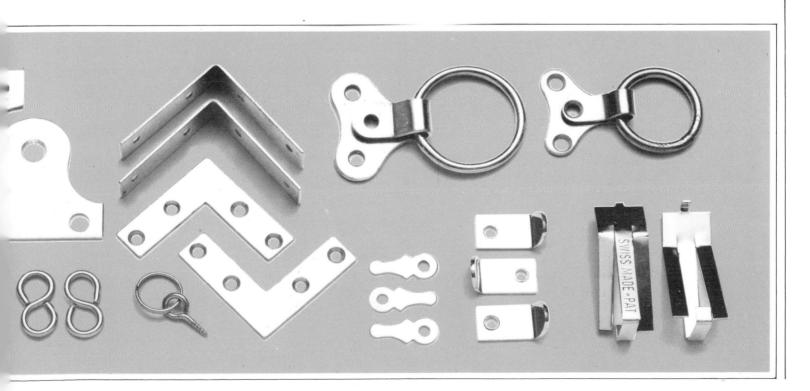

Picture framing The photographs on these pages were taken at Sielle and Cuthbert, Framing Consultants, London *(1)*. This firm still offers a highly individual framing service in which the components may be hand crafted to suit the work of art. Racks of sample frames are kept to allow the customer to see the shape and finish of a number of different types of mouldings.
Cutting the moulding
A length of plain wood is shaped on a spindle to form the moulding *(2)*. The carved designs on an old frame can be copied on to new wood *(3)*. Small section mouldings are cut on a mitring guillotine *(4)* but heavy wood must be clamped and sawn by hand. The mitred corners are held in a vice and pinned together

(5) to construct the frame. Incomplete frames are hung on wooden bars *(6)* projecting from the walls of the workshop.
Gilding The gilding process requires considerable skill and patience. The frame is given several thin coats of gesso *(7)*. When dry the gesso is rubbed down until it is perfectly flat. The next stage is to apply red bole which acts as a mordant for the gold leaf. The bole is thoroughly wetted out before the leaf is applied *(8)*. The gilder's brush is passed lightly across the face to attract a film of natural grease which helps to hold the gold. The thin leaf is then picked up on the brush, dropped on to the damp bole and brushed lightly into the shape of the moulding.

Creases in the gold disappear as it dries. When the frame is dry the gold is even and very bright. To simulate the ageing process it is rubbed gently *(9)* to dull the colour and allow traces of the red bole to show through.

2

3△ 4▽

1

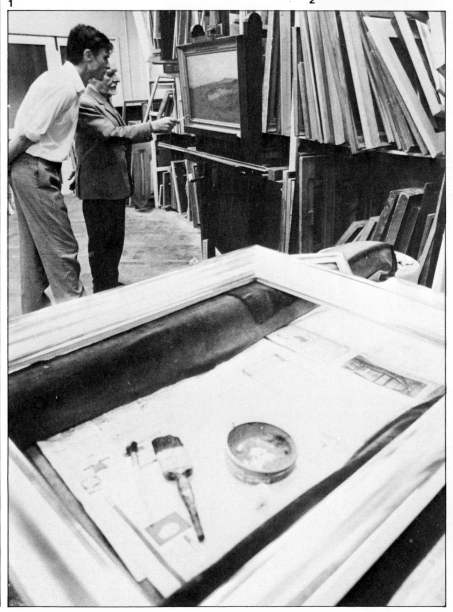

5△ 7▽

Display

Once framed, a print should be hung where it is displayed to best advantage. Important factors to consider are lighting, viewing height and temperature – prints can deteriorate if they are exposed to extreme heat. In fact, the eventual location of the print will probably be the result of a compromise – an ideal position for viewing and appreciation may well be the worst place for the print from the point of view of potential damage.

Lighting

Any light fades printed images on paper; less light only means less fading. Short of total darkness, there is no way to ensure that fading will not take place, and it is an irreversible process. However, it is always possible to avoid excessive light which

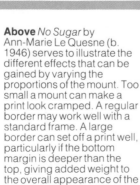

Above *No Sugar* by Ann-Marie Le Quesne (b. 1946) serves to illustrate the different effects that can be gained by varying the proportions of the mount. Too small a mount can make a print look cramped. A regular border may work well with a standard frame. A large border can set off a print well, particularly if the bottom margin is deeper than the top, giving added weight to the overall appearance of the print when framed.

would accelerate fading: as a rough guide, the amount of light normally required for casual reading is equivalent to that needed for viewing prints.

Today there is a tremendous variety of lighting fixtures available and a wide range of different types of bulbs in different wattages. There is no one answer to the problem of lighting – it is best to experiment with different systems to discover which works best in your own home.

Spotlights positioned on the ceiling can focus light on the print; they are easily adjusted and efficient. Wall spotlights serve the same purpose but are more obtrusive. Strip or pencil lights can be attached to the frame or held in a bracket above or below it. It is also possible to obtain special frames which incorporate a number of incandescent bulbs behind the moulding, illuminating the surface of the print with an even glare-free light. Galleries often use banks of fluorescent striplights surrounded by translucent plastic covers. These lights effectively simulate daylight, but may look inappropriate in the home.

Whichever lighting fixture you use, make sure not to ruin the effect by leaving an unsightly flex hanging down behind the frame. Centre the flex and bring it down in a vertical line to meet the

Above The colour of the mount is crucial. Try out different combinations to decide which looks best. Light mounts make the print look darker and dark mounts have the opposite effect. Colours already used in the print can be picked out for the mount or a contrasting shade may prove more effective.

skirting board. Fix it with a retaining pin and run it along the wall parallel to the floor.

Positioning

The viewing height is determined by the function of the room in which the print is hung. In a living room where people are seated for a good proportion of the time, it would not be sensible to position the print high up on a wall; in a hallway, too low a position would force you to stoop or crane your neck to see the picture. Too often pictures are hung in inaccessible places, such as over a mantelpiece, precluding any detailed examination and forcing you to the other side of the room to see them at all. Large prints can be positioned over a sofa, but a small etching or similar work in this situation would be lost. Small prints are best hung at eye level, rather than lower, to permit close examination.

Never hang prints above a radiator or air duct. Exposing prints to heat speeds up the deterioration of the paper: a temperature of 18°C/65°F is reasonable. The area above a mantelpiece is probably the worst position of all, not only for viewing, but the heat and atmospheric corrosion from fires causes damage quite quickly.

Care and Restoration

Prints are delicate, and vulnerable to destruction. Furthermore they are difficult to restore, particularly for the amateur, so that generally speaking, you would be well advised to leave restoration work in the hands of the professional. For these two reasons considerable care should be taken of any prints you might own, especially if they are valuable. Having said this, stress must be laid on the need for self-help. Given scrupulous care and attention, your prints should never need the assistance of a restorer.

The deterioration of a print is due mainly to light, but other factors such as room temperature, humidity, atmospheric pollution and the amount of handling that prints suffer from, are also crucial to their survival. Any amount of light, however little, causes some damage to the paper on which prints are made. Sometimes the surface is bleached white; on other occasions it might be darkened. In addition, nearly all the inks which are used in printmaking will change their colour if only to a very limited degree. In the case of water-based inks and watercolours, the effect of light, especially direct sunlight, can be devastating.

Care of Prints

There are a number of steps which can be taken to stop the process of deterioration, or at least retard it. Certainly the best way to preserve your prints would be to shut them away in the dark, laid flat in acid-free boxes and placed in an air-conditioned environment. While museums must consider doing this when the prints in their collections are not on public display, most private owners, and in particular the printmaker himself, must take a more practical outlook. The long term policy of museums can be mainly ignored and a few simple precautions taken instead.

Do not hang prints in direct sunlight or bright daylight. Obviously, to display your prints light is essential, but whenever light from any source falls on to printed materials there is always the possibility of a harmful chemical reaction taking place. The part of the light spectrum which is considered most responsible for print degradation covers the range from infrared through to ultraviolet, and these harmful radiations are emitted by tungsten and fluorescent tube lights in the same way as sunlight, though to a lesser degree. Try to hang prints in those recessed areas of your house which are in shadow and not bathed in either sunlight or artificial light. You should try to avoid hanging your prints in a place where the room temperature is constantly changing, for example directly above a heating radiator or above a fireplace which is in use. A steady temperature in the range of 15°C to 20°C/60°F to 70°F would be best. Also keep your prints off a damp outside wall as paper prefers a relative humidity of only 55% to 65%. All paper will absorb water and as a

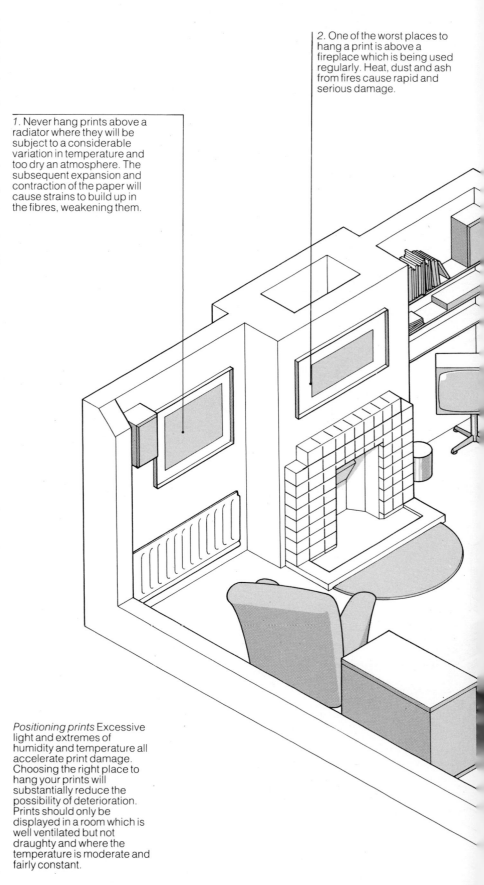

1. Never hang prints above a radiator where they will be subject to a considerable variation in temperature and too dry an atmosphere. The subsequent expansion and contraction of the paper will cause strains to build up in the fibres, weakening them.

2. One of the worst places to hang a print is above a fireplace which is being used regularly. Heat, dust and ash from fires cause rapid and serious damage.

Positioning prints Excessive light and extremes of humidity and temperature all accelerate print damage. Choosing the right place to hang your prints will substantially reduce the possibility of deterioration. Prints should only be displayed in a room which is well ventilated but not draughty and where the temperature is moderate and fairly constant.

result it will expand. Absorption of water is a fast reaction but de-absorption is far slower. If you place a print in a badly heated or ventilated room it will be locked into a permanent cycle of expansion and contraction and the stresses and strains on its surface will cause quick deterioration. Prints stored or hung in poor situations such as those described above will begin to buckle and curl along the edges. For evidence of this try dampening any page from a magazine and then heat drying it.

Another unwanted effect that damages prints which have been displayed or stored in poor conditions is known as biological activity or biodegradation. These terms refer to the fungi and

3. Never hang prints on a damp outside wall. An increase in humidity can allow moisture to penetrate to the surface of the print and cause fungal attacks.

4. Do not expose prints to strong sunlight. Bright light of any kind only accelerates fading.

moulds which attack paper and produce a variety of coloured spots on the surface of a print. As both these conditions are caused by organisms which are living they will eventually lead to the destruction of the area of the print where the attack is taking place. Many damp spots and foxing are caused by this form of attack. Though paper conservation experts are agreed that the exact cause of foxing is still uncertain, prevention can be assisted by keeping your print in a stable environment.

If you are going to embark on framing your own prints you will need to take careful note of the types of mounting board which is best for the purpose – and which will not affect your print through eventual degradation. Do not use glues of any type on your prints until you have tried them on wasted prints of the same material. If you do need to glue one surface to another, use wallpaper type pastes such as Polycell or Gloy. Never use petroleum-based adhesives such as Cow Gum or any synthetic glues. Also, whenever possible try to use perspex instead of glass because it will help filter out some of the damaging effects of ultraviolet light. Perspex also has the additional advantage of not splintering into a thousand pieces when it is dropped. Broken glass in a frame can lacerate a print into pieces and it may render the print irreparable.

Storage

When storing your prints it is essential to reduce the factors which cause deterioration to an absolute minimum. In the case of light this is easy, but for temperature and humidity a careful balance is required. Direct contact between a print and its container is not advised, especially if it is wood, as certain woods contain resins which can enter the print and cause staining.

For general storage, if the prints are not mounted they can be stored in good quality wood-free folders, with an acid-free tissue interleaved between each print, and these can be placed in solander boxes. Ideally, these should be stored at 15°C to 16°C/60°F to 62°F with a relative humidity of 55% to 60%. Obviously, a little variation either side can be tolerated. Remember to check all your stored prints regularly to make sure that they are free from deterioration. To do this properly you should study the whole of the print surface, back and front, with a magnifying glass.

Cleaning and Repair of Prints

The repair and conservation of prints is a highly skilled area of work where a knowledge of the craft skills involved in the various processes of printmaking is required. Allied to this knowledge there should be a familiarity with the various

Right Three stages in the restoration of a poster. Many posters, dated after the 1850s, were printed on mechanical wood pulp paper which, after a period of time, becomes very acidic. This particular poster was later pasted onto cotton supports which contributed further to the acidity. In order to remove the backing the poster was faced with tissue paper impregnated with adhesive. The backing was then removed and the paper de-acidified. It was then ready for relaying on a new paper support. **Below** The tissue facing is removed using an industrial hot air blower. Residue is removed with a solvent.

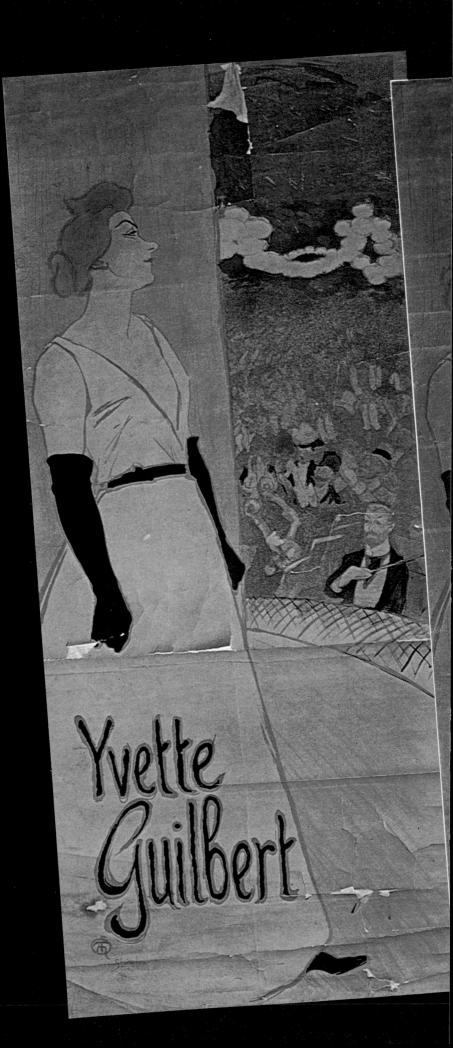

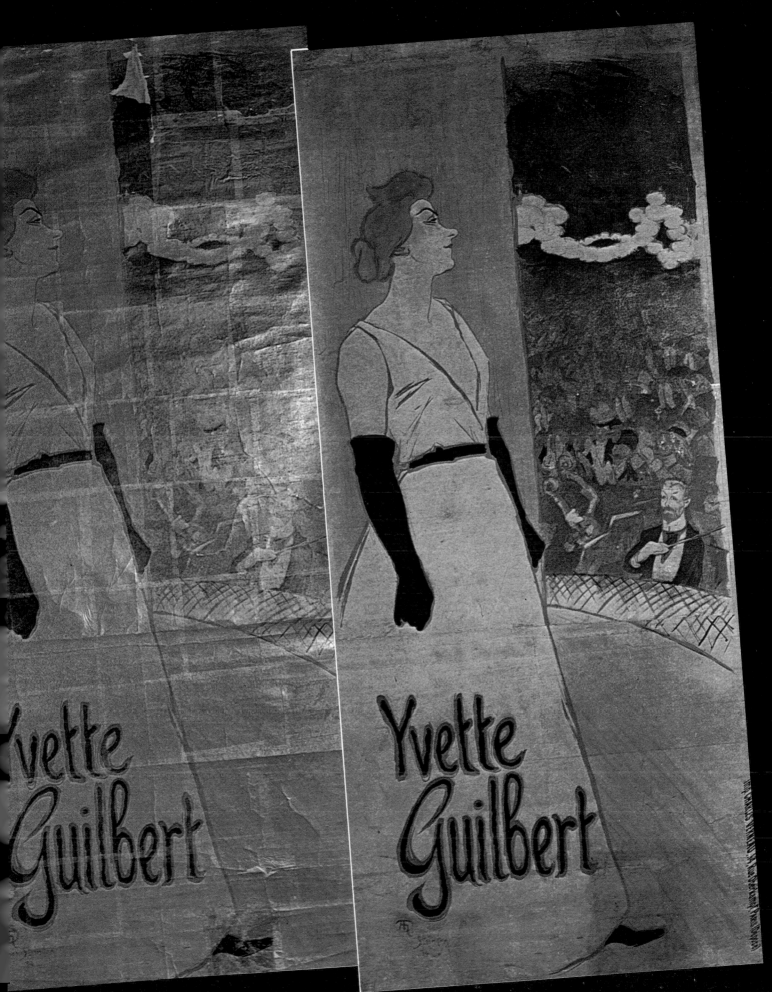

used to brush off the dust, again working from the centre outwards. Likewise dusting with a fluff or lint-free cloth can also be done.

Often some dirt is ingrained in the paper surface, and this may sometimes be removed by the use of a very soft rubber eraser. This requires great patience, and the greatest care is required to see that the surface texture of the paper is not damaged as the eraser is used across the print. Mechanical cleaning (such as the vacuum method or brush method) should not be practised if there is any sign of ink flaking or if the document is at all damp, weak or flimsy.

Relaxation

In many cases it is necessary to relax the print, that is moisten it, before repair is undertaken. The print or document is dampened either by lightly sponging the paper's surface with a damp sponge, by rolling it in a damp cloth, or by placing it between sheets of damp, pure white, acid-free, blotting paper. When the print is sufficiently limp it can be worked into shape with gentle finger pressure and suitable specialized tools. The difference between flattening and relaxing is that in the latter process the print is kept in a damp and flexible condition so that repair work can more easily be carried out.

Washing

The print can be washed either with non-aqueous liquids (often volatile and containing no water) or aqueous liquids (containing water) after proper testing has been carried out in order to ascertain the stability and sensitivity of both the ink and the paper. The solvent should be of analytical quality, free from acidity and alkalinity and unwanted residues. The greatest care is required in the selection of the solvent, and it should be used only under carefully controlled conditions. Many organic solvents are inflammable and injurious to health, so special working chambers and facilities are required.

The working procedure is to put the print and solvent together in a shallow stainless steel or earthenware dish and rock it to start a gentle wave motion. For an aqueous solution the bath may be slightly warmed if cold water does not produce a cleaning action. If paper has been sized with gelatine or has been tub-sized, then an aqueous washing solution will dissolve the size in the paper. This will result in a paper which has a reduced water resistance or one which may be 'waterleaf' in character, that is, similar in character to blotting paper.

De-acidification

A large number of documents and old prints may have built up an unacceptable level of acidity in their structure, and this must be removed or stabilized. If not, the print image and the surface of the paper can become seriously damaged. Spe-

cialist techniques of de-acidification are used by the restorer, and the chemicals and procedures employed by them are not suitable for general use. However, a simple method is available to the amateur providing that the printing inks, paint and paper have been suitably tested beforehand by a restorer. It involves immersing the print in a solution of 1.5g of calcium hydroxide per litre of distilled water for about 20 minutes, followed by immersion in a solution of 2g of calcium bicarbonate per litre for a further 20 minutes. The paper print or document is then drained and dried between acid-free blotting paper.

Bleaching

The bleaching of a print is sometimes considered necessary because of surface stains or discolouration. This involves a gentle chemical destruction of the areas which are discoloured. Therefore, before the procedure is adopted, the stability of the materials of the print must be known with respect to solvent and bleaching compounds. These bleaching compounds are frequently chlorine compounds, peroxides or complex reducing agents, and all are used in carefully controlled conditions of acidity and alkalinity. As well as whitening the paper, the bleaching chemicals attack the fibrous structure of the print and can, if not controlled, break down the whole of the printed area. It is advisable, therefore, that this procedure should not be attempted except by a trained restorer who has access to the correct scientific equipment to monitor and control the required reactions. The correct washing of such bleached prints is necessary to ensure complete removal of the bleach residues in order to prevent further chemical attack on the paper structure. Bleaching is not usually considered as part of normal archival repair.

Repair

The restorer carries out his work so that, in general terms, the finished product is close in texture and characteristics to the original. This means that where filling or patching is done, the repair paper should be of the same texture, or at least a similar texture, as that of the original. It must be acid-free, pure and clean, and unable to contribute to additional strains and hazards such as buckling. For this reason it is better to patch with ungrained paper. It is also an essential requirement that all repairs can be reversed without additional damage to the print so, for example, if any glue is used there must be an antidote in the form of a solvent. Tears, where there is sufficient overlap in the surfaces of the print, can be repaired with a suitable adhesive, although on some large tears it may be necessary to use a thin backing paper to in-fill the damaged areas. The adhesives used in this operation must be acid-free, colourless and odourless. Furthermore, they must be easily removable and not shrink on drying.

If there are any missing portions in the print the damaged edges should be chamfered (thinned) and the torn repair paper fitted in and tied with a suitable adhesive. If all the edges are damaged, the best procedure is to inlay the print in a frame of paper torn to fit it.

In recent years methods of print and document repair based on wet forming have been developed, whereby the damaged areas are filled in with a slurry (paste) of fibre and water. This is known as leaf casting and it requires special equipment, although a simpler hand controlled method has lately been pioneered. Both methods require a slurry of fibres to be made up with water, either from suitably cleaned de-acidified papers with fibres similar to that of the document, or from modern pure fibres. This slurry is then fed into the damaged part of the print whilst the whole is suitably supported. To ensure a better bond, a small amount of material such as methyl cellulose is added as an adhesive to the slurry. The document should have been cleaned and all the preparatory stages completed before this delicate operation is attempted. The primary skill in using this type of equipment is in selecting the correct fibres for infilling, their treatment, and control-

ling the way in which they are added to the damaged area.

Sizing

Sizing reduces water penetration into a sheet of paper, but the term is often used to describe not only this property but also a process of strengthening the sheet of paper, particularly the surface.

The method involves using a solution of photographic quality gelatine and immersing the document in it if it has sufficient mechanical strength to be moved and then dried by hanging up. If too much gelatine is used, the print will become brittle and possibly take on a sheen, hence care is required in selecting the strength of the gelatine solution. If the print is too weak, it can be laid on a suitable support material and brushed or sprayed with the same sizing solution. The support used for the document must be stable to the size, and not form a bond between size and print when it dries.

The materials for repair work must meet some required specifications. Papers must be free from lignin and have a low acidity (pH) or be neutral. Their strength and weight will vary but all the

Below A lithograph after being cleaned and restored. The damage to the print (inset) was considerable and included the disappearance of whole areas of ink. These patches have been retouched by hand.

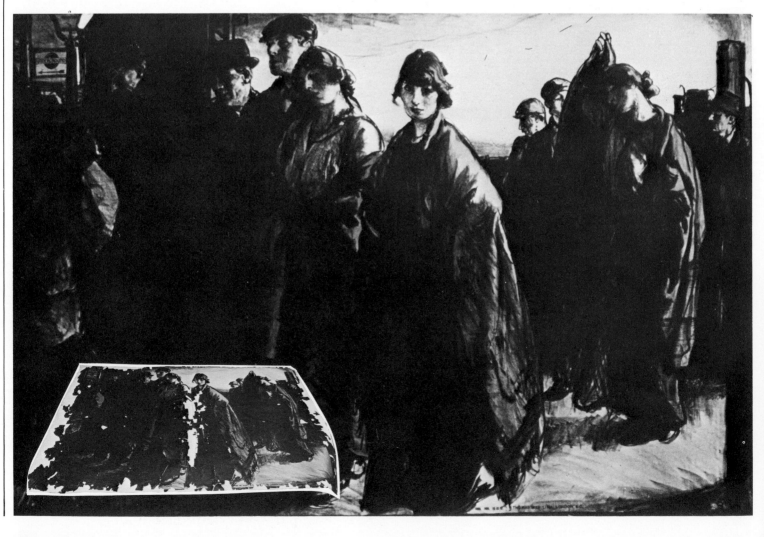

papers must have the quality of being able to be torn. This will allow them to be shaped for an in-fill. They should also age well, according to the normal ageing resistant tests currently available. Adhesives used in repair should also have a low acidity and be flexible as well as free from offensive colour and odour, and the adhesion bond produced must be reversible by simple solvent techniques. They should contain a minimum of mineral salts.

In some cases, if the print is too badly damaged for any of the above techniques to be applicable, then lamination between transparent plastic, or backing with a sheet of special fabric is normally practised. The same general rules apply here; that these techniques must be reversible and not cause any damage to the print, and the materials used must be chemically pure, of a good transparency, and both the fabric and adhesives used should comply with the basic archival specifications tests. Remember that all the techniques of restoration discussed here are to help you establish the method which might be able to be used to treat your damaged prints. The actual processes are best given over to an expert restorer.

Packaging

The basis of all packaging is to prevent damage to the print. This can come about through manhandling as well as moisture or water penetration.

The print should be wrapped in acid-free tissue and backed with a high quality pure wood-pulp board for strength, and then placed in a polyester sleeve and sealed. The boards should have sufficient strength to withstand the normal expected hazards of transport. The package should then be wrapped in a strong kraft paper, possibly a polyethylene-coated kraft to give outside protection and protection from moisture penetration. It should be sealed with packing tape, and not tied with string as this may bend the package and damage the prints.

Insurance

For those valuable prints or documents which you have collected, adequate insurance should be taken out against normal fire, flood and theft risks. Insurance against similar risks can also be arranged where the item is in the hands of a professional restorer, but it is not usually possible to insure the quality of his workmanship. The restorer should have insured his own premises against the normal risks, in addition to any peculiar risks due to the nature of his business. Finally, remember to update the insurance premium on your valuable prints. To do this, most insurance companies will insist upon a valuation of the prints every two or three years.

Above This print has been spoiled by a large stain. It was removed by the use of an oxidizing agent. Bleaching of works on paper can be detrimental to the paper structure and should only be carried out by a trained restorer.

Glossary

A

Acid The most common acids or acidic solutions for etching plates are nitric acid, sulphuric acid, hydrochloric acid and ferric chloride solution.

Alum Chemical used with water and nitric acid as a solution, applied to a zinc or aluminium plate in lithography, to remove dirt and oxide from the surface.

Aquatint An intaglio etching process used to create a range of tone. A finely powered resin is dusted over the plate. The resin is heat-fused to the plate and acid is used to etch through the finely grained resist of resin dust.

Aqueous and non-aqueous liquids Aqueous liquids are non-toxic water-based solutions for washing papers. Non-aqueous liquids are toxic solutions or liquids which do not contain water.

Aspheltum A type of stop-out varnish used on etched plates which require further work. Aspheltum in liquid form is used to protect the ink-receiving image during the preparation of a lithographic stone.

B

Baseboard The area, in screen process printing, where paper is positioned ready for printing. Ideally, the baseboard should have a vacuum suction pump to hold the paper firmly in place during printing. The baseboard is also the base of an enlarger in photographic enlargements of negatives, where the light sensitive (bromide) paper is positioned for light exposure.

Bath The liquid used for etching plates, usually acid.

Bench hook Wooden support mounted onto a working surface to aid the positioning of a block or plate during cutting.

Bevel Any sloping edge but particularly the slope on the edge of an etching plate or lithographic stone. The bevel is at an angle of 45° so that the plate or stone will not cut the paper under the pressure of the press rollers during printing.

Bite The action of the acid in the etching bath on a metal plate.

Bitumen of Judea A type of fast drying varnish, also called ASPHELTUM.

Bleaching Reducing a stain on paper.

Block General term for a plate used in relief printing.

Bridge The area of material which holds a character or number together in a cut stencil – for example, the centre of 0 or 8.

Burin A cutting tool used for engraving on wood or metal. Also called a GRAVER.

Burnish Applying pressure to a sheet of paper on a plate in order to take a print. Also, the action of using a burnisher, to repair or reduce lines in an etched plate.

Burnisher A rounded steel tool used for removing or reducing the size of etched lines in a plate. Also used for repairing bumps and dents in a plate.

Burr The ridges of metal formed by the cutting action of a drypoint needle or a mezzotint rocker. The burr (on one or both sides of a direct cut) can be left on the plate to produce a soft, furry line in printing or removed altogether.

C

Calendering Passing paper between cotton and steel rollers during papermaking to leave a high surface finish.

Carbon print Gelatine type of coated paper used in early experiments in the development of photogravure.

Carborundum stone and powder Very hard, fine abrasive stone or powder used to impart a fine grain or surface tooth to glass, a printing plate or stone.

Chinagraph pencil Grease-based pencil which will accept printing ink.

Collotype Photomechanical process of printing in which the image is transferred from a raised gelatine film surface on a glass support. The printed results are almost continuous tone, with no halftone screen effect.

Colour printing and four colour process Printing by any process in more than one colour. The four colour printing process employs the standard colours, cyan (blue), yellow, magenta (red) and black.

Conservation board A high quality board with a low acid content used in framing and mounting. It is usually made from cotton rag fibres and will not damage papers. Also known as MUSEUM BOARD.

Conté pencil A non-greasy black pencil, ideal for any preparatory work on a lithographic plate or stone which is not meant to print.

Copper engraving An engraving produced from a copper printing plate.

Crosshatching Technique of creating tonal variations on a plate by drawing parallel lines in one direction and then more lines at right angles to the first.

D

Dapper A leather tool in the shape of a rounded pad used to 'push' printing ink into the lines of a plate.

Direct printing Intaglio and relief printing method when the plate makes direct contact with the paper.

Drawtool A sharp steel tool used for cutting metal printing plates to size.

Drypoint An intaglio technique which does not involve the use of acid. In drypoint, a sharp round point is used to scratch the image into the metal plate

Dustgrain photogravure Technique used in the development of early photogravure to produce a tonal effect.

Dutch mordant An etching solution commonly used in intaglio printing which consists of a mixture of water, hydrochloric acid and potassium chlorate crystals.

Dyeline General term for proprietary types of coloured copy reproductions, such as those used for architects' plans. The most common colour is blue.

E

Échoppe Early type of etching tool, similar in shape to a writing nib.

Edition, editioning, non-standard editions The agreed total number of prints of an image printed by or for the artist. Each print in an edition is numbered in a certain way: for example, 10/60 would be the tenth pull in an edition of 60. Editioning is the production of the agreed number of prints, and the subsequent numbering and signing of each print by the artist. In non-standard editions, each print is unique in terms of colour content.

Electron microscope photographs Photographs taken through an electric microscope, greatly enlarging the source material and enhancing the colours.

Electrostatic printing The process of attracting printing inks or dyes to the surface of a material by an electrostatic (electric charge) pulse. Xerox is one of the best known proprietary makes of electrostatic copier.

Embossing Impressing type characters, metal plate or other types of hard flat material on paper or board to produce a raised surface.

Engraving Engraving covers a number of intaglio techniques, all of which involve the cutting of a design or image into metal plates or wood blocks. The metal or wood is removed with an engraving tool called a graver or burin.

Etching An indirect intaglio technique in which the surface of the plate is covered with an acid-resistant material called the ground. The image is cut into this material to expose the metal underneath. The plate is then immersed in an acid bath. Only those exposed parts of the plate are eaten away by the acid. The depth of line (etch) is controlled by the length of immersion in the acid and also by its strength.

Etching needle A sharp needle-pointed steel tool, used to prepare images on a plate in intaglio printing.

F

Frottage A drawing and lithographic technique. A rubbing is made by placing paper over a relief surface or a previously printed image, taking an impression of the image underneath. Brass and stone rubbings can be classified as frottage. In lithography a transfer can be taken on paper and put down on a zinc plate or stone.

G

Gelatine print See CARBON PRINT.

Gesso A finely ground chalk mixed with a pliable glue. Gesso derives its name from the Italian term for chalk or plaster. The material is used extensively in the preparation of ornamental mouldings for picture frames.

Gouge The tool used to gouge or scrape out large areas of unwanted surface material in the preparation of a woodcut or linocut.

Gouge chisel Similar to a gouge. A gouge chisel has a strong wooden handle so that it can be struck by a mallet to make deep cuts in the wood.

Grain The grain of wood is the directional growth lines.
End grain is the end of a piece of hardwood, used for wood engraving, not woodcuts.
Side grain is the side of a piece of hardwood, used for woodcuts only.
Paper grain is the direction of the fibres and other materials used in the manufacture of paper. Grain can be determined by flexing a sheet of paper or board – the lightest response indicates the grain direction.
The grain of stone is the surface that is thrown up after graining a lithographic stone so that it is ready to receive a drawing or transfer.
The grain of metal is the surface that is thrown up after graining a zinc lithographic plate so that it is ready for drawing.

Graver A bevel engraving tool (also called a BURIN) used in the preparation of images on metal plates printed by the intaglio and relief methods.

Gravure sur bois (engraving in wood) A French term generally used to describe both end grain and side grain methods of wood engraving or woodcut.

Groove and cleat A method of preparing a screen for screen process printing. A mesh is laid over the frame and is then forced by a cord into a groove cut around the outer sides of the frame.

Ground The material used to coat a plate prior to etching. The image is made by scratching away the ground to expose the plate to the acid. Soft ground remains soft after its application to the plate while hard ground becomes firm and hard.

Gum arabic A translucent gum solution used in the preparation of lithographic stones and metal plates and as a resist for greasy ink or lithographic crayon during the drawing stage.

H

Halftone A halftone is the effect created on film or a print by a halftone image. A halftone in printing gives an optical illusion of continuous tone when in fact the image is composed of small dots of varying size. A glass or plastic screen used in the back of a process camera is used to make halftone negatives or positives by exposure to light sensitive film.

Hard ground See GROUND.

Hingebar In screen process printing, the screen frame is attached to the hingebar which in turn is attached to the baseboard. This arrangement enables the screen to be lifted clear of the baseboard so that paper can be slipped in and out easily.

I

Inks Opaque printing inks, when printed as a solid over other inks, do not allow light to be transmitted from the inks underneath. For example, if blue is printed over yellow the result will be blue and not green.
Water-based inks are formulated so that they can be printed from relief plates and rubber and polyvinyl rollers. The finished print is sensitive to water.
Metallic printing inks are composed of aluminium, bronze and copper powders which give a lustrous and brilliant finish to the printed surface.
Fluorescent inks are intensely bright, unique in that they reflect and emit light.
Lithographic inks are basically similar to relief printing inks but tend to be more viscous and greasy. Solid blocks of lithographic drawing ink are dissolved in distilled water before use.
Relief inks are designed to print raised surfaces such as type, line or halftone engravings and electrotypes (reproductions made from an original block or plate). They are usually of moderate tack and viscosity.
Gravure (intaglio) inks must possess sufficient body to be pulled from the engraving on the plate and they must be free of any hard particles that could scratch the plate surface.
Screen process inks print sharply when forced through the screen mesh by the squeegee. They should offer little resistance to the squeegee.
High gloss inks are specially formulated to print on good quality coated papers, such as art paper, and they are manufactured for use in relief, lithographic and screen process printing. When dry, the colours look varnished and enhance the surface gloss.

Ink squash Ink squash occurs at the edge of a solid area of printing ink. Too much pressure during printing produces excessive ink squash.

Intaglio A process in which the image or design to be printed is cut or etched into a metal plate, usually copper. The technique involves printing from the recesses below the surface of the metal plate.

K

Key block The printing plate or block (usually black or another dark colour) which determines the position (registration) of the succeeding printing plates or blocks in colour printing.

Key image In multi-block colour printing by the relief process the key image is the first colour (image) to be printed.

Kraft paper A strong grade of wrapping paper, usually brown or buff in colour, highly glazed on one side. To make kraft paper impervious to water or liquids, a coat of polyethylene is applied to one or both sides.

L

Leaf casting Repairing damaged areas of paper in a print by filling the tear with a paste made up of wood fibre and water (slurry).

Letterpress printing A general term applied to relief printing process employing rotary and high speed industrial presses. Most newspapers are printed by letterpress.

Levegator Heavy cast iron circular weight with a handle, used for grinding and graining lithographic stones.

Lift ground See SUGAR LIFT.

Lignin A term for particles of foreign matter in paper.

Linocut A relief print made from a block of cut linoleum.

Linter Fibres of pure cotton.

Lithography The process of making a printed impression (lithograph) from images or drawings made on a lithographic stone (Kelheim limestone) or metal plates (zinc or aluminium), based on the water-repellent properties of greasy inks. Lithography is a planographic process – that is, prints are taken from a level surface.

Chromolithography Printing in the four colour process (cyan, magenta, yellow and black) on white paper. Colour stock would degrade the colour process.

Lithographic crayons and pencils Lithographic crayons are greasy black crayons, manufactured in ascending grades of hardness, numbered 1 to 5, for drawing on stone or plate. Lithographic pencils are made of the same drawing material as lithographic crayons, but come in pencil form.

Litho oil The oil solvent base used in the manufacture of lithographic printing inks.

Litho stone Heavy limestone blocks to allow regrinding and prevent breakage. After the stone is ground, its porous surface is ready to receive drawing lines and tones made with greasy crayons or pencils or with tusche, a liquefied grease. The best stones come from the Kelheim quarries in Bavaria, although these quarries are now worked out.

Lucite Proprietary type of plastic sheeting similar to perspex.

M

Manière noire Technique in lithography of covering the stone with ink and producing an image by scraping through to the stone underneath.

Marine ply A type of plywood which is impervious to water.

Masonite See HARDBOARD.

Mat See MOUNT.

Metal cut Technique of relief printing which involves cutting directly into a metal plate using a graver or a burin and acid.

Mezzotint A type of intaglio printing in which the surface of the plate is pitted with minute indentations which hold the printing ink. A rocker is used to produce

graduations of tone.

Monotype A method of pulling a single reverse facsimile of an image made on a hard surface (perspex, glass, porcelain, metal or stone) by superimposing a sheet of paper and rubbing (burnishing) the reverse side until the whole or a part of the image is transferred.

Monograph A print (or colour wash drawing) made in one colour only.

Mount (mat) The surround to a picture frame through which the image is visible. Mounts are usually made from flat sheets of card or board.

Museum board See CONSERVATION BOARD.

Multiple tool Cutting tool with two cutters on the head for making parallel lines. Used in preparing plates in relief printing.

N

Nap rollers Lithographic wooden rollers covered with calf skin. Used for rolling black lithographic ink onto the stone or plate.

Niello Fifteenth century engraving technique. A black compound of sulphur was melted into grooves cut or etched into the metal so that the image stood out more clearly against the metal. Frequently used to decorate armour.

O

Offset, offset printing To offset in colour relief printing the key plate or block is inked and the image transferred onto a prepared plate or wood block. This helps to position the next colour.
Offset printing is a lithographic printing method, where the image is offset after inking onto a printing

cylinder covered with a rubber blanket and transferred onto paper. The opposite of offset printing is direct printing.

Oilstone A fine grade carborundum stone or similar stone used for sharpening cutting tools. Oil is usually applied to the stone to reduce friction.

P

Paper Handmade paper is made by hand in a frame, manufactured from pure cotton linters or linen, usually with deckled edges.
Cartridge paper is a strong white opaque drawing or printing paper. The surface is smooth but not coated or glossy.
Mouldmade paper is similar to handmade paper in weight and appearance but is made mechanically. Mould paper is more suitable than handmade for colour work because it is more robust.

Perspex Translucent or coloured plastic which can be used as a substitute for end grain boxwood in engraving. Similar in density to boxwood but considerably less expensive.

Photogravure The image on the printing plate or cylinder is produced photographically or electronically for intaglio printing.

Photolithography The image on the stone or plate is produced photographically or electronically for lithographic printing.

Photomasking film Light sensitive photographic film used in the preparation of screen stencils for screen process printing. Similar in effect to light sensitive coatings used for photo etch relief printing and photographic intaglio printing.

Photomechanical process A general term for the process of image-making

using a camera and/or light sensitive film or other light sensitive coated materials.

Photo engraving The image on the printing plate or cylinder is produced photographically or electronically for relief printing.

Photo etching A method of etching a plate using a photographic light sensitive coating. A film negative is placed in contact with the light sensitive coating on the surface of the plate exposed to a light source. The photo resist hardens where it has been exposed to light; the other areas remain soft and can be washed away. The plate is then ready for etching in the normal way.

Photo plates Optical glass plates coated with light sensitive photographic emulsion. The modern form is photo film.

Pigment The particles of fine colour solids used to give colour, body and opacity to printing inks and paints.

Plankwood Wood used for woodcuts cut so that the grain runs along the surface.

Planographic A form of printing in which the print is taken from a flat surface as in lithography: from a plate, stone or other matrix.

Plate etch Solution used to condition the printing plate in lithography and help clarify the printing image. Usually, nowadays, a proprietary brand.

Pochoir The French term for STENCIL.

Printing press There are many different types of printing press; some are designed specifically for one process, others can be used to print images originated in a variety of ways. Large commercial presses are often entirely mechanical, but smaller workshop presses are usually hand-operated.

Process camera Large commercial camera (usually

mounted on a track or rail) used to produce line, halftone and continuous tone negatives and positives on large sheets of photographic film. The process camera is used to colour separate original colour artwork for reproduction through primary colour filters. It is also known as a reproduction camera.

Process engraving A general term to describe engraving relief plates and cylinders by photochemical or photomechanical means.

Proof The preliminary print taken to examine the progress of the work at successive stages. Proofs are pulled to check colour, weight of ink impression, ink squash, registration and the effects of different paper surfaces.
An artist's proof is a preliminary pull, inspected and modified by the artist, and retained as a unique work. Artists' proofs are usually numbered to a maximum of six. Proofing is the process of taking a proof pull.

Push knife A tool used to mix and transfer printing inks from tin to palette, similar to a wallpaper scraper.

PVA A proprietary brand of screen coating filler for use on the screen mesh after tusche is applied.

R

Reducing agents Chemical solutions, such as a mixture of potassium ferric cyanide and sodium hyposulphate with water, used to reduce chemically the density of photographic emulsions.

Register The exact positioning of colours, one on top of another, in multicolour printing. When colours are out of register, this is usually seen as a fault and steps are taken to correct the placing of the colours. Sometimes, however, a degree of misregistration is intended

as a feature of the print.

Micro-register systems Mechanical systems for checking the exact registration of multiple image prints.

Registration frame A mechanical aid for registering multi-image prints.

Relief printing A process in which the image to be printed is created in relief. Materials such as wood, linoleum or plaster may be cut away to leave the image in relief or a relief surface may be built up from the flat by adding objects such as keys, coins, leaves or card cutouts.

Resin A finely grained substance which forms a porous film deposit that can be used as a ground for aquatints.

Resist Any solution or coating which, after it has hardened in the light or air, resists acid or water.

Rocker A rounded steel tool shaped so that its teeth bite into and pit the surface of the plate. Rocking prepares the surface for a mezzotint.

Rosin A product extracted from gum rosin and used in the manufacture of printing inks and varnishes.

Rotary printing Printing from curved plates.

Roulette A toothed wheel instrument used to make small perforations in the ground or on the plate surface in etching and drypoint.

S

Scauper Tool used in wood engraving for clearing away large areas of wood around the image.

Scraper press A flat bed press which rules the back of the paper to receive the inked impression, as the bed

passes under pressure.

Screen process printing
Screen process pinting is a variety of stencil printing. It differs from other modes of printing in that it does not depend on paper (or other materials) and on an image-bearing surface coming into contact through pressure, but on ink being transferred onto a substrate from a stencil bearing an image. It is also known as silkscreen printing and screenprinting.

Screen wash The general term for various brands of solvents which are used to clean printing ink and stencil off screens in screen process printing.

Serigraphy General term for the process of using stencils to transfer an image to paper.

Seroid American brand of latex-based ink used as a washing fluid when preparing tusche for a screen in screen process printing.

Shellac Type of varnish, soluble in white spirit or turpentine.

Shim A card, wood or metal insert positioned under the hingebar when printing onto card or board in screen process printing.

Silicon carbide An abrasive which, when mixed with water, is used to prepare a grained surface on lithographic stones.

Sizing The use of a gelatinous mixture as a sealer or filler in papermaking. Sizing strengthens the surface of the paper and reduces water penetration.

Snakestone A polishing stone used to smooth areas of a plate or lithographic stone.

Soft ground An etching ground which stays soft after it is applied to the plate. Soft ground becomes porous easily and will produce a softer textured image than hard ground.

Solander boxes Boxes designed to hold prints for transportation or display, usually made of wood or plastic. Those designed for displaying prints can often be hung on the wall.

Spitstick An engraver's tool, used for engraving lines of varying width on a plate or wood block.

Squeegee A rubber-edged tool, similar to a windscreen wiper, used to force printing ink through a screen stencil in screen process printing.

Stamp printing Method of making a printed impression upon paper or fabric by stamping the block directly onto the surface, without the use of a press. Examples include potato or carrot cuts, plaster and linocuts.

Stencil A sheet of cut paper, card, metal, wood or stretched gauze through which ink or paint is brushed to transfer an image. A direct stencil is any stencil which is made or prepared on the mesh of a screen process printing frame. The stencil can be drawn directly using a resist or stop-out solution. The wax resist and tusche method are specialized ways of making direct stencils. An indirect stencil is any stencil which is made or prepared away from the screen mesh. The simplest type of indirect stencil is one which is made of cut-out frame paper or proprietary brands of stencil film (also called a knife-cut stencil). An indirect photo stencil is a photographic, light-sensitive emulsion-coated stencil which when exposed to light receives an image through a film positive bearing the image. The mesh on the frame in screen process printing is coated with the light-sensitive emulsion and after drying is exposed to the film image. An indirect photo stencil is a photographic, light-sensitive stencil, usually manufactured in the form of a two-layer film. One layer is the emulsion and the other is a transparent backing sheet which is removed before the stencil is exposed to light through a positive film sheet

bearing the image. The stencil is made away from the screen, and is placed in position on the mesh after development.

Stone printing Producing a print from a drawn lithographic stone.

Stone tint A process of using two or more lithographic stones to add colour variants to a lithographic print, more common when lithographic printing was first developed.

Sugar lift Sugar lift is a technique used in aquatint where the artist draws a positive image using a special medium containing sugar, thus ensuring that it will never dry completely. When the medium is nearly dry a varnish resist is applied to the plate and the whole plate is immersed in water. Only the sugary drawing underneath the resist is attacked, causing the varnish to 'lift' and expose the plate for aquatinting in the usual manner. This technique is also called lift-ground.

T

Teepol A proprietary brand of detergent which, when added to water, increases its viscosity.

Tusche method In lithography and screen process printing, the process of applying liquefied grease (tusche) with a brush onto a lithographic stone or a screen.

Tympan The brass sheet on a lithographic printing press which is placed over the stone or plate to allow the leather scraper to apply even pressure when the bed of the press is pulled underneath.

U

Undercutting In etching, undercutting is a fault which

occurs when acid erodes fine lines, causing them to widen or join together.

V

Vacuum forming The process of heating a sheet of plastic and then pulling it over an object on a baseboard by vacuum pressure from a suction pump. The plastic liner in a box of chocolates is an example of a vacuum formed object.

Varnish Any solution which is applied to a plate to resist the action of acid or water; also called stop-out varnish.

Vehicle The liquid component of a printing ink. The vehicle carries the pigment enabling the ink to flow.

V tool Tool used in linoleum cutting with a v-shaped cutting edge.

W

Waterleaf Paper with little water resistance – for example, blotting paper, or handmade papers which have little sizing in them.

Wax resist A method of tusche application for a screen process printing stencil, which involves the use of wax rather than a greasy ink.

Wet forming Method of repairing prints and paper documents, involving the use of a paste (slurry) made up from rag fibre and water.

White line method A method of wood block printmaking in which the image is defined only in outline so that each separate area can be individually coloured in.

Whiting A powder which, when mixed with water, forms a cleaning paste for

use on the surface of the plate before applying a ground in etching.

Wood block printing Printing from an engraved wood block.

Woodcut One of the relief processes of printing. Woodcuts are made on side grained or flat grained wood.

Wood engraving A relief process of printing where the image work is usually very fine with minute cut lines. End grain wood is used.

Index

ACKNOWLEDGEMENTS

Key: T-top R-right L-left B-below

The illustrations are reproduced by courtesy of the following:
Associated American Artists, New York: 70, 88
Christie's Contemporary Art Ltd.: 55, 75B, 78TR, 78-9, 79, 87, 90, 91R
Editions Alecto: 14B, 96, 111, 138, 147B, 152, 154-5T
Galerie Louise Leiris, Paris: 146B
Gemini G.E.L., Los Angeles (1974): 154B
Imperial War Museum, London: 84
Jarrold Printing, Norwich: 71
London Magazine Editions: 148T, 149T
Marlborough Graphics: 120
P.I.R.A. Leatherhead: 41
Private Collections: 14T (Cooper-Bridgeman Library), 68-9(c) Mati Basis, 126TL, 142-3(c) Eduardo Paolozzi, 148B Slade School of Art, 149B(c) Henri Chopin, 153B(c) Richard Hamilton
Tate Gallery Print Collection: 126TL, TR, B, 127T, 150L
The Petersburg Press: 15T(c) David Hockney 1961-3, 105R(c) David Hockney, 147T(c) Richard Hamilton 1970, 150-1(c) David Hockney, 152T(c) Eduardo Paolozzi 1970, 153T(c) Jim Dine 1969
The Trustees of the British Museum: 7TL, 7B, 12, 13, 15B, 53T, 64, 65, 66, 75TR, 103B, 104, 105T
The Victoria and Albert Museum, London (Crown Copyright): 7TR, 8T (Munch-Museet, Oslo), 15R, 16-17, 17T, 18-19, 51, 52, 53BL, BR, 57, 58-9, 63, 67, 75TL, 76, 77, 78TL, 85, 91L, 92, 98-9, 101, 102-3, 103L, R, 121R, 123, 124, 156B, 157R, 174-81
Waddington Galley: 146T

Every effort has been made to locate the artists whose work is illustrated and to acknowledge them accordingly. In the event of an omission, please contact the copyright holder.